LINGERIE & DESIRE

LA PERLA

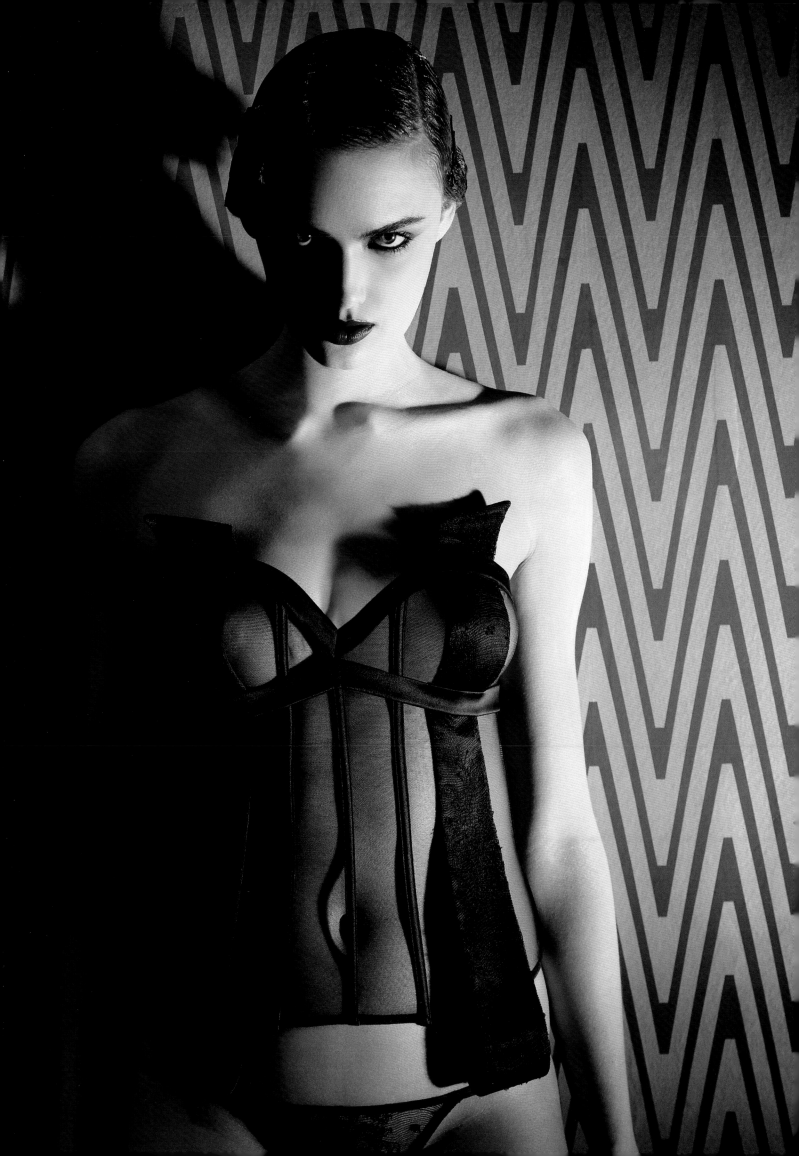

LINGERIE & DESIRE

LA PERLA

RIZZOLI
NEW YORK

New York · Paris · London · Milan

Cover:
Photo: Mary Rozzi
Model: Jeisa Chiminazzo

First published in the United States of
America in 2012 by
Rizzoli International Publications, Inc.
300 Park Avenue South
New York, NY 10010
www.rizzoliusa.com

Originally published in Italian in 2012
by RCS Libri S.p.A.

© 2012 RCS Libri S.p.A, Milan

2012 2013 2014 2015 / 10 9 8 7 6 5 4 3 2 1

ISBN: 978-0-8478-3916-2

Library of Congress Control Number:
2012934944

Printed in China

Art direction:
Sergio Pappalettera/Studio Prodesign

Assistants:
Daris Diego Del Ciello, Gaia Daverio

Text by:
Isabella Cardinali

Translation:
Sylvia Notini

Editorial:
Giulia Dadà

Production:
Sergio Daniotti

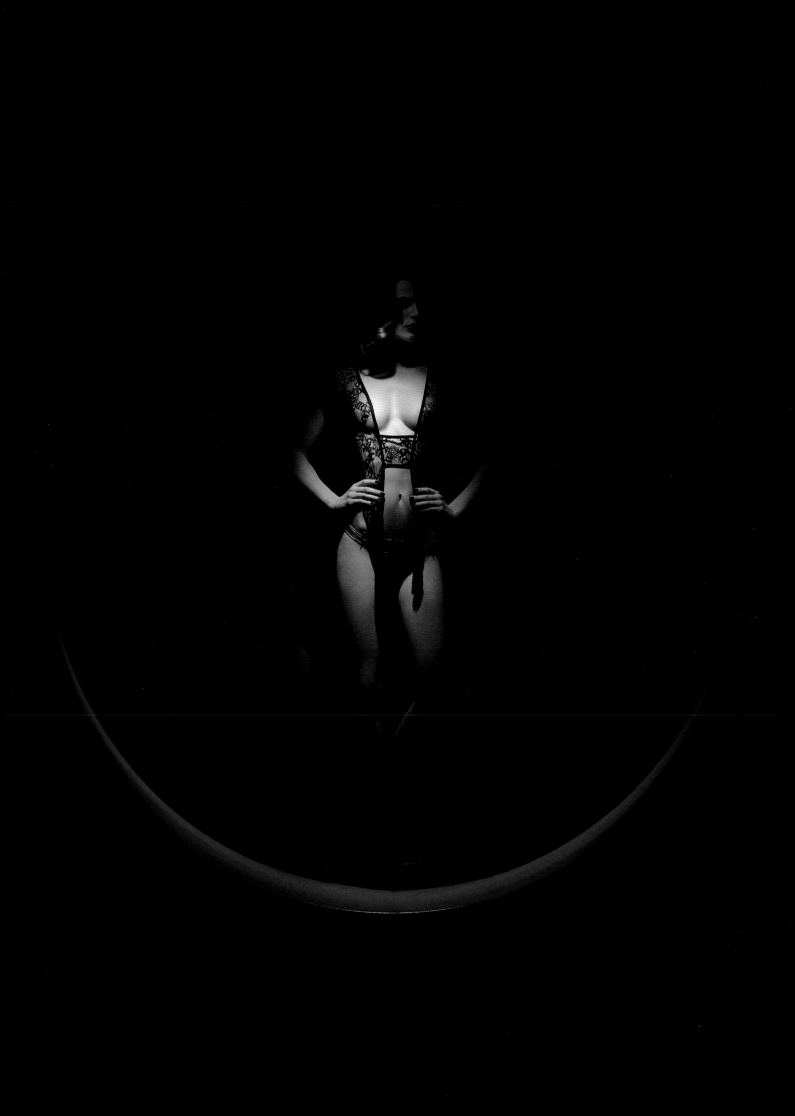

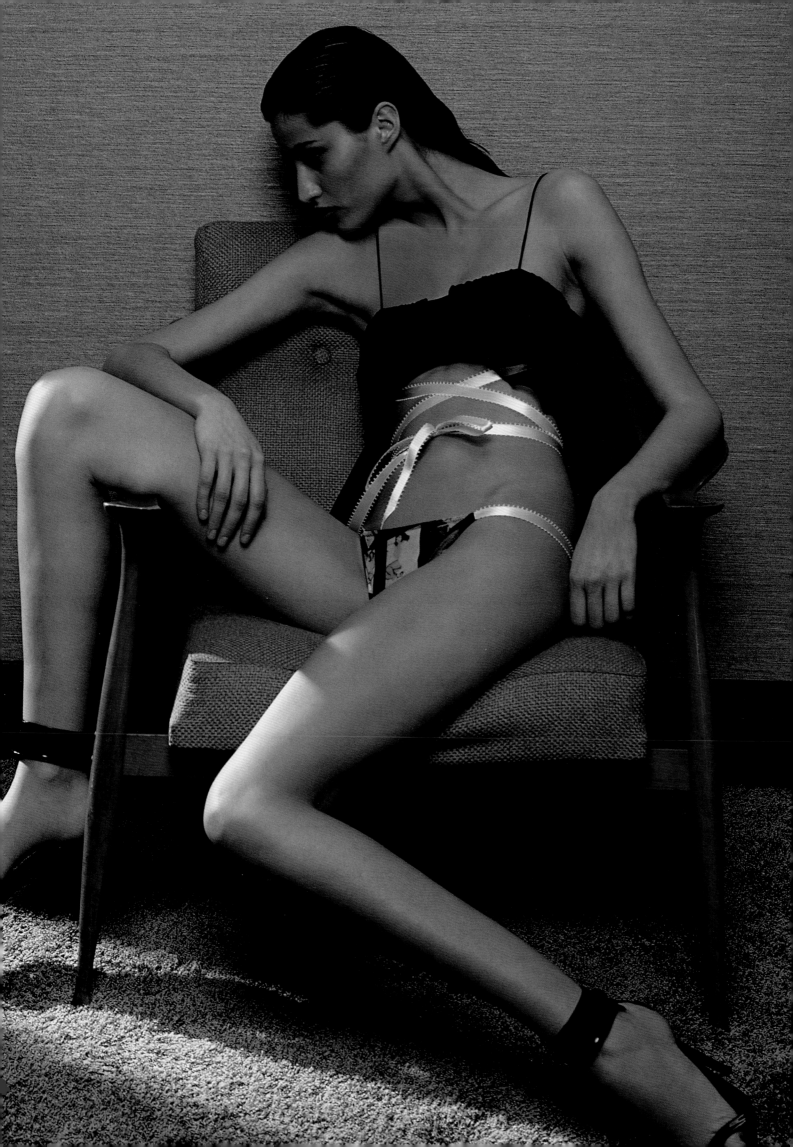

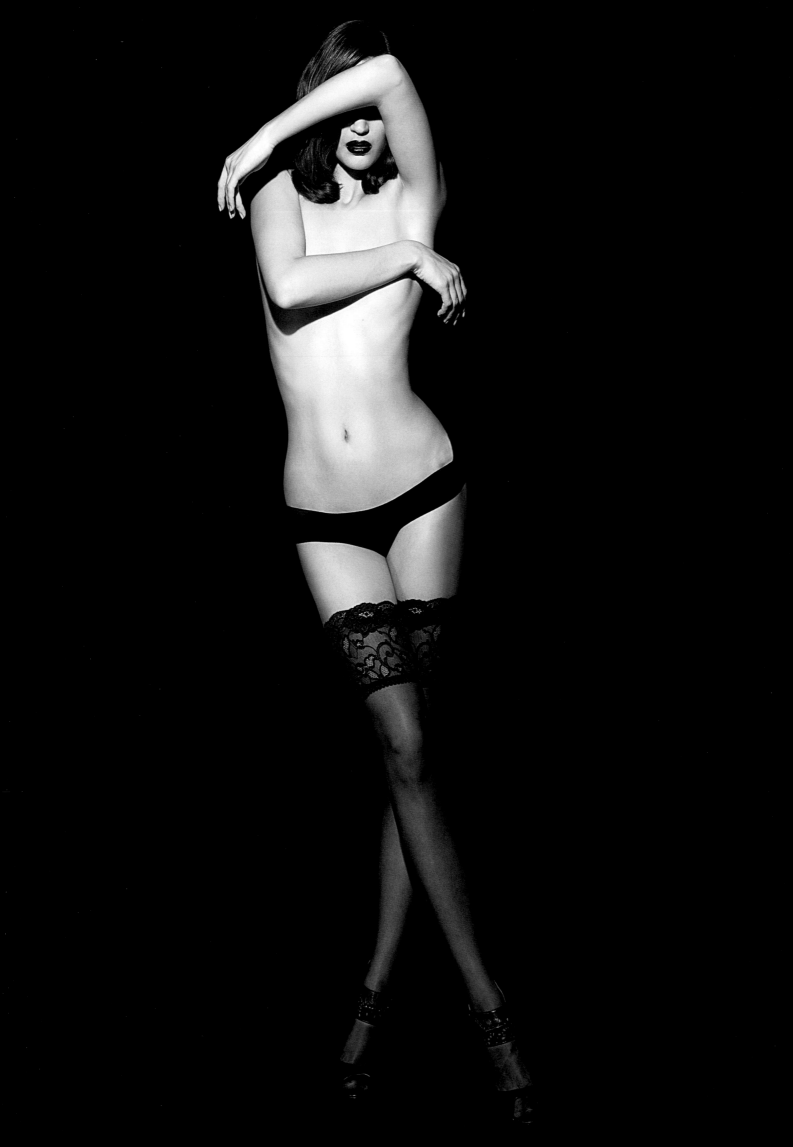

LIGHT AND SHADOW ON THE BODY

by Renata Molho

Lingerie: a sweet, alluring word, a play of light and shadow, a promise yet to be made but eternally awaited. In a world that seems to have lost interest in mystery, where all things are explicit and everything is displayed; a world where meaning is void and emptiness filled with sound, this word still conjures feelings both powerful and contradictory. It is the key to a universe of thoughts tinged with a myriad different nuances at the heart of which is desire. Desire as intense as passion, of course, but primarily the desire for success. "The body has become increasingly important to an understanding of one's own identity," wrote Bryan Turner in *The Body and Society* in 1984, words that have grown even more meaningful today. The body and its image have taken on an absolute value. In this close-knit dialogue between interiority, wellness, and physical fitness, what lies in the middle, between being naked and being clothed, is of the utmost importance. That subtle instrument to which we entrust the secret, the truth, the result of our effort to harmonize body and soul. A teasing piece of lace, an exclusive fantasy, a sumptuously persuasive material, a silvery hue: everything is conceived to offer the best version of the story we write day after day and only allow some to read.

The history of lingerie started long ago and has traversed lighter and darker moments. At one time it was reserved for use by the aristocracy and only later conquered by the lower classes. It became a manifesto of freedom in the protests of the twentieth century, when the demand for liberation was voiced by the burning of bras.

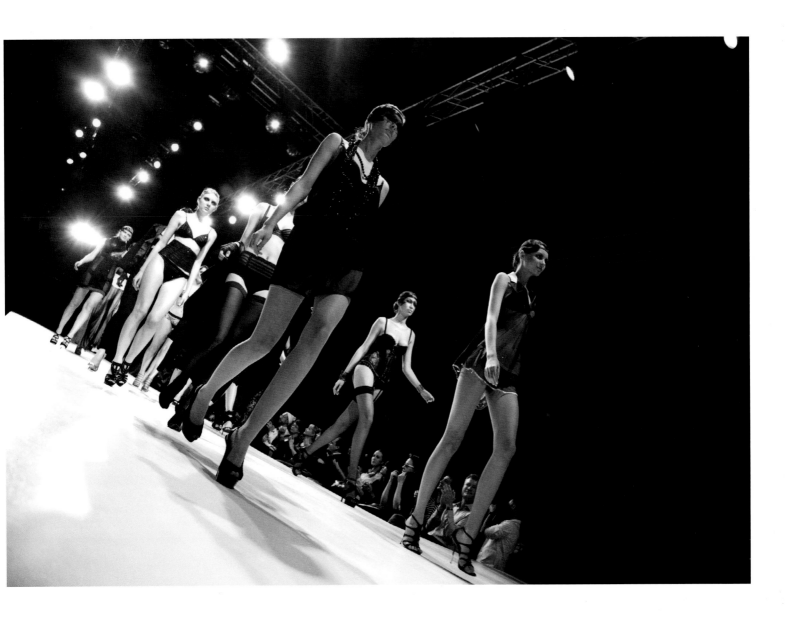

But the fascination with lingerie was far from over and soon undergarments began to play a leading role on the world's catwalks — at first, simply peeking out from underneath clothing and later by influencing the very silhouette of clothing itself. From the revival of the corset and dresses as intangible as slips, to the thin shoulder strap winking from under a sweater: the means of female seduction have never ceased to release their fragrance, igniting the fantasies of entire generations and eventually becoming a fetish for the younger ones.

In an age when plastic surgeons are raised to the rank of sculptors, the line between lingerie and clothing has been blurred. Corsets worn on the outside, bras worn like trophies, and culottes cheekily peeking out from clothing between perfectly shaped buttocks, often make us regret the days when there was a formal distinction between top and bottom, inside and out. But there are still those who, ignoring the fads and keeping at bay any sign of vulgarity, travel across the decades convinced of the importance of keeping certain meanings intact thereby building a world with its own specific language, one that brings to mind the cultivated atmospheres of the film *Belle de Jour* rather than the stroboscopic ones of nighclubs. This is a world that has a rich vocabulary, spanning from the playful to the more flirtatious and the innocent to the overtly allusive, with a single common thread: the elegance of the intent — a constant draw to the quality of style and performance.

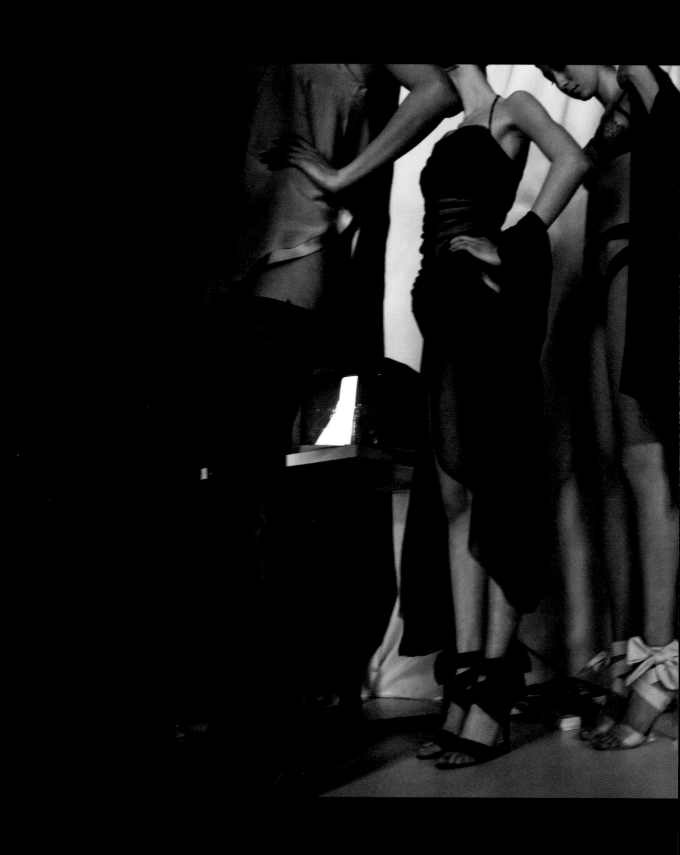

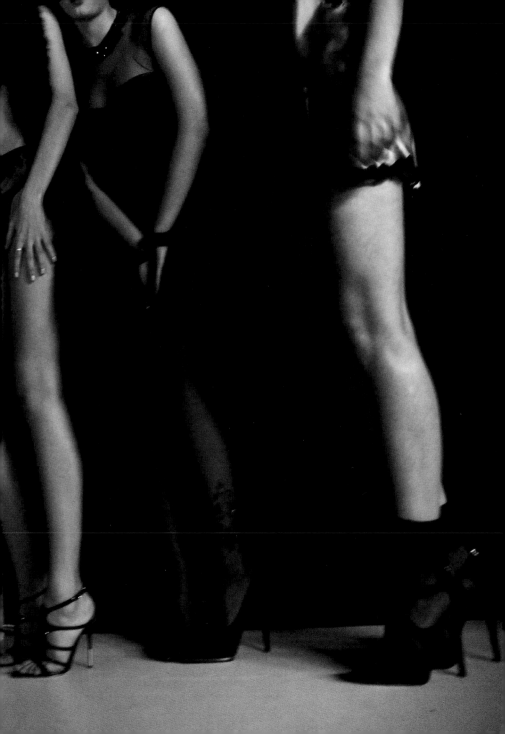

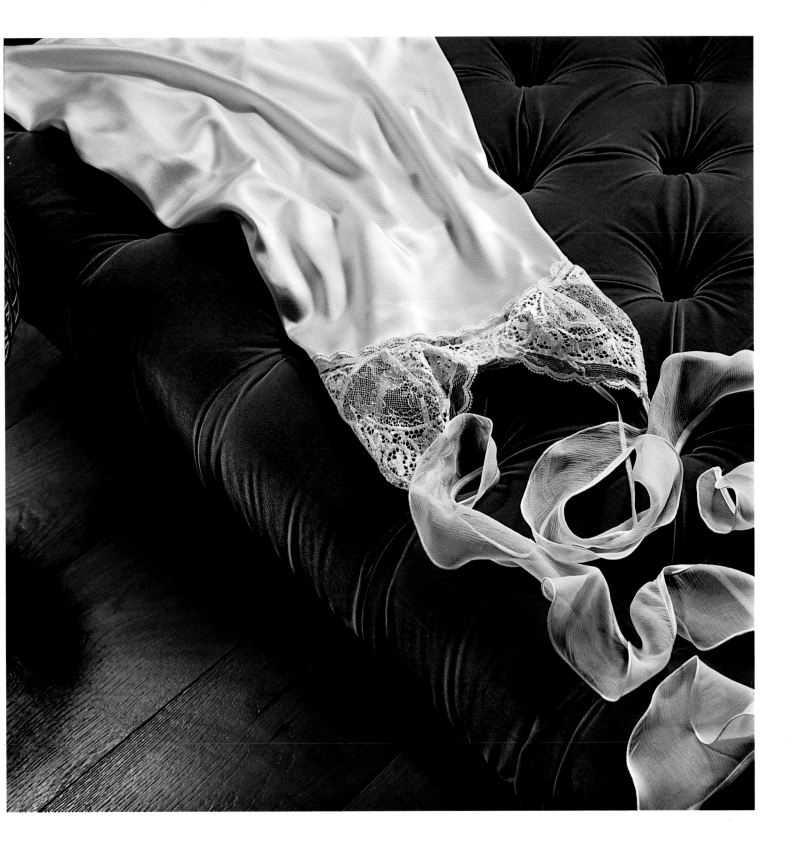

1. Illustration by Cecilia Carlstedt for *La Perla* magazine F/W 2005
2. Illustration by Lovisa Burfitt for "Hotel Wonder" exhibition,
Milano Fuorisalone 2006

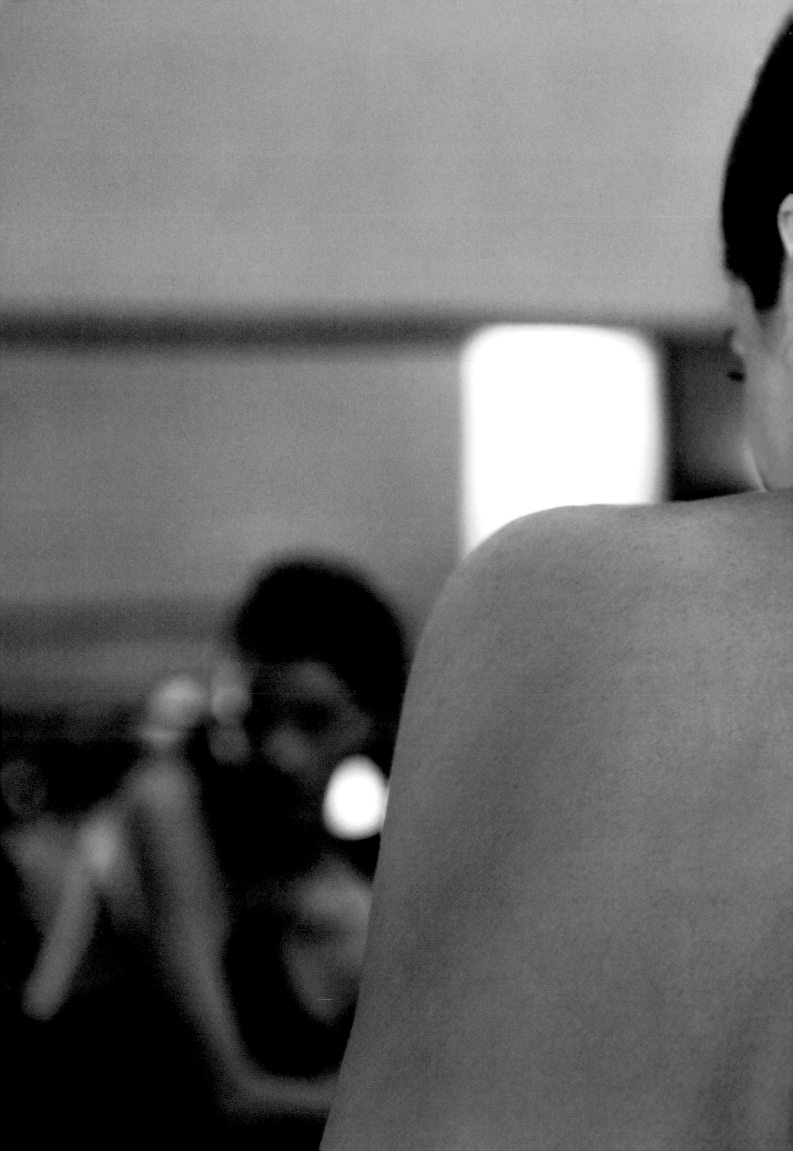

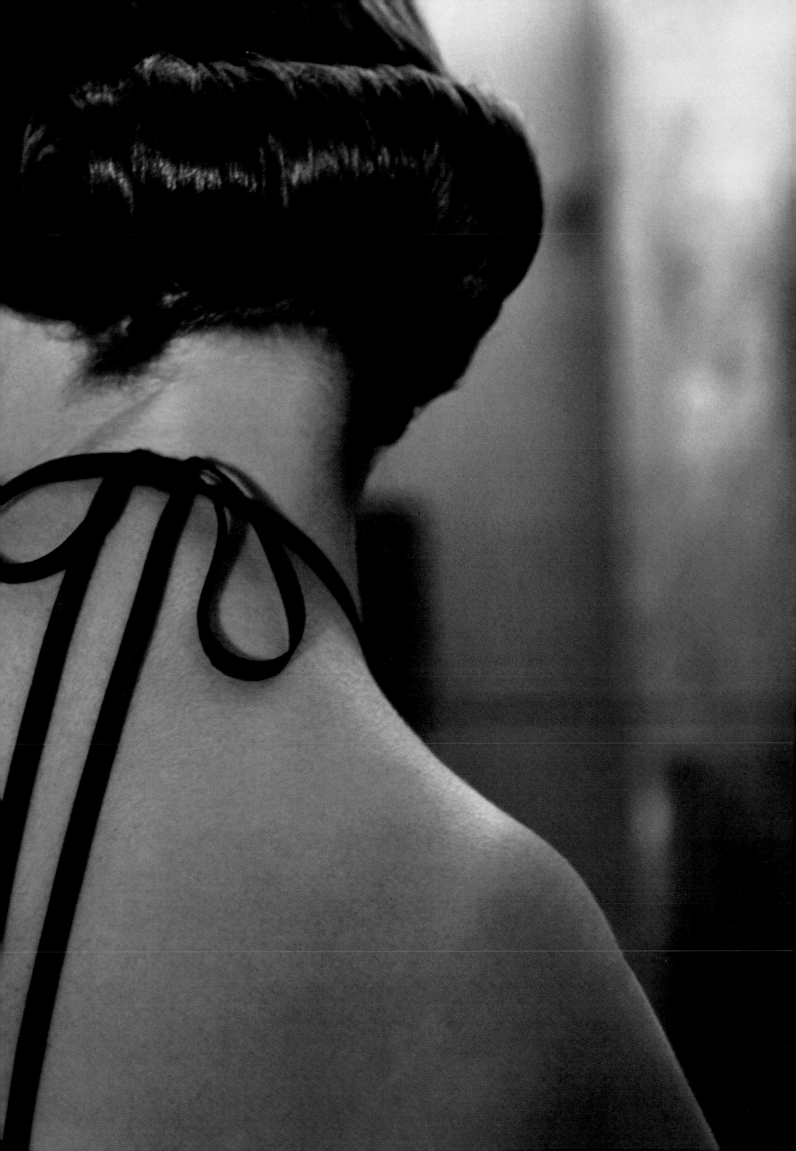

LACE, WEAVE OF DREAMS

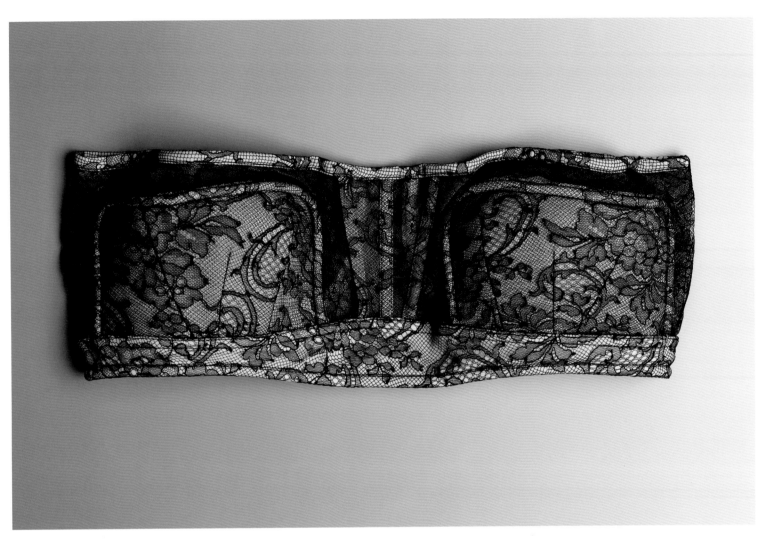

Flowers, spirals, and arabesques emerge from the intertwining and knotting of fine threads in a wondrous spider web. At one time handmade lace was so highly valued that it was considered a luxury item only few could afford; aristocrats would list lace-trimmed garments among their most prized possessions alongside family jewels. The investigation into how to create lace-making machines based on the same mechanism used to manufacture hosiery began at the end of the eighteenth century in England. However, it was not until 1812, at the height of the Napoleonic wars, that John Leavers finally succeeded in building machinery capable of producing lace comparable to handiwork. In spite of the skepticism of many English craftsmen who viewed the mechanization of lacemaking with trepidation, the demand for lace grew to the point that the British government sought to protect this industrial secret by making capital punishment the penalty for any attempt to export its lace-making machines. Only four years later, however, three English workers—certain that they could make a fortune in France—

decided to defy the ban. One night they dismantled a number of machines and transported them in pieces by ship across the rocky English Channel to Calais, where they found workers willing to set up a new workshop. French aristocrats were naturally very pleased to access lace easily on the national market and, by 1820, numerous workshops had been established throughout Calais. To this day, the French district of Caudry-Calais is reputed to produce the most intricate and precious laces. One of the trademarks of the unique Dentelle de Calais are the picots, small decorative loops edging the lace that can be seen when it is held up to the light. Today, the mechanical frames that have been used since the nineteenth century are employed to manufacture lace in a complex procedure that entails no fewer than thirty discrete steps and that requires highly skilled labor and a great deal of time. The lace that gradually emerges from the machines of Calais is what enthralled Ada Masotti, founder of La Perla, as a young girl, and it is the only kind of lace she ever used for her creations.

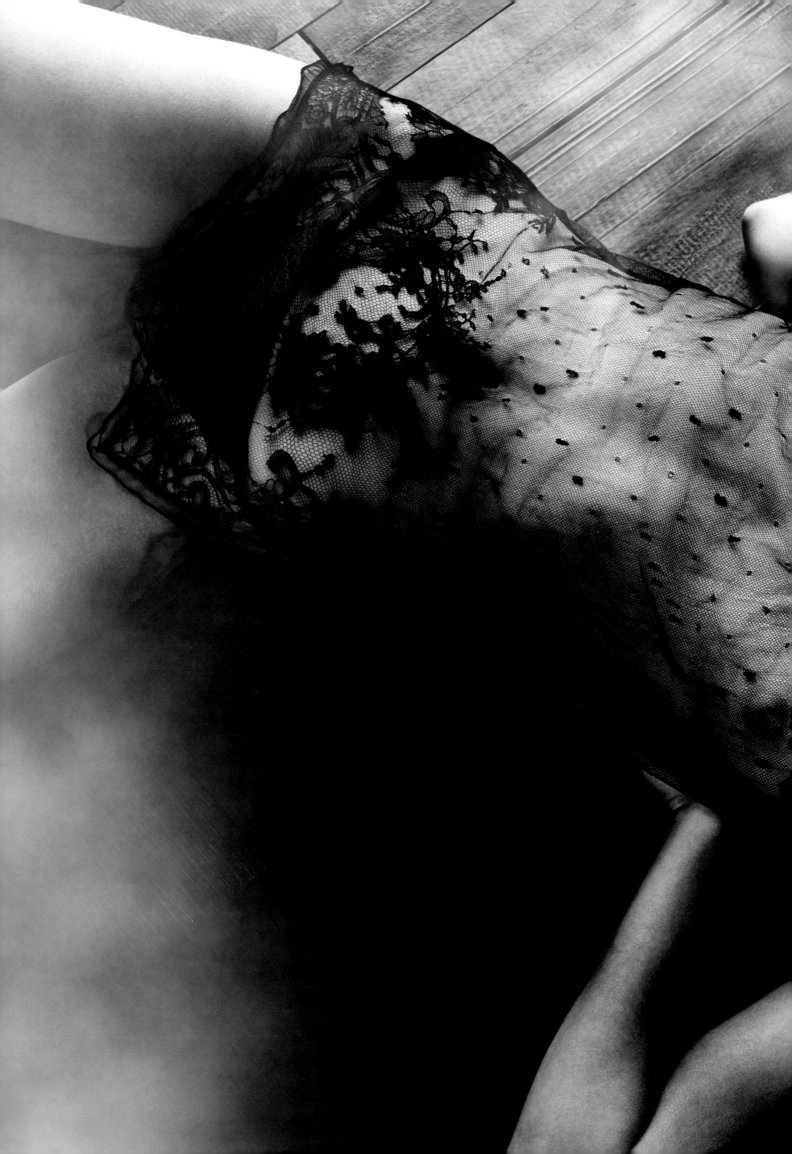

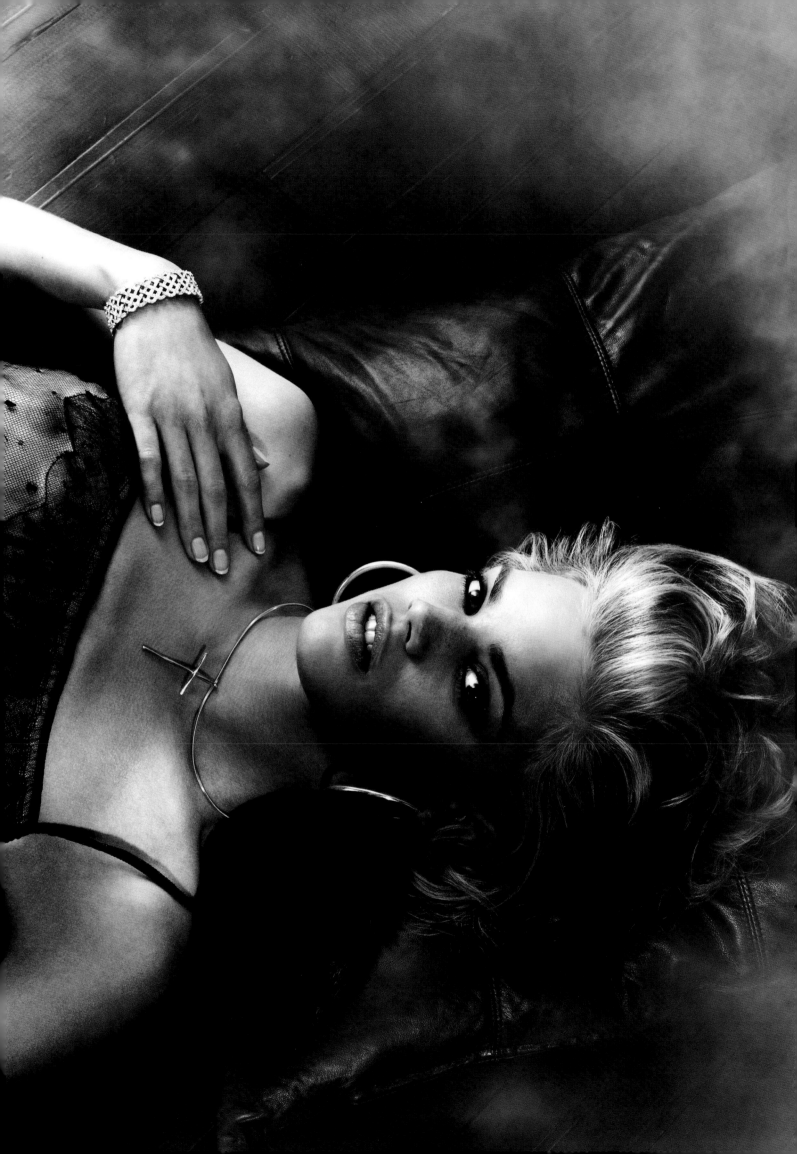

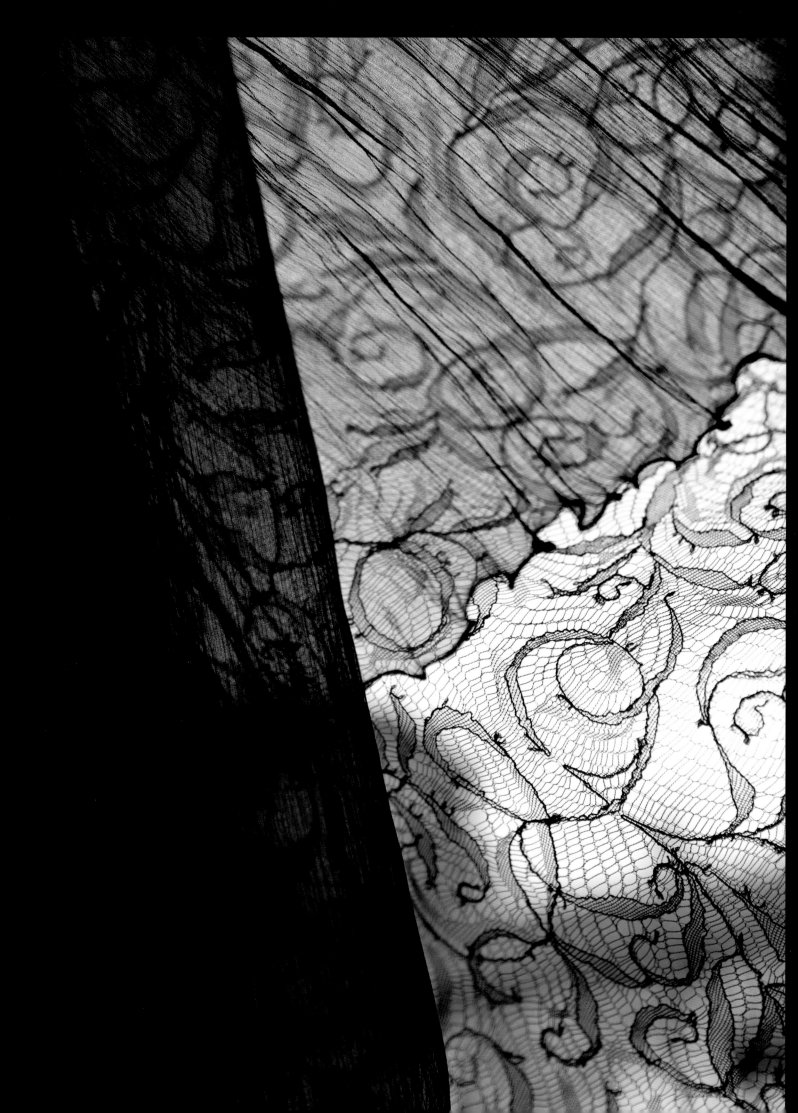

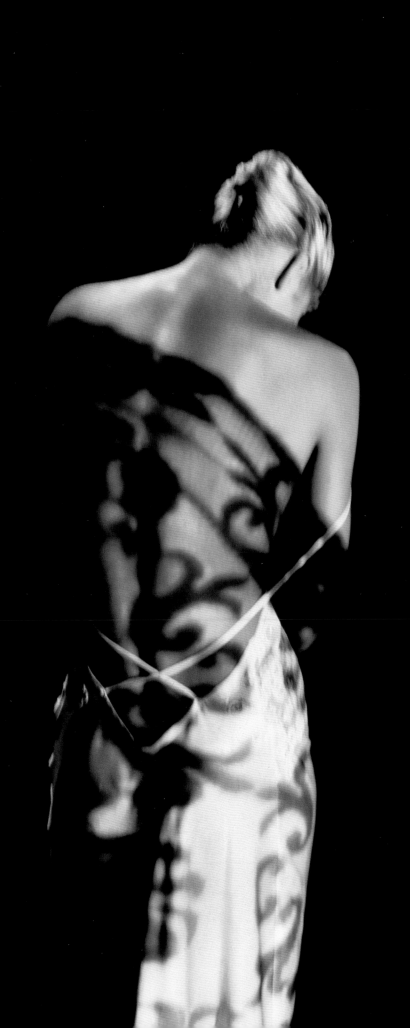

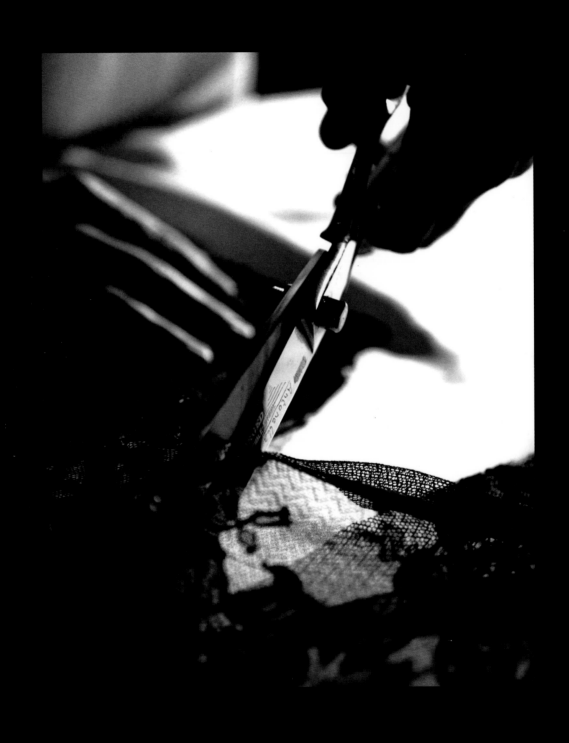

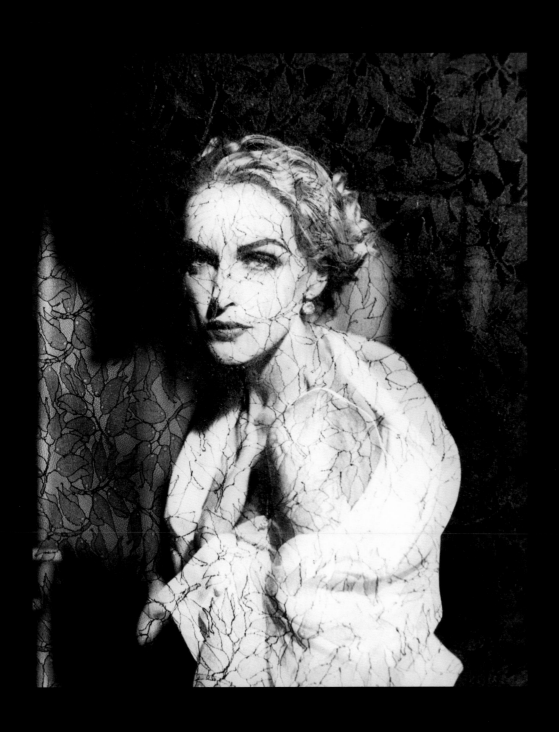

ONCE UPON A TIME

This is the story
of a woman
with an exceptional gift
and a wondrous dream.

■ ■ ■

"Golden Scissors" was the nickname given to Ada Masotti at the workshop where she trained to become a corsetiere. Her manner of cutting, as fearless as it was delicate, made silk and lace float from her hands as lightly as clouds. There was indeed gold in the dexterous hands and dreams of this young girl who grew up in the shadow of the porticoes and towers of Bologna. This jewel of a city had once been a city of water, crisscrossed by a network of canals that connected it to the surrounding countryside, where silkworms were bred. It is not surprising that she found her vocation in Bologna, where silk was woven and embroidered amid the hustle and bustle of small workshops producing precious creations that would come to represent one of Italy's finest traditions.

As a child, Ada Masotti loved to spend her time surrounded by fabrics and spools, and by the time she was a young girl she was already an expert in à jour and Aemilia Ars embroidery. After spending many years managing the most prestigious workshop in the city — and boosted by the vibrant energy that characterized postwar Italy — in 1954, Ada Masotti decided to open her own atelier. Her long adventure began with two sewing machines in a kitchen on Via Marsala, a historic street in the city center sheltered by porticoes, Bologna's hallmark. By her side were a hired worker, her husband, Tonino, and their son, Alberto, all of them at her service even when all that was required was packaging the marvels that came out of the extraordinary woman's hands and imagination.

The corsetiere's trade coursed through her blood; she knew how to create lingerie that made women feel beautiful at the mere thought of wearing it. Her impeccable understanding of the female body was indispensable for an artisan who had to trust her own sensibility to

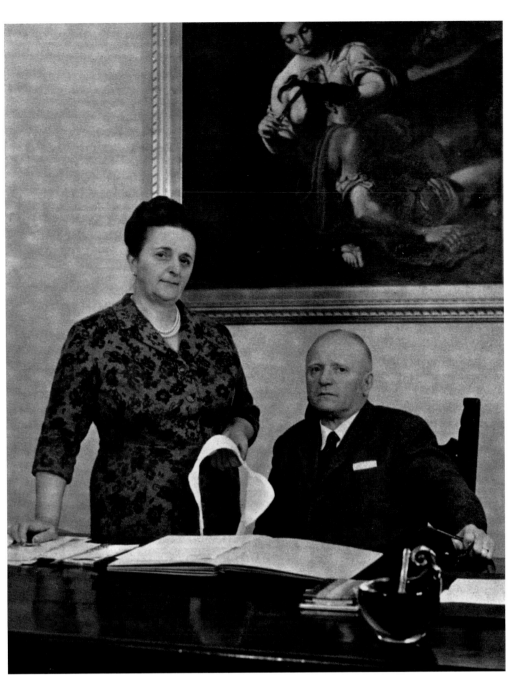

shape every article she created, as prior to the invention of elastic material, pliancy could only be obtained by covering rubber threads with fabric. The first lingerie sets they created were transported in small velvet-lined suitcases similar to those used by jewelers. In fact, it was this enclosure that gave the Masotti family the idea for the name of their new business. "La Perla" is inspired by the harmonious form and the preciousness of the most feminine jewel of all, the pearl. It proved a fortuitous choice leading to the successful establishment of the atelier in the city and, soon thereafter, recognition throughout the region.

Early on, the family found in Ubaldo Borgomanero a charismatic collaborator. A salesman gifted with excellent skills of marketing and communication, he gave the family invaluable advice and always kept Ada Masotti up to date on market trends and developments in the lingerie sector. As the years passed, the workshop gradually turned from a small atelier to a full-fledged company. Eventually, the helm was handed to the young Alberto Masotti, who gave up a nascent medical career to dedicate himself wholeheartedly to the family business and helped it become a leader in the luxury lingerie sector on an international scale.

Though Ada Masotti died suddenly in February 1992, she lived long enough to see her brand become a reference point for women across the world. She succeeded in passing on the experience of what she referred to as "il mestiere di creare bellezza" (the art of creating beauty) to her fashion designers and pattern makers, founding a school within the company that remains a precious resource today. In October 2008, the company was acquired by JH Partners—a San Francisco based private equity firm whose goal is to preserve La Perla's "DNA" and spread its Italian identity throughout the world.

Ada and Tonino Masotti

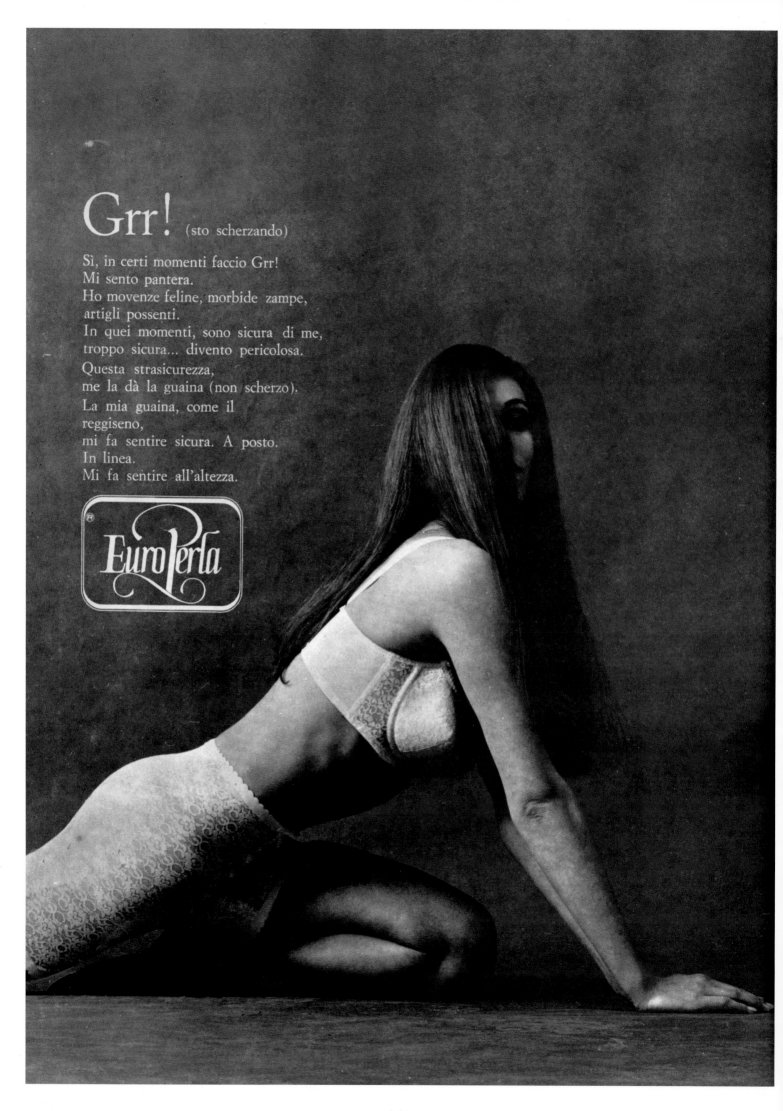

Grr! (sto scherzando)

Sì, in certi momenti faccio Grr!
Mi sento pantera.
Ho movenze feline, morbide zampe,
artigli possenti.
In quei momenti, sono sicura di me,
troppo sicura... divento pericolosa.
Questa strasicurezza,
me la dà la guaina (non scherzo).
La mia guaina, come il
reggiseno,
mi fa sentire sicura. A posto.
In linea.
Mi fa sentire all'altezza.

EuroPerla

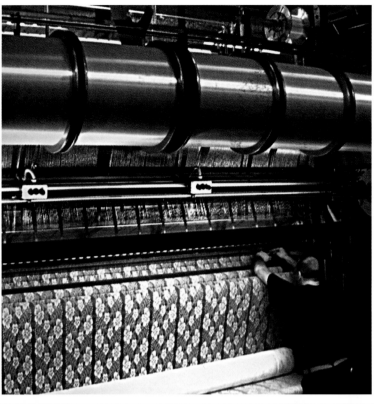
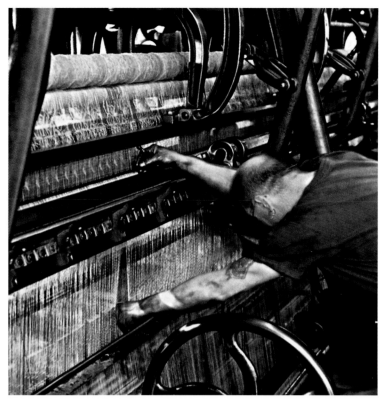
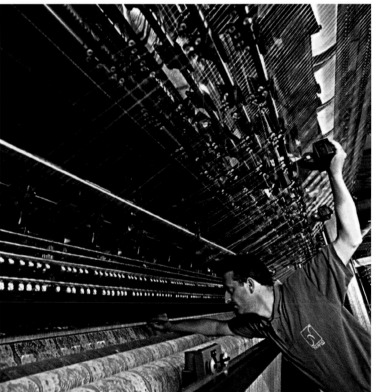
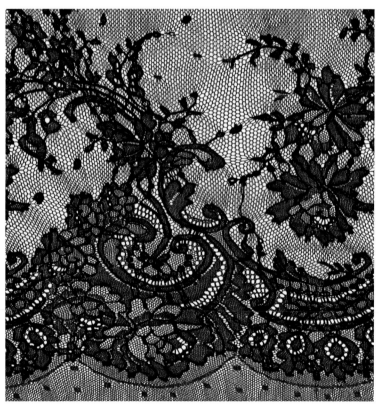

Left: 1960 La Perla advertising campaign
Above: Leavers lace-making machine. Dentelle de Calais factories
On page 32: La Perla workshop, 1964, Bologna;
On page 33: La Perla factory (photo Nate Larson)

31

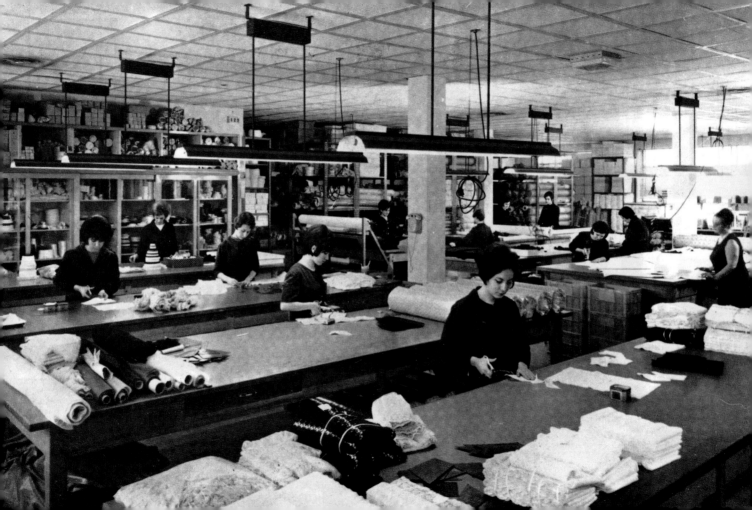

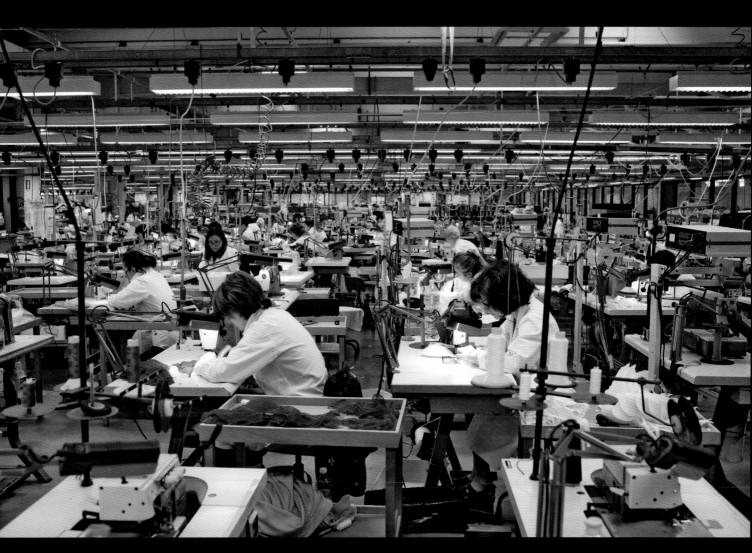

sixties

The consumer society of the swinging sixties spawned a generation of young people looking for a fresh, sexy, and unconventional style. New fashion icons emerged to the rhythm of The Beatles, The Rolling Stones, Jimi Hendrix, and The Who. Brigitte Bardot was legendary, and destined for fame were the waifish Twiggy and Jean Shrimpton. The classical canons of beauty were revisited with an eye to an all-encompassing freedom that took its cue from music, art—particularly pop art—and new social movements. First and foremost were the ideals of peace, love, and "flower power," as championed by the hippie generation. As this wave of profound change swept across the country, La Perla launched a new concept in lingerie: it released more colorful collections with multicolor floral, plaid, and checkered patterns alongside its more traditional white, black, or nude creations. Ada Masotti was aware that, thanks to the innovation introduced by designers such as Mary Quant, fashion was being revolutionized and lingerie could not afford to lag behind. In the fabulous sixties, speed was of the essence.

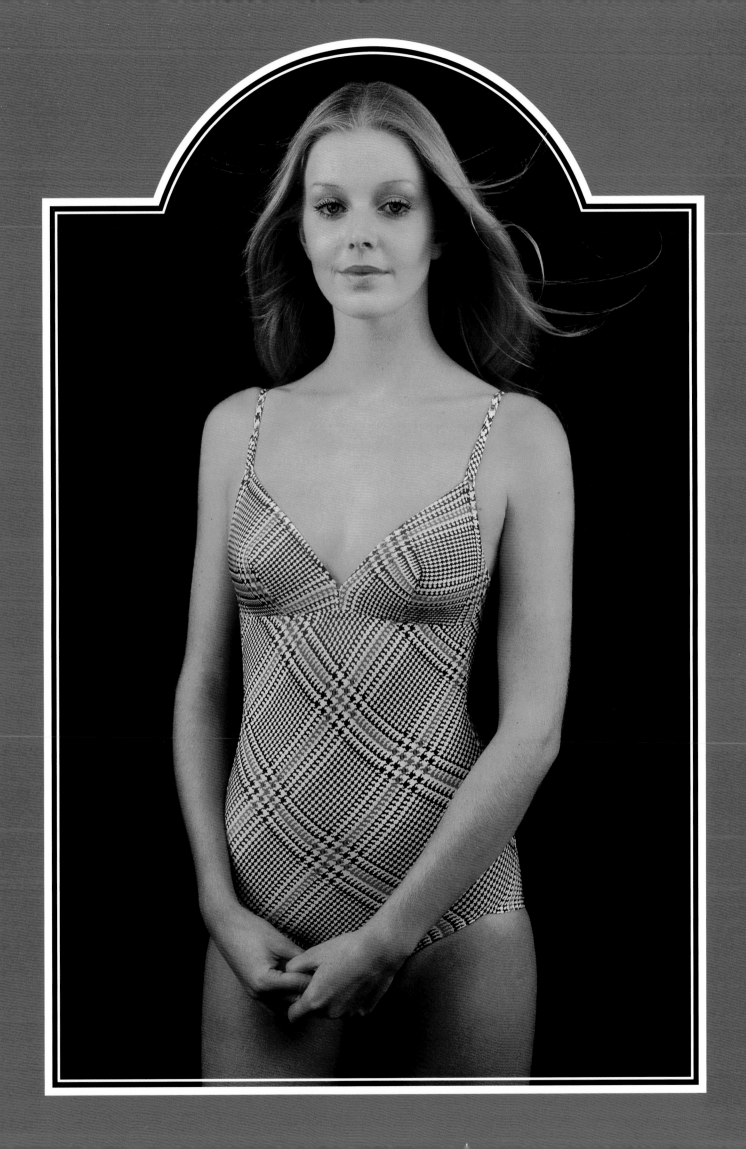

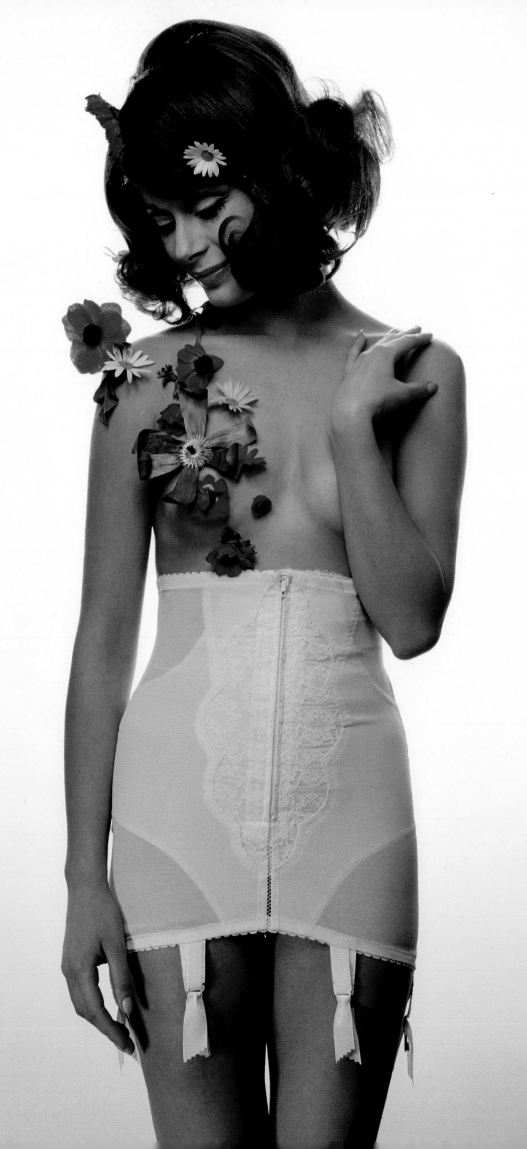

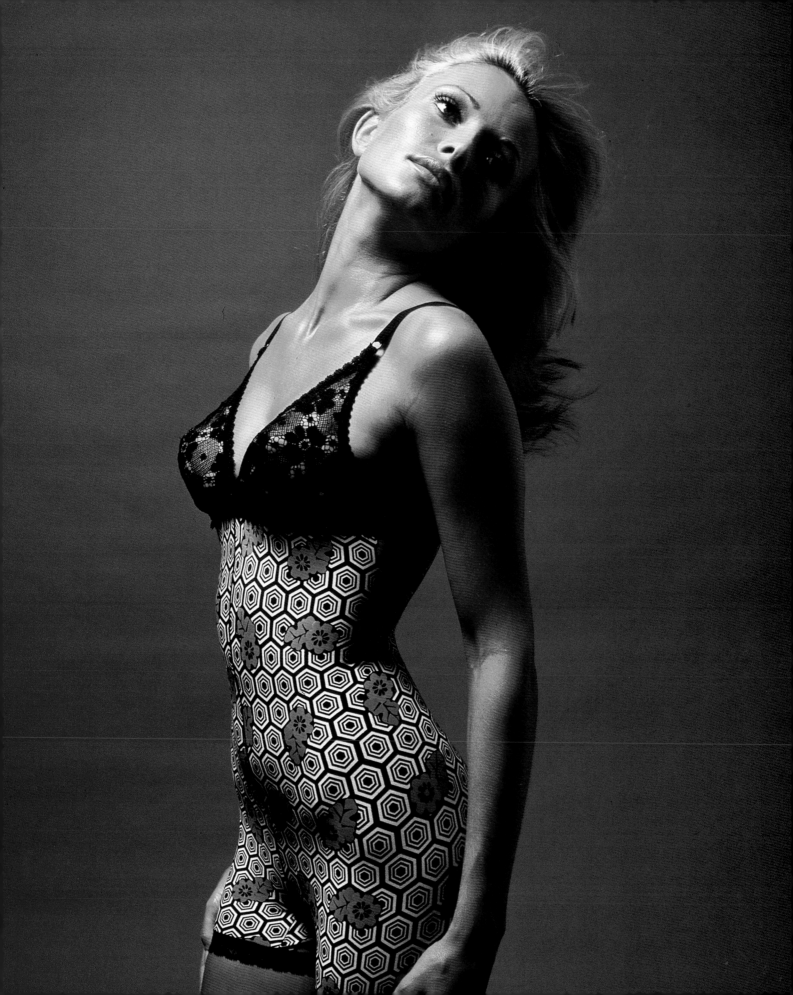

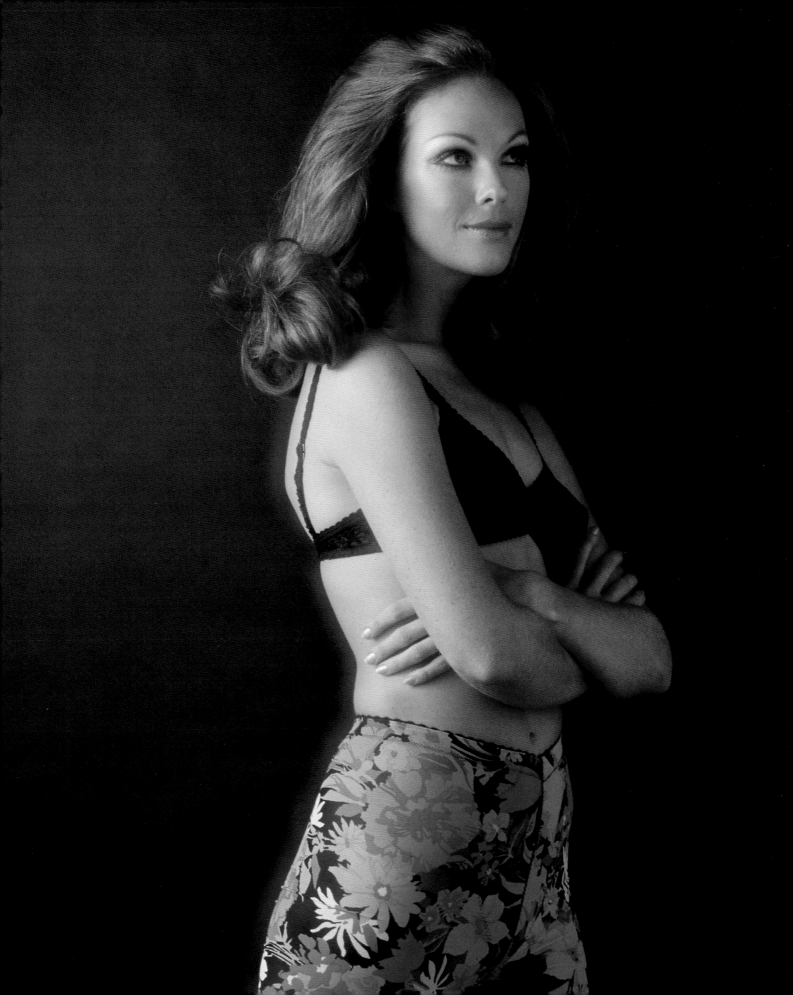

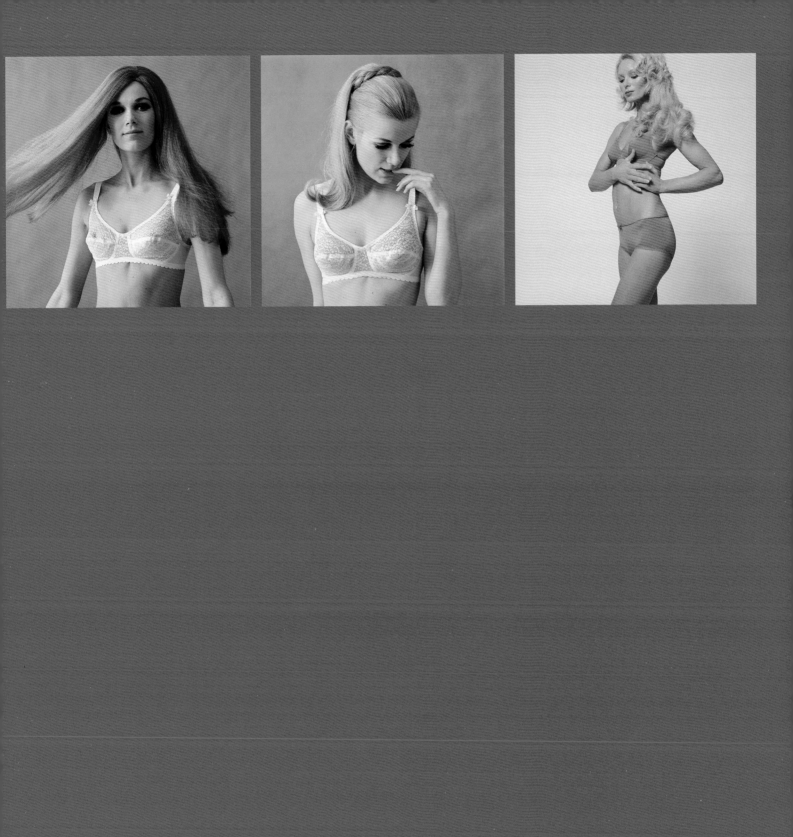

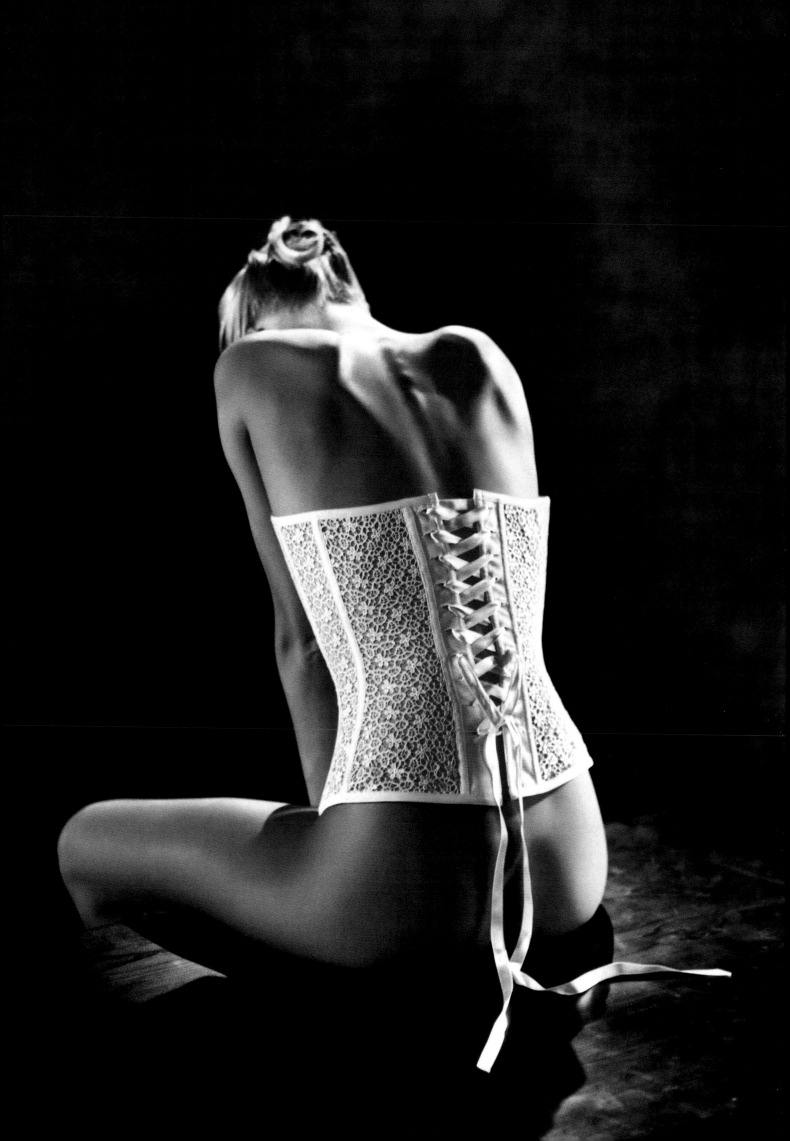

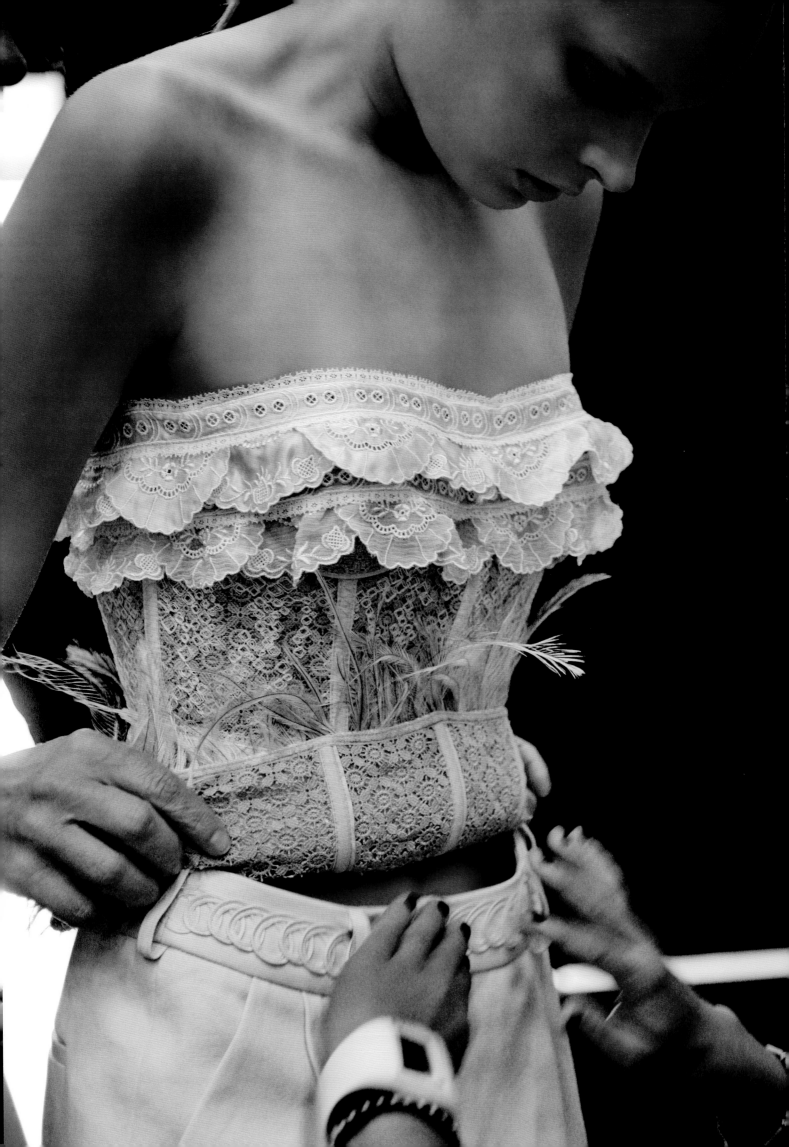

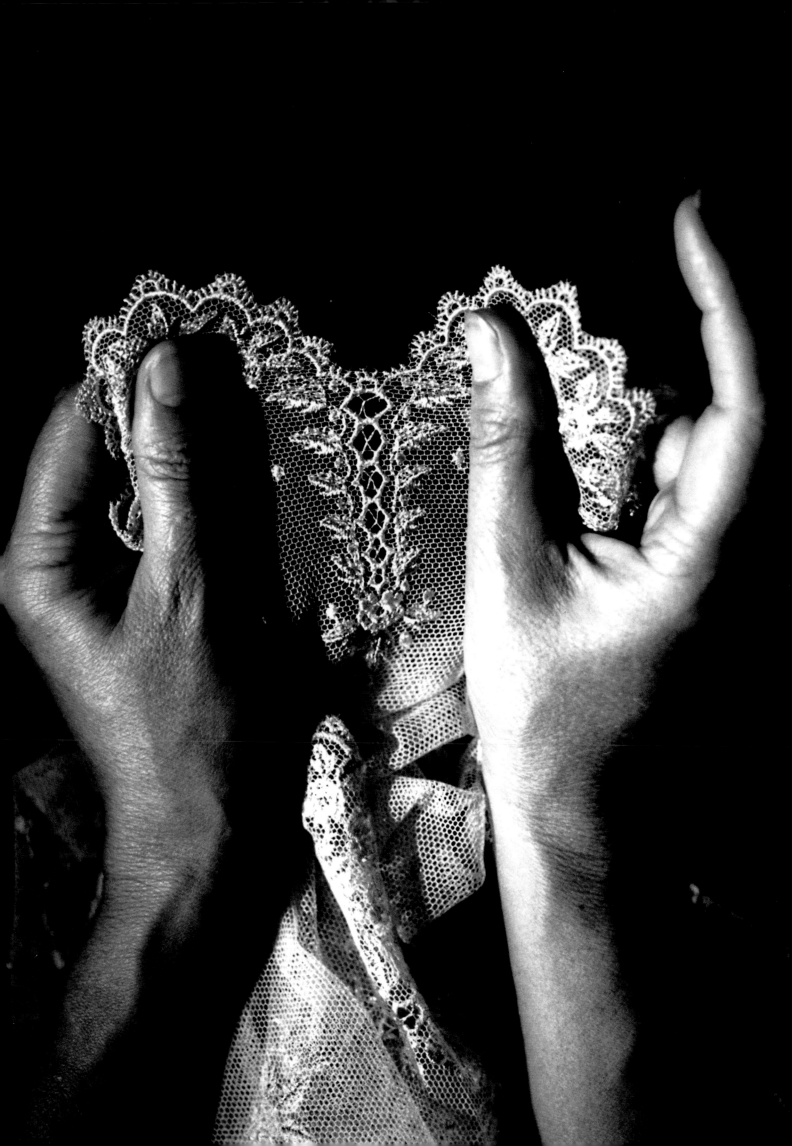

VEILED AND UNVEILED
BY DIAPHANOUS LACE
OR SCULPTED BY THE
SINUOUS LINE OF A BUSTIER,
THE BODY DEFINES THE
INTIMATE LIAISON BETWEEN
WOMAN AND LINGERIE.
IT IS THE METAMORPHOSIS
OF INVENTION, A WORK
OF ART, AT ONCE OBJECT
AND SUBJECT OF DESIRE.

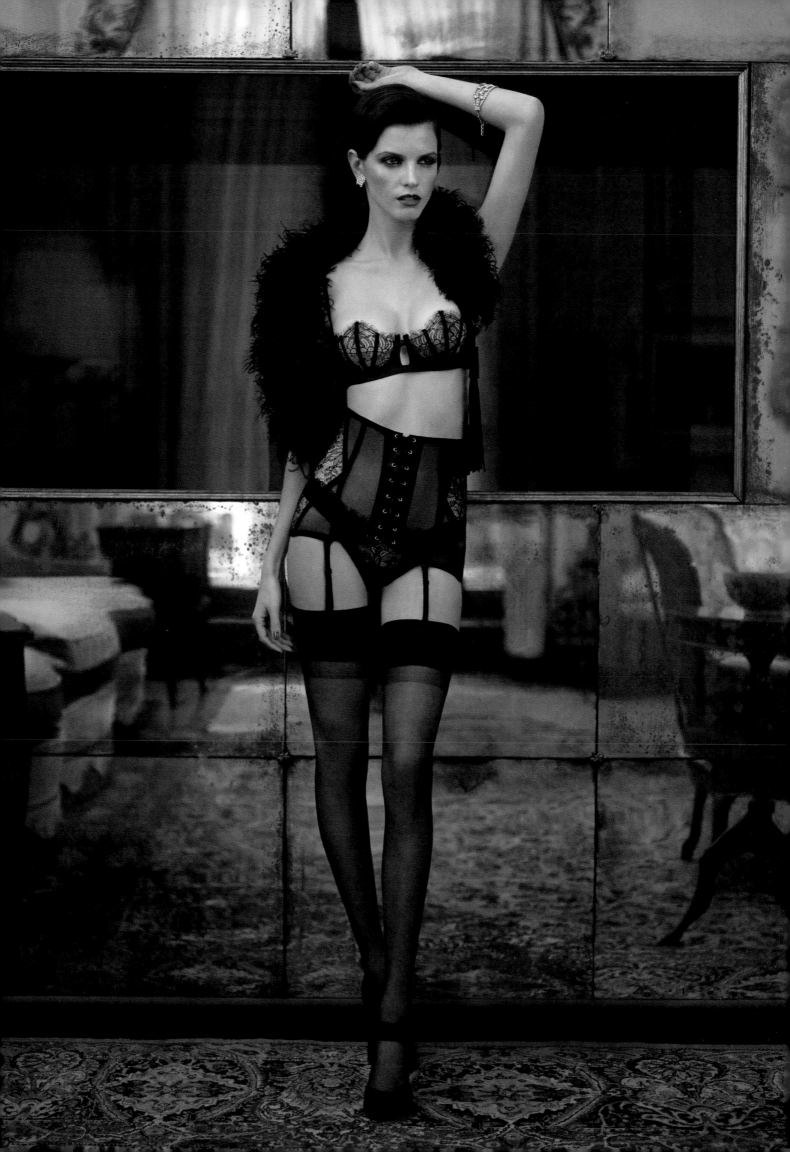

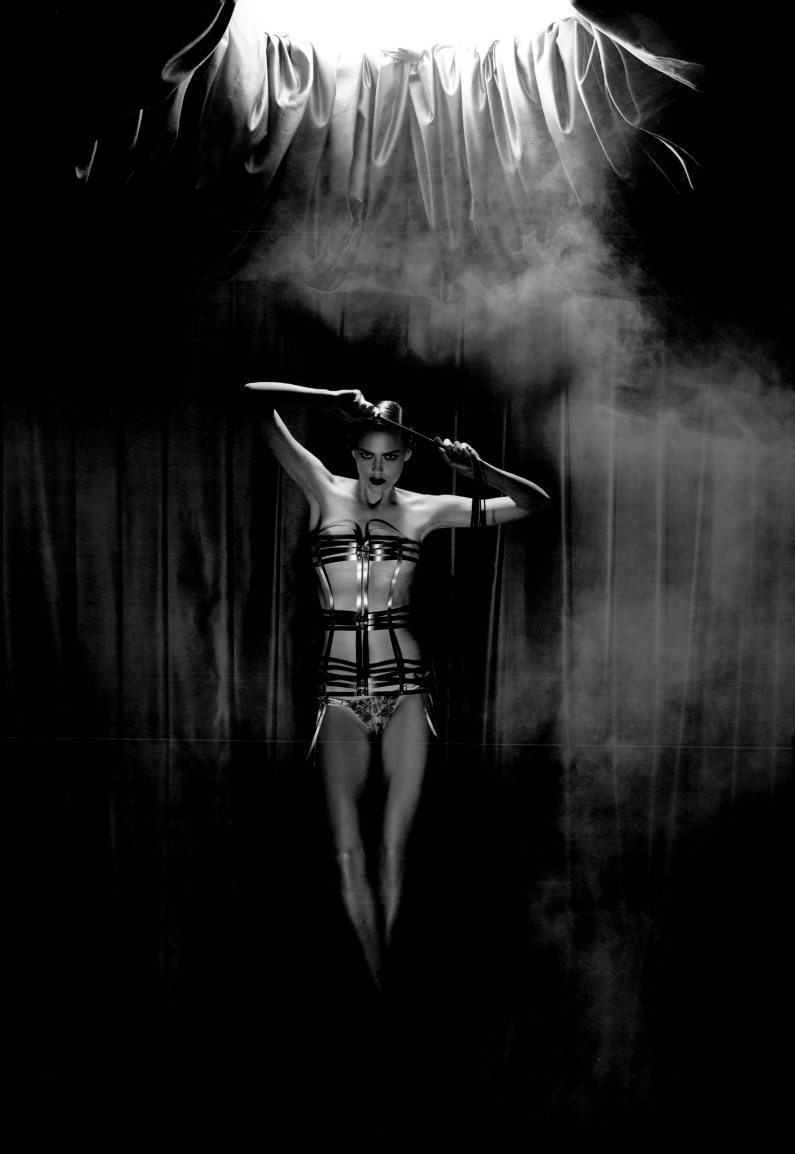

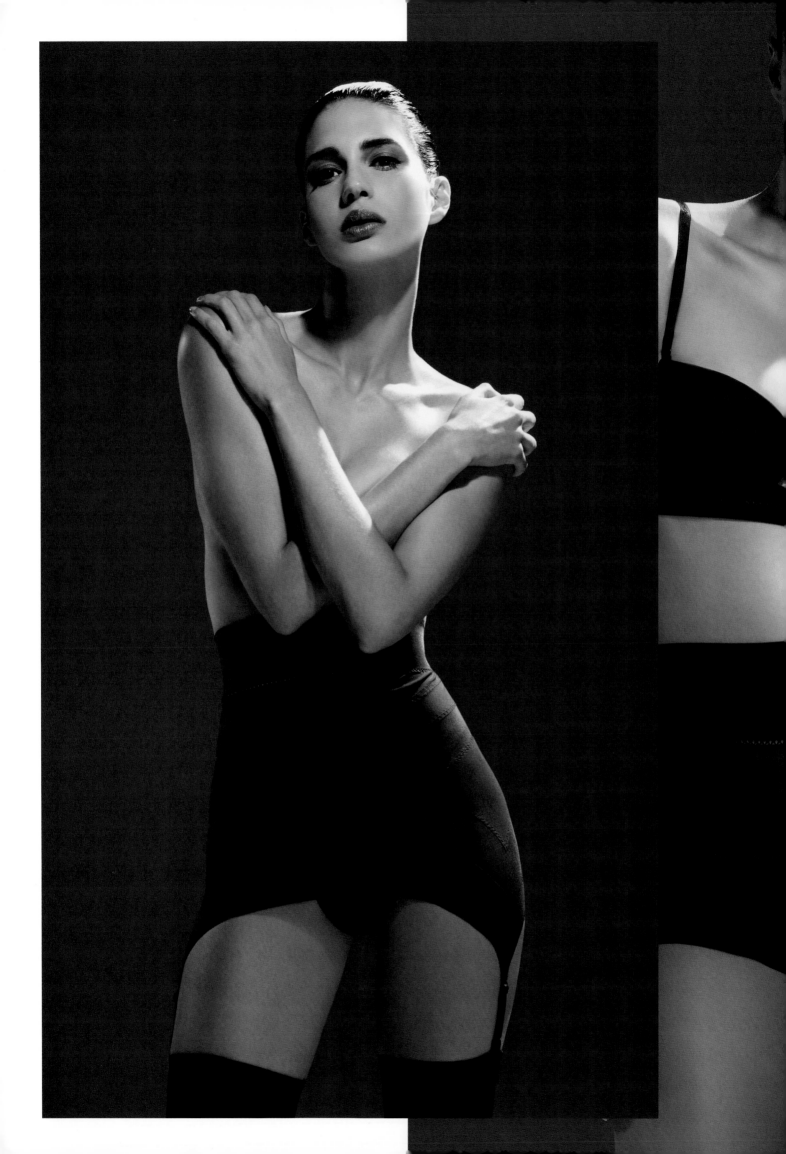

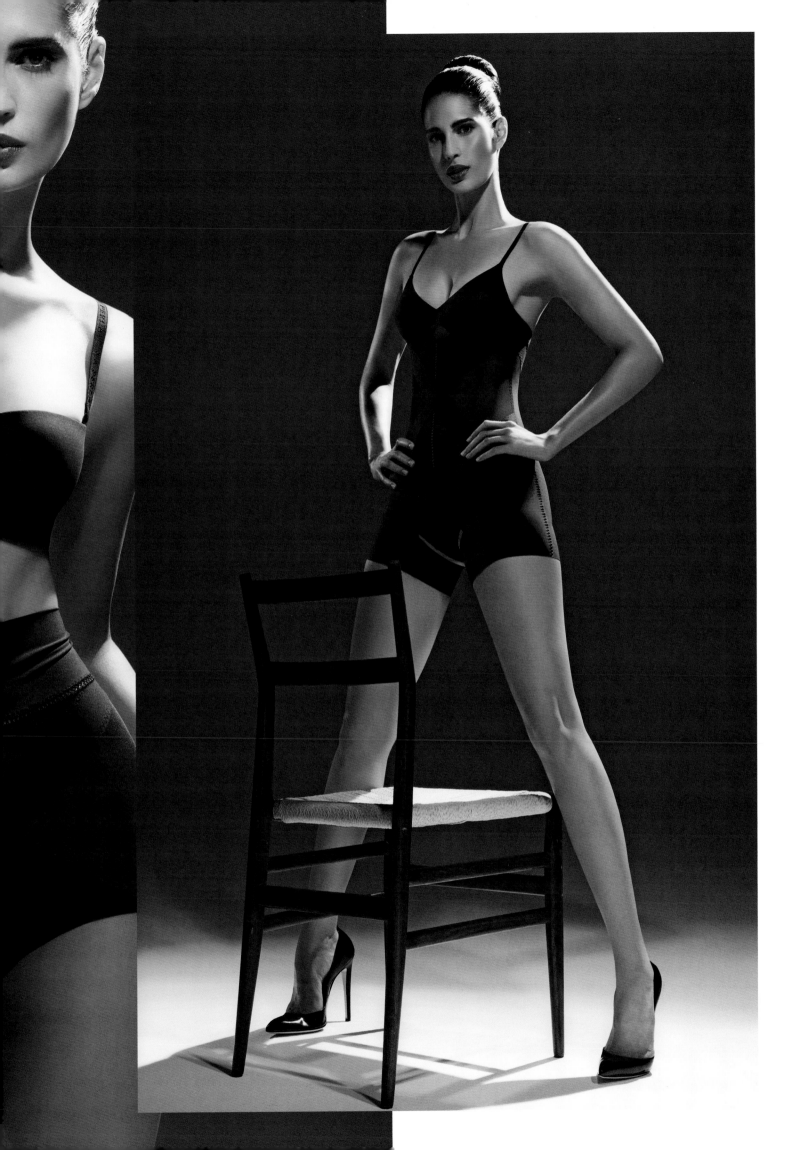

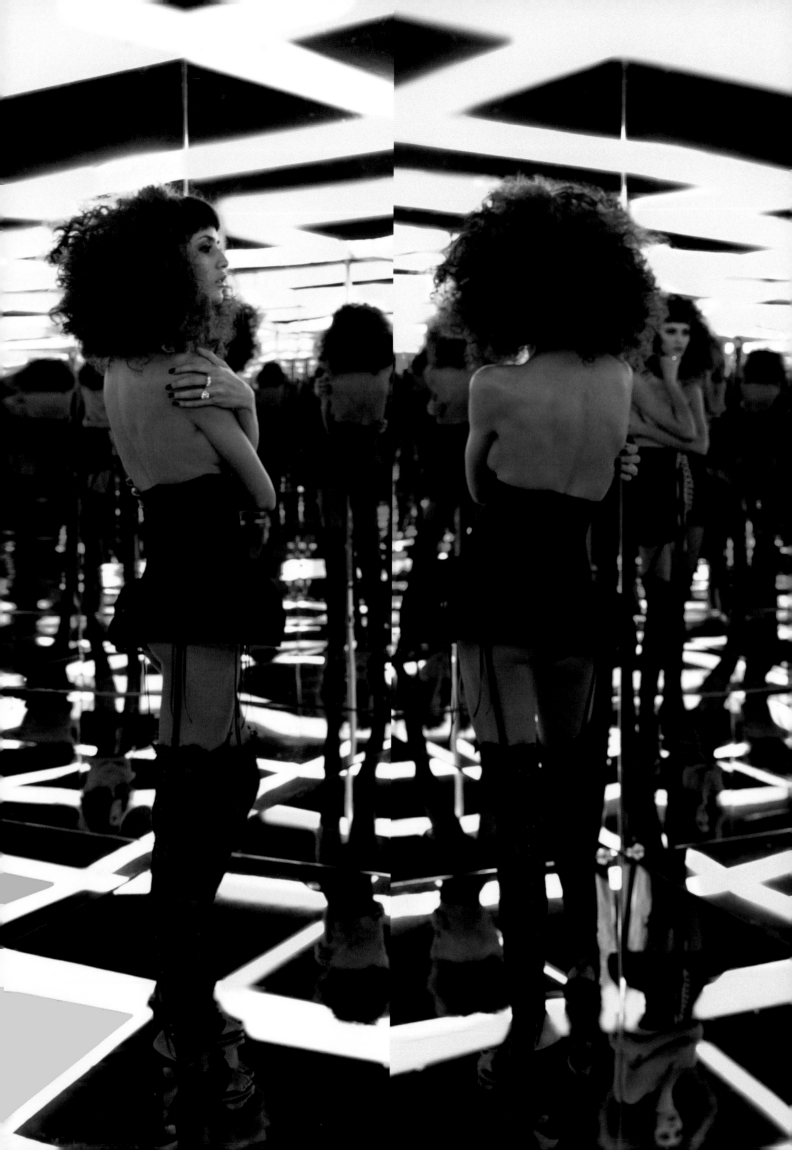

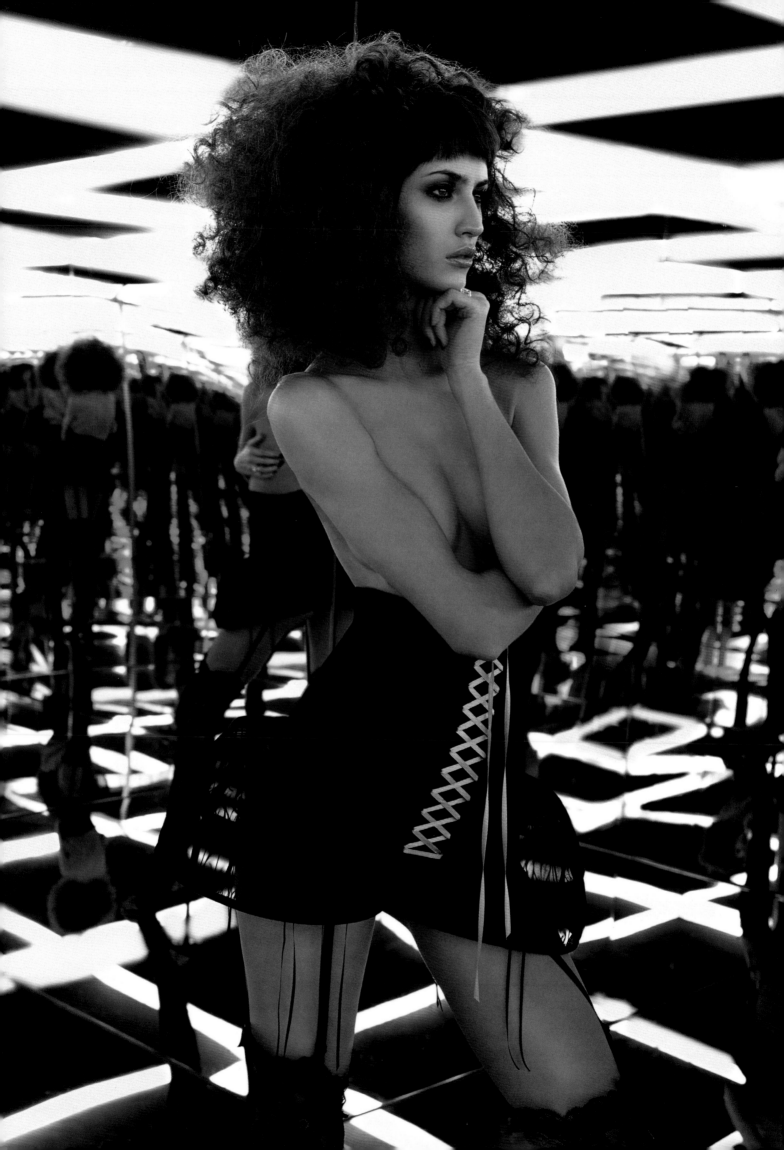

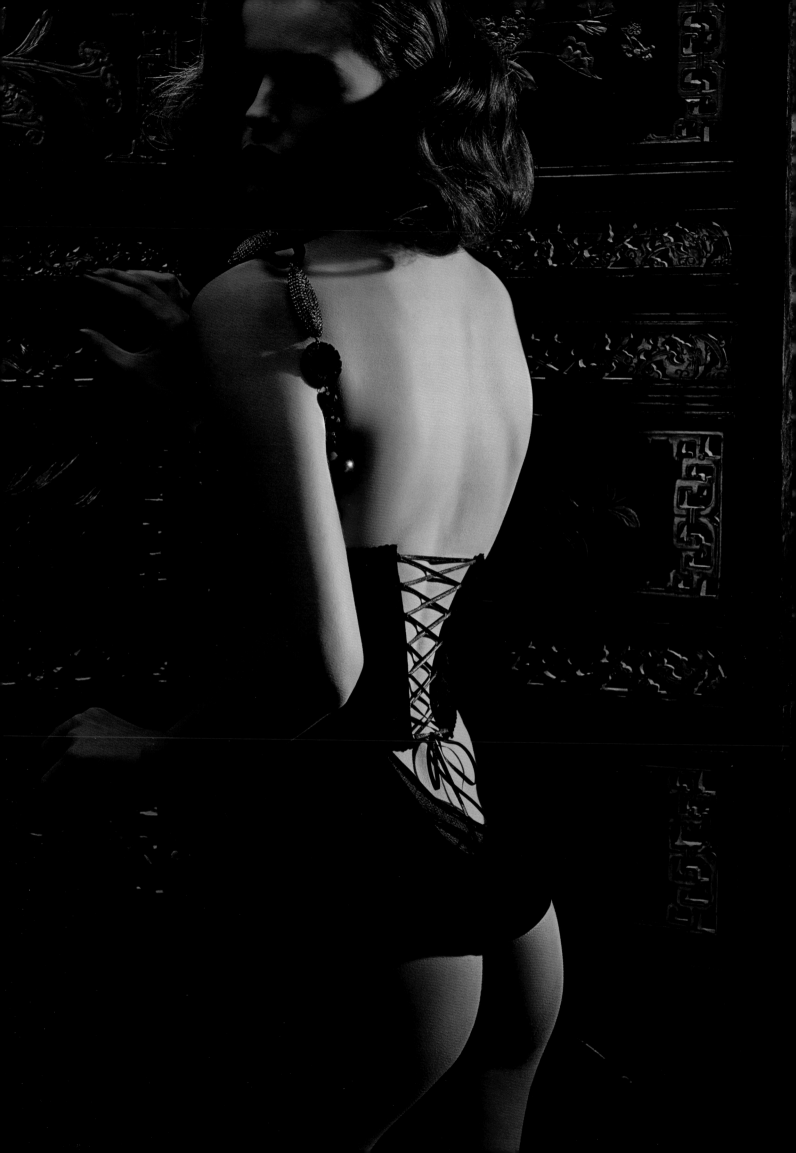

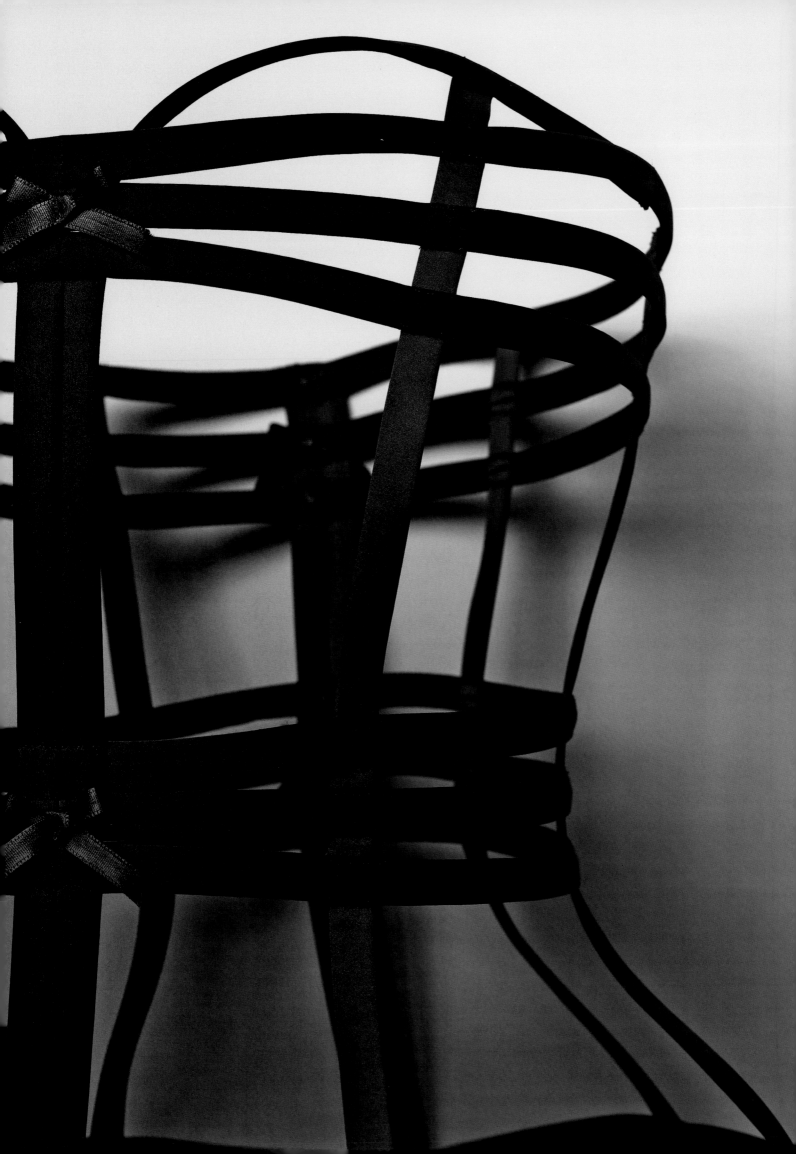

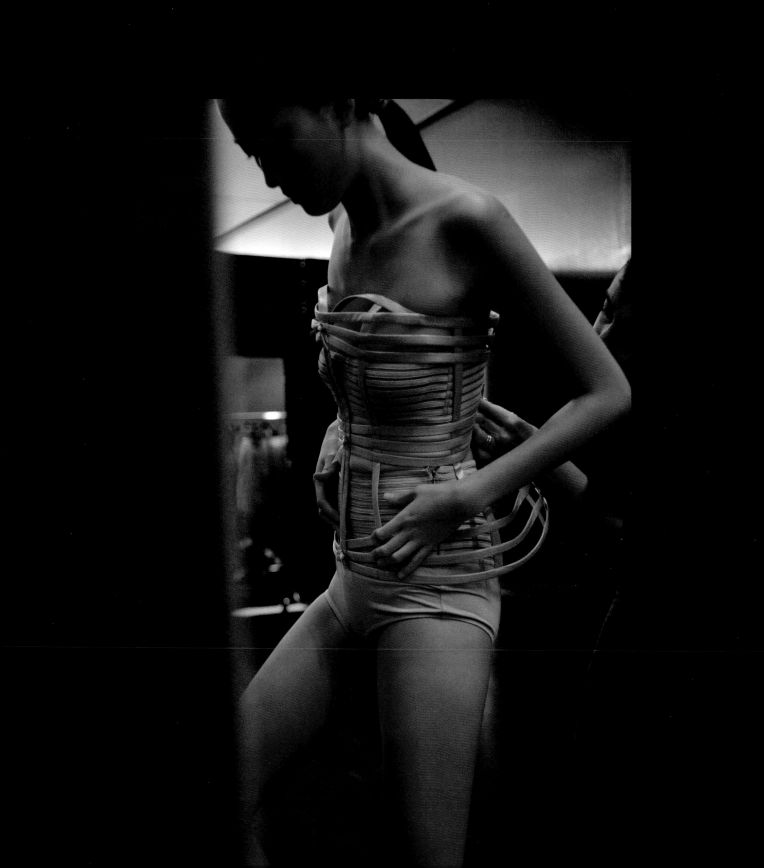

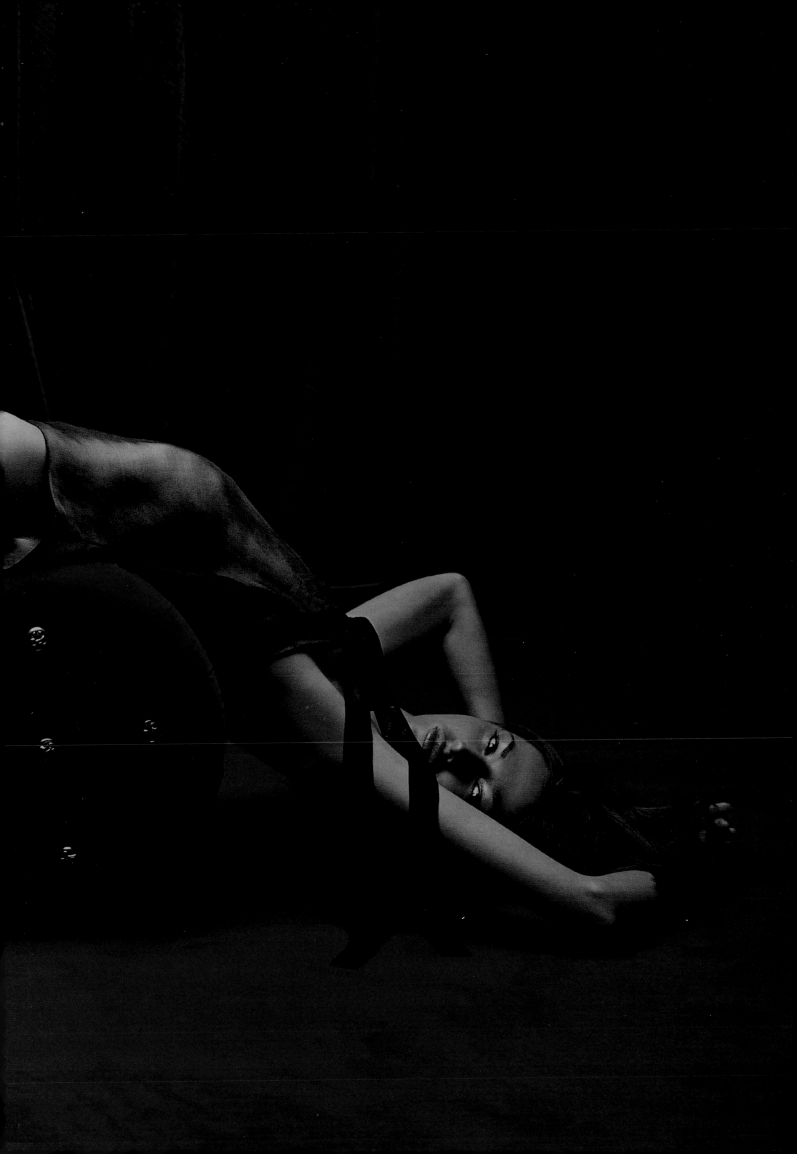

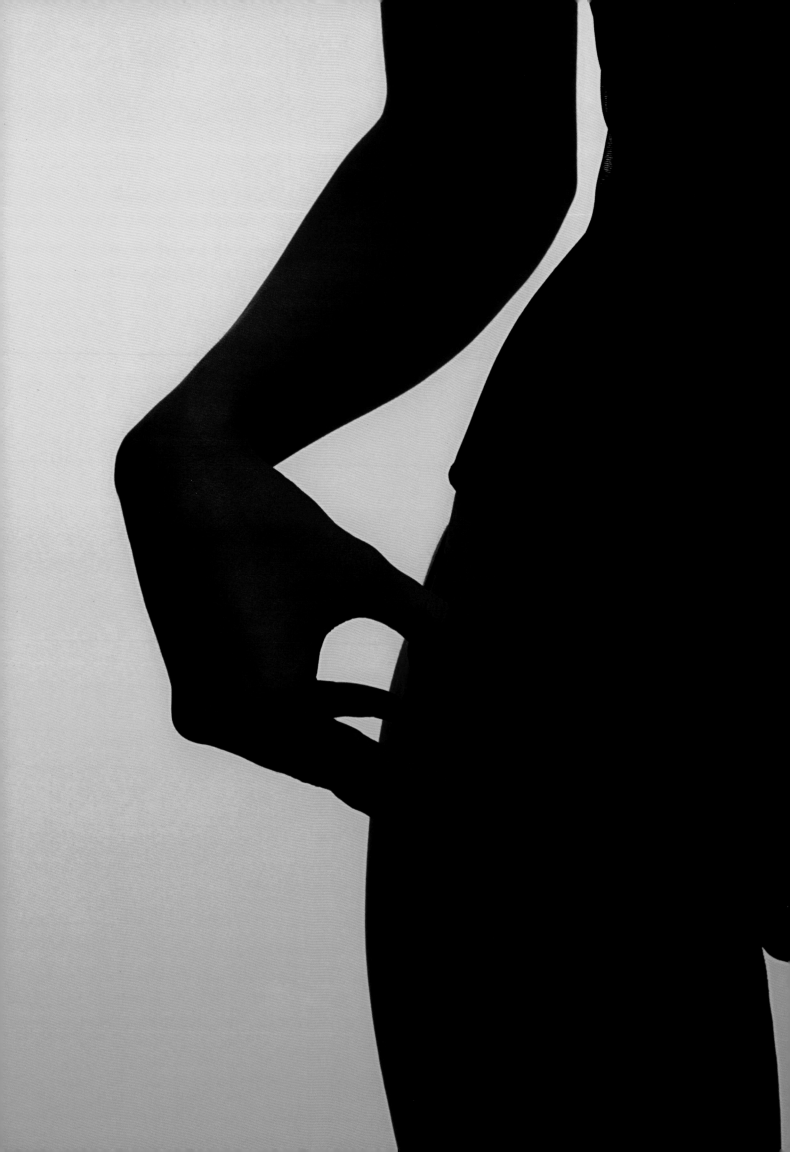

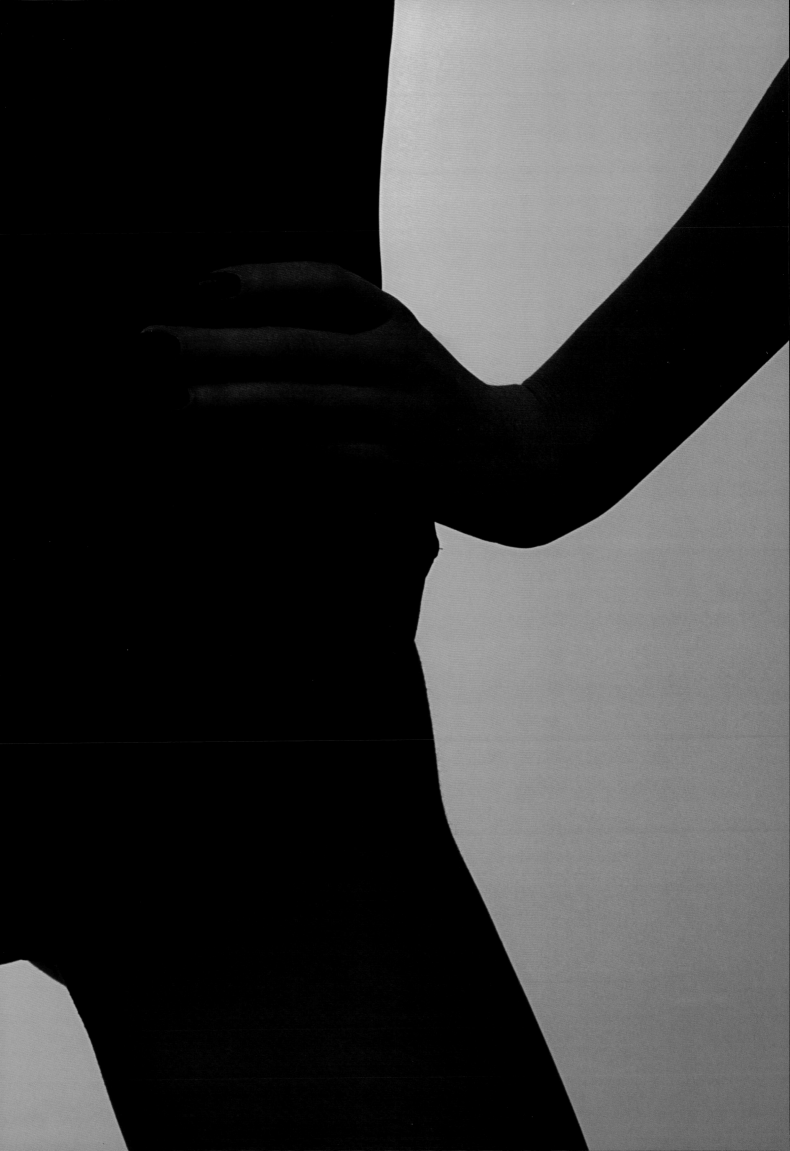

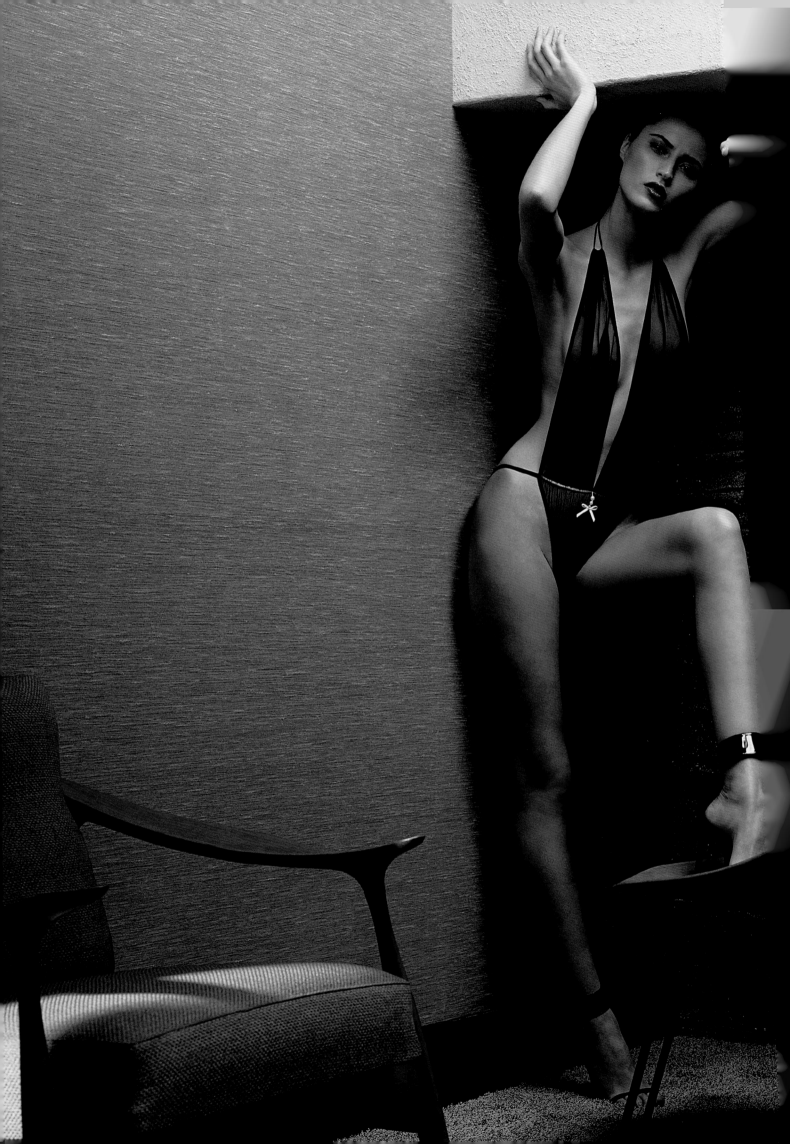

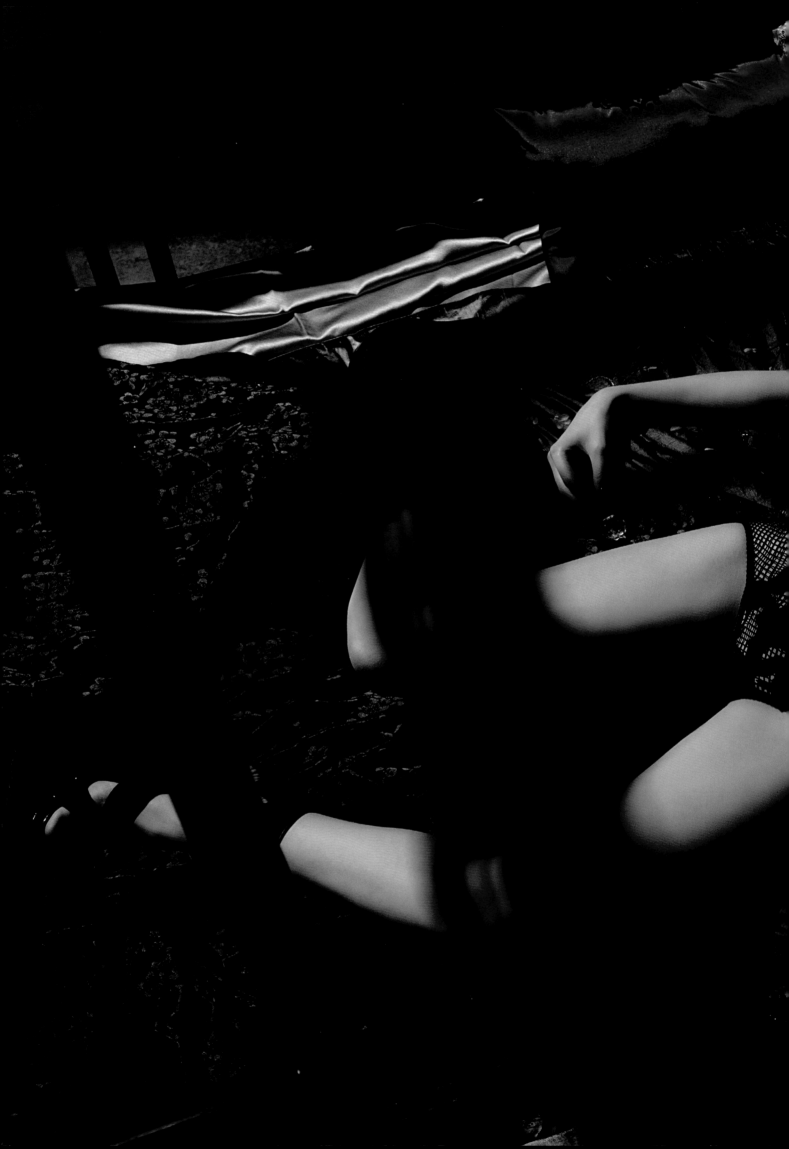

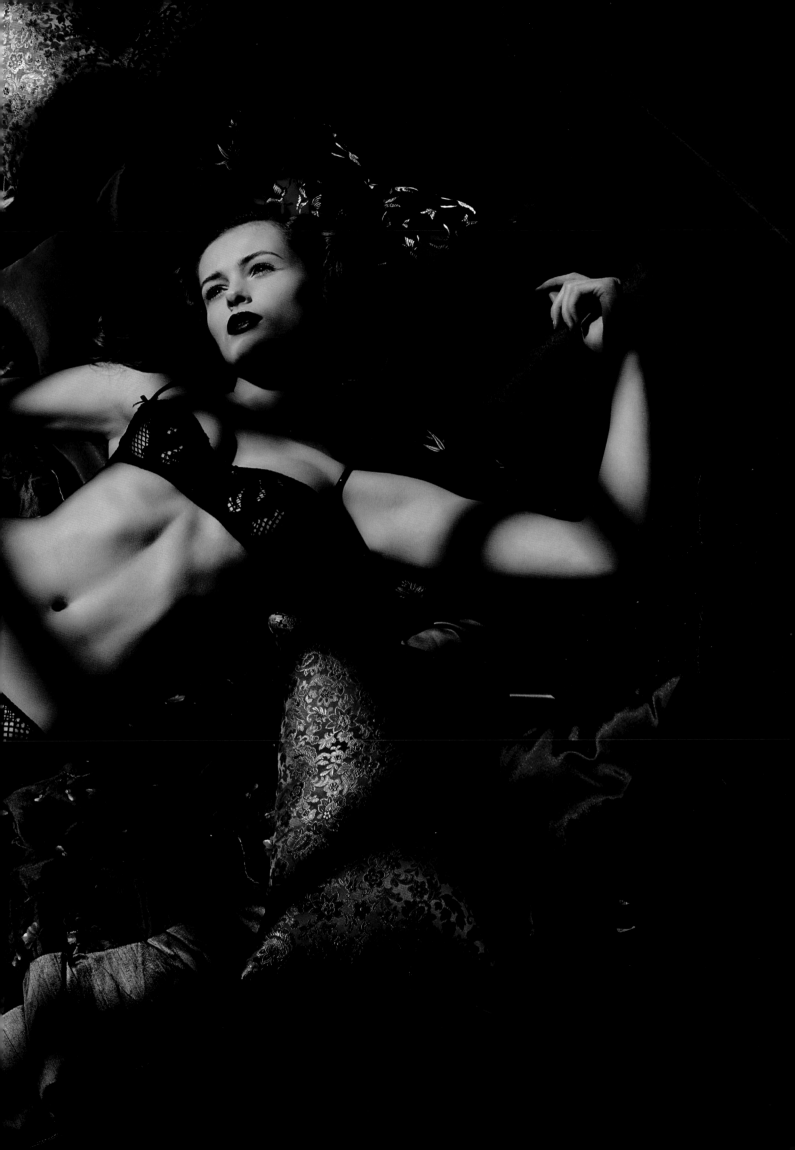

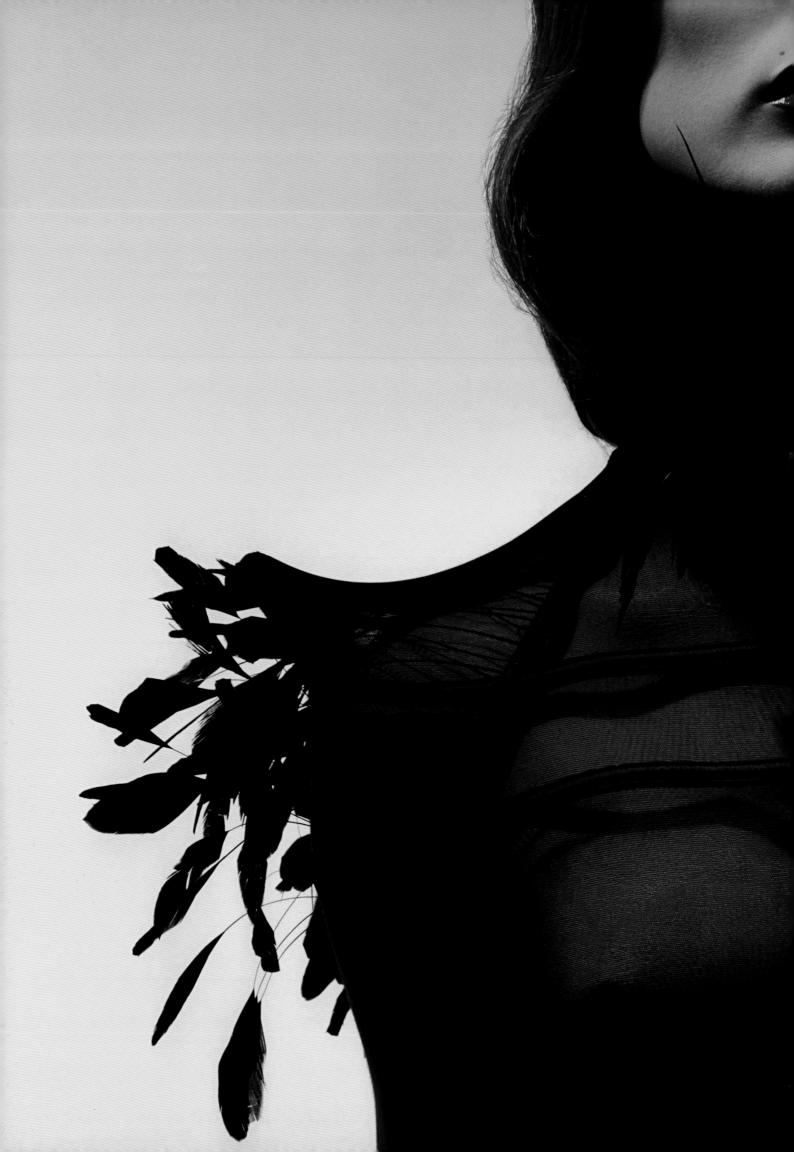

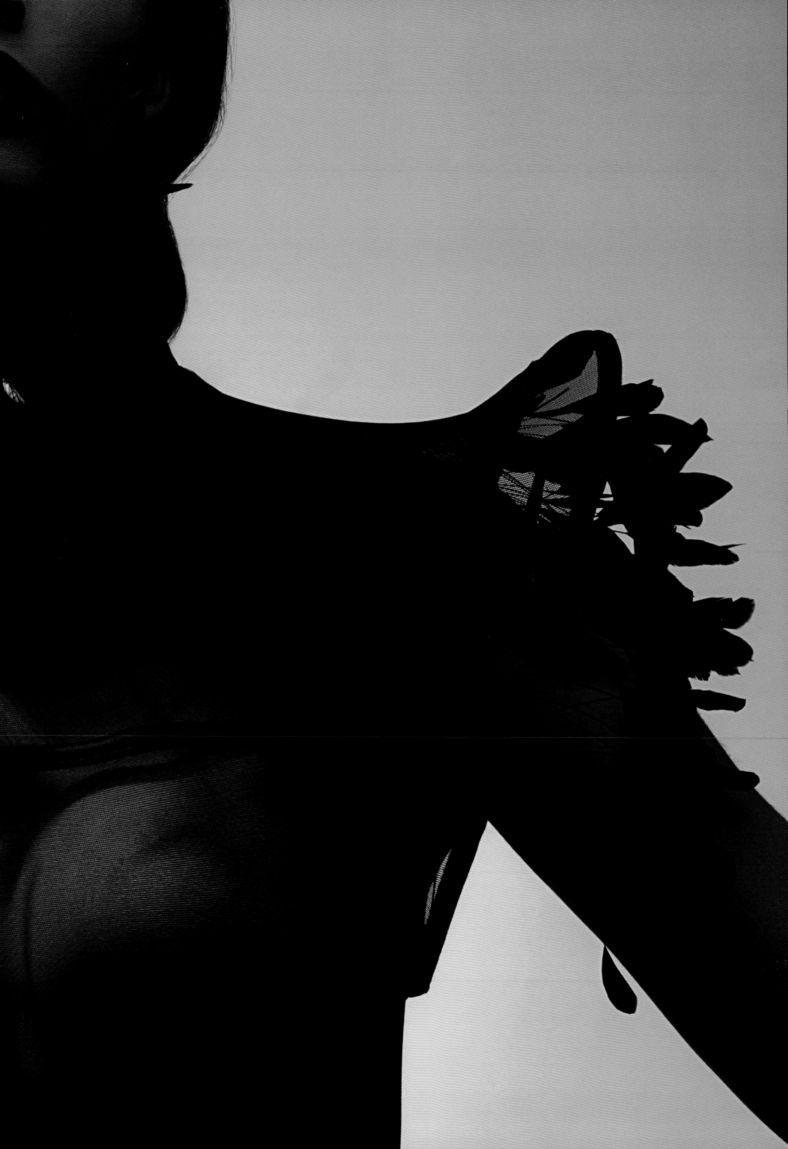

seventies

The great youth revolution carried on into the seventies. It was a time of sexual freedom, conscientious objection, and a commitment to women's rights. Music had new heroes like Pink Floyd and different trends coexisted in fashion. There were eclectic ethnic and folk influences but also an unprecedented emphasis on legs—elevated by platform shoes, revealed by miniskirts and hot pants, and accentuated by bell-bottoms. The desire to look taller and the preference for slim, muscular bodies called for lingerie that would give the wearer a sleek and natural shape. La Perla moved in the same direction and furthered its research by creating lightweight, comfortable, and loose-fitting designs including versatile silk knits. But toward the end of the decade, lingerie evened the score by revisiting the seductive allusion that had been stripped from it by the women's liberation movement. Ada Masotti felt that it was time for a return to lace, silk, and see-through fabrics and thus the wheel of fashion came full circle once again.

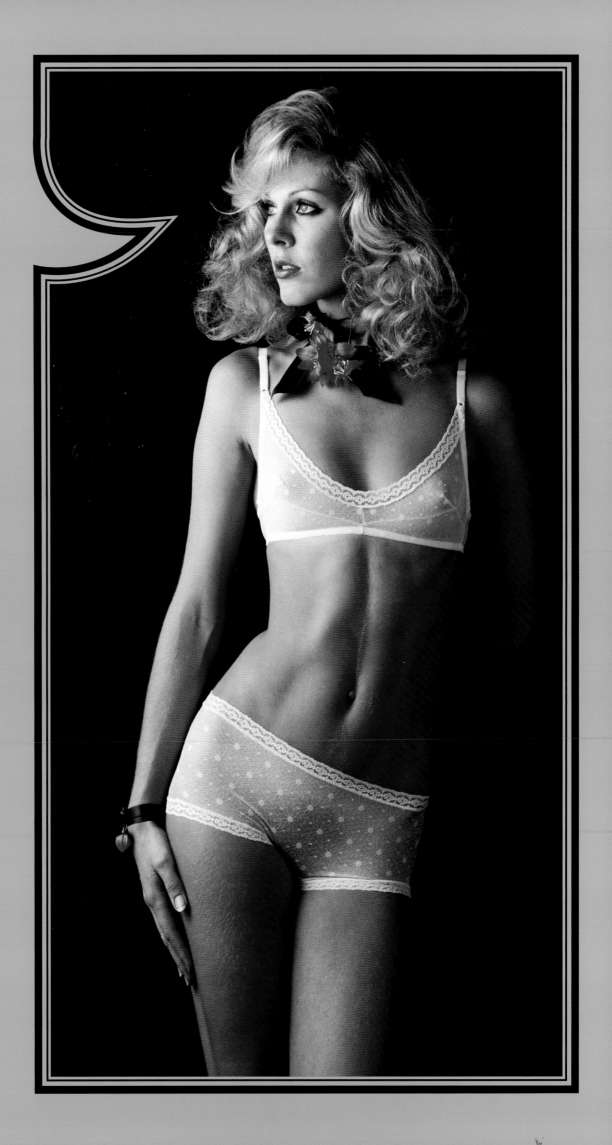

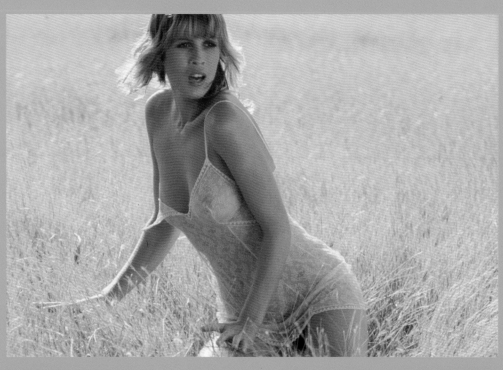

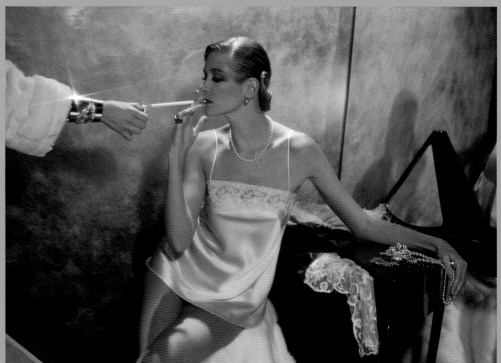

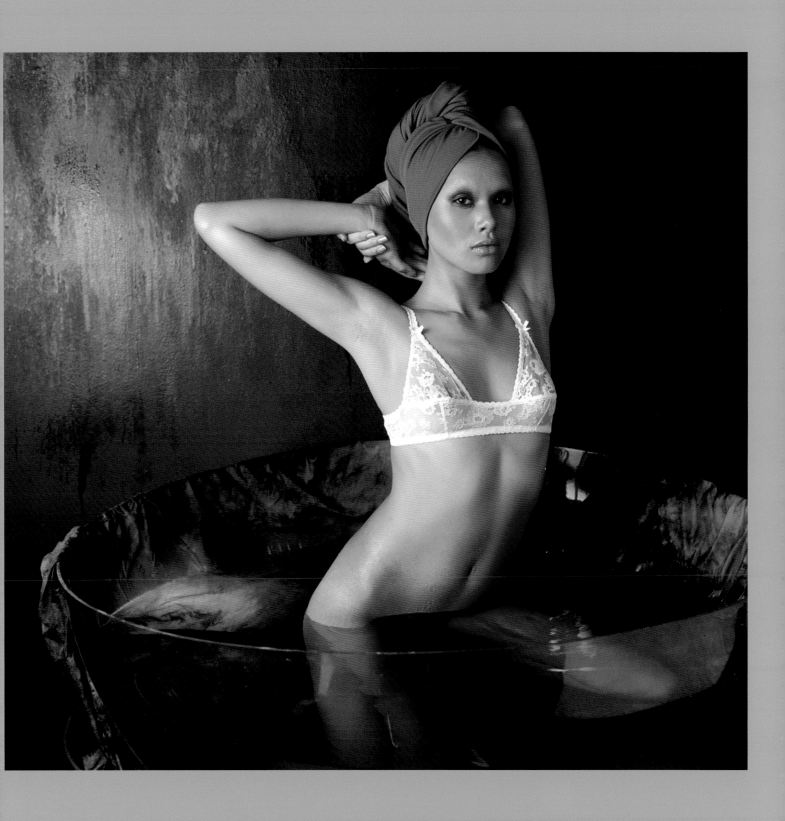

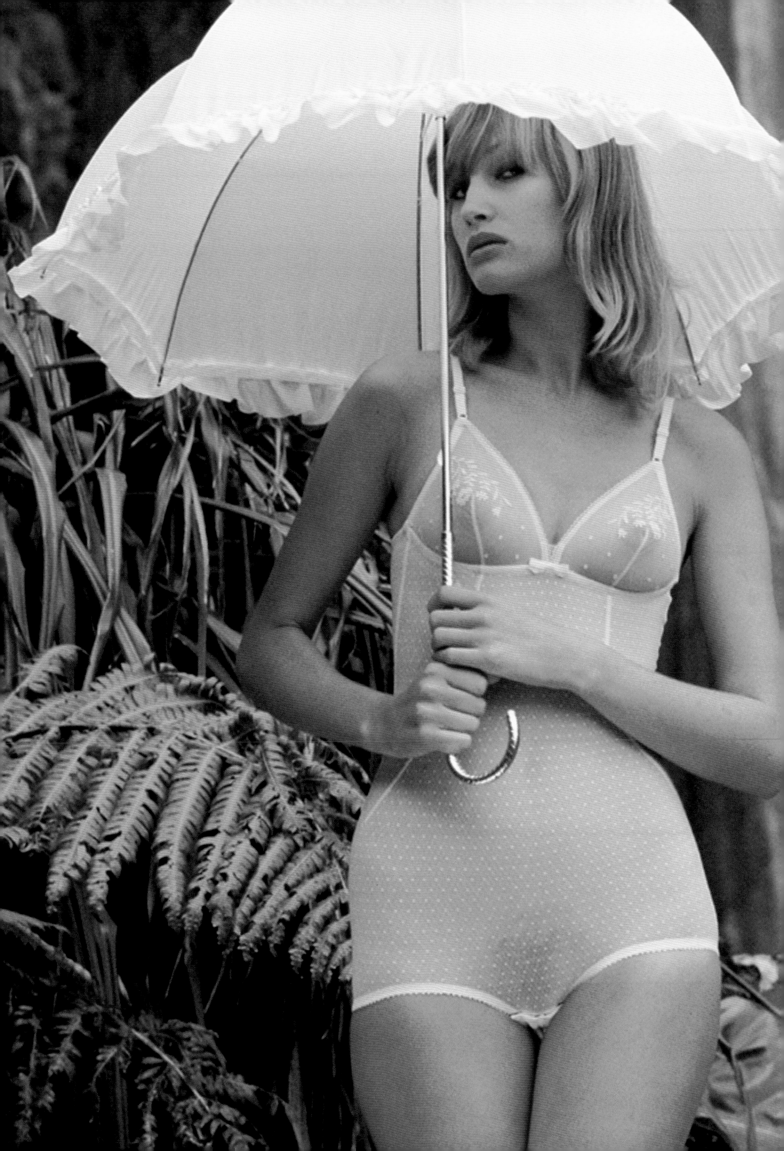

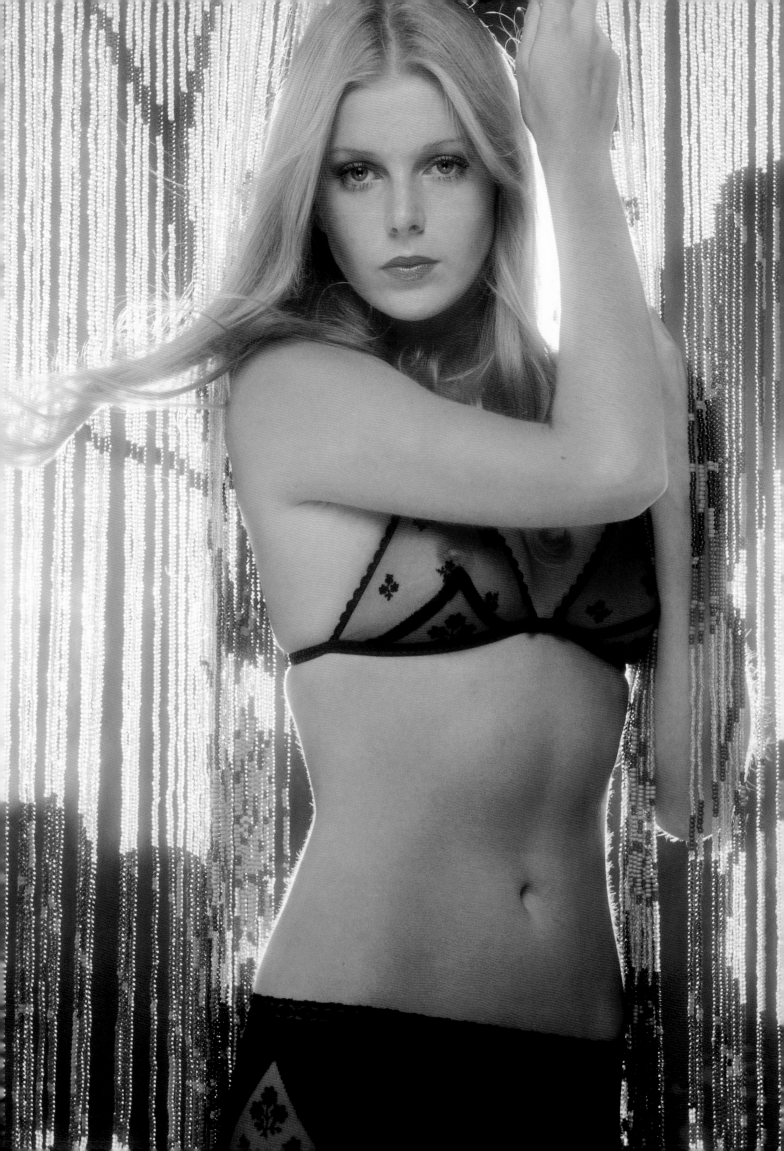

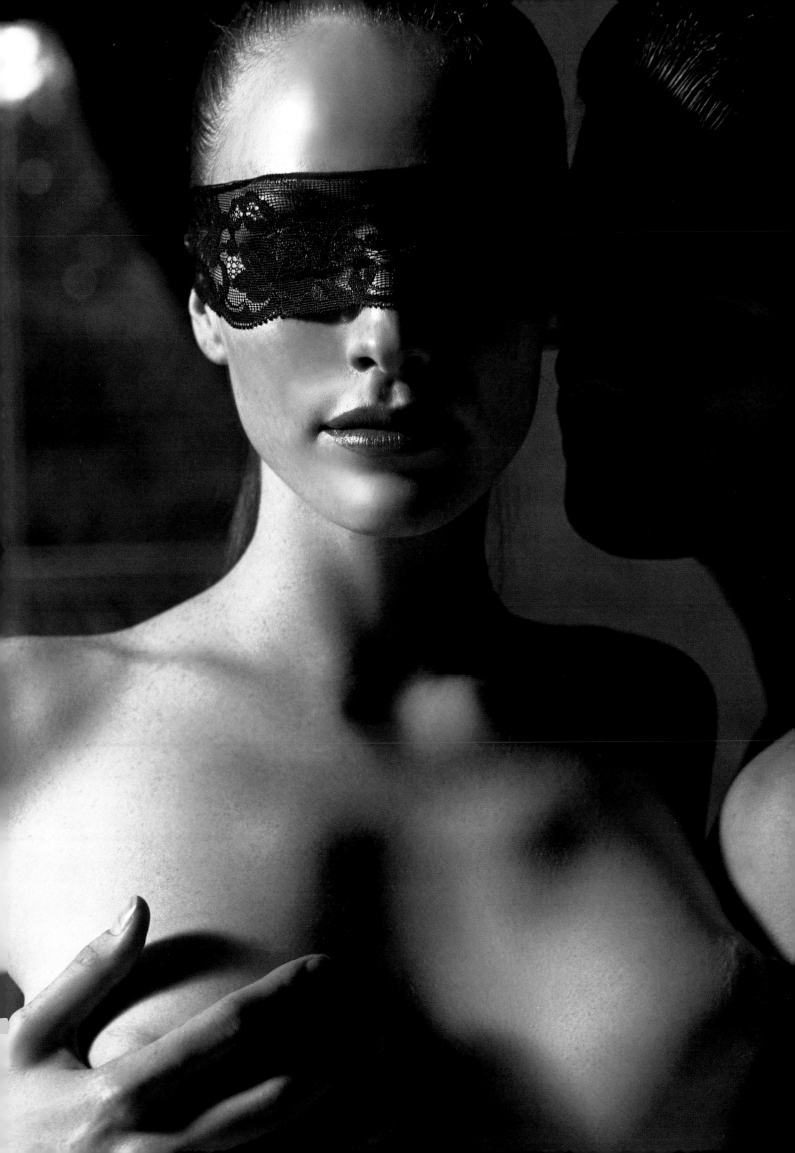

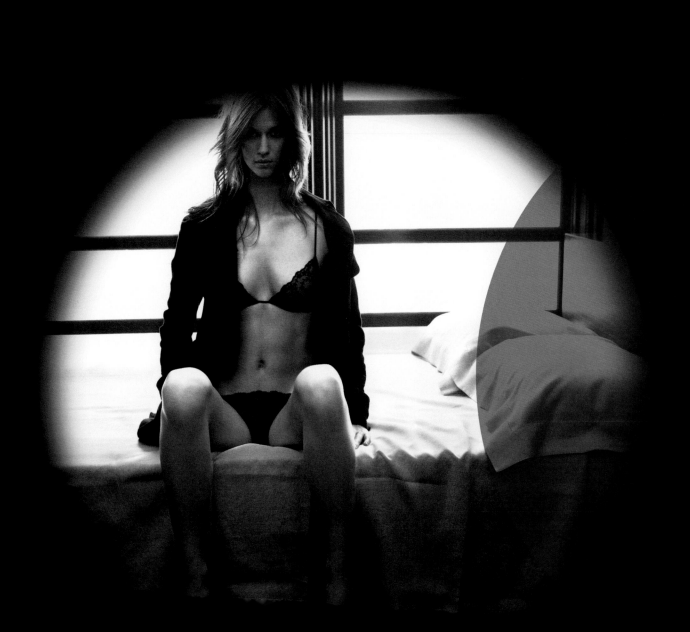

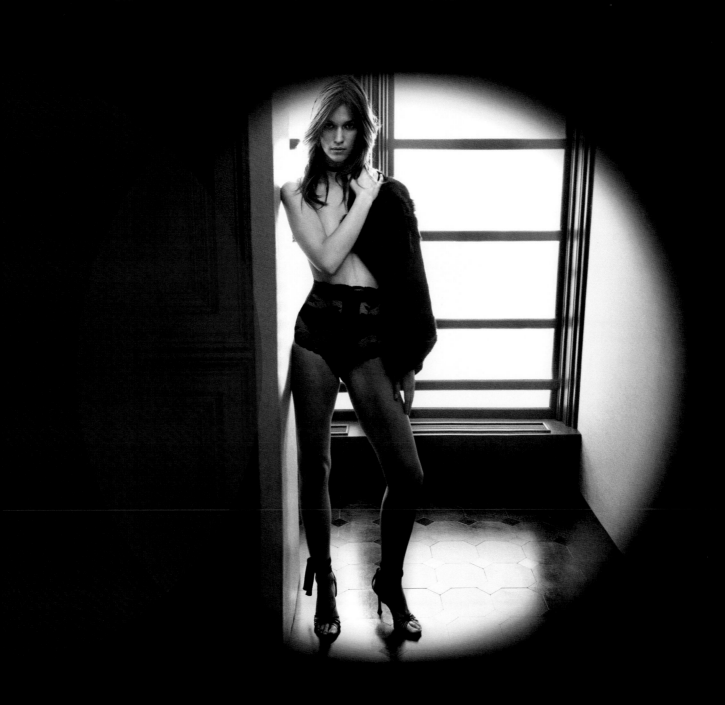

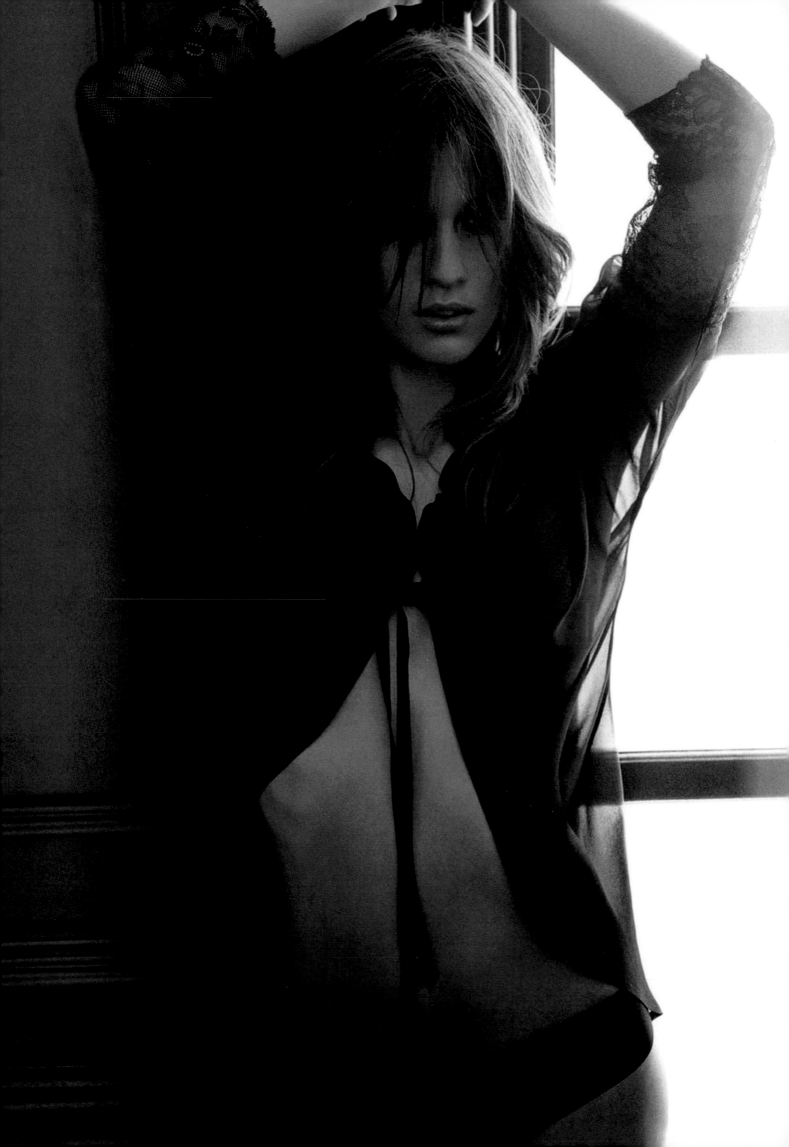

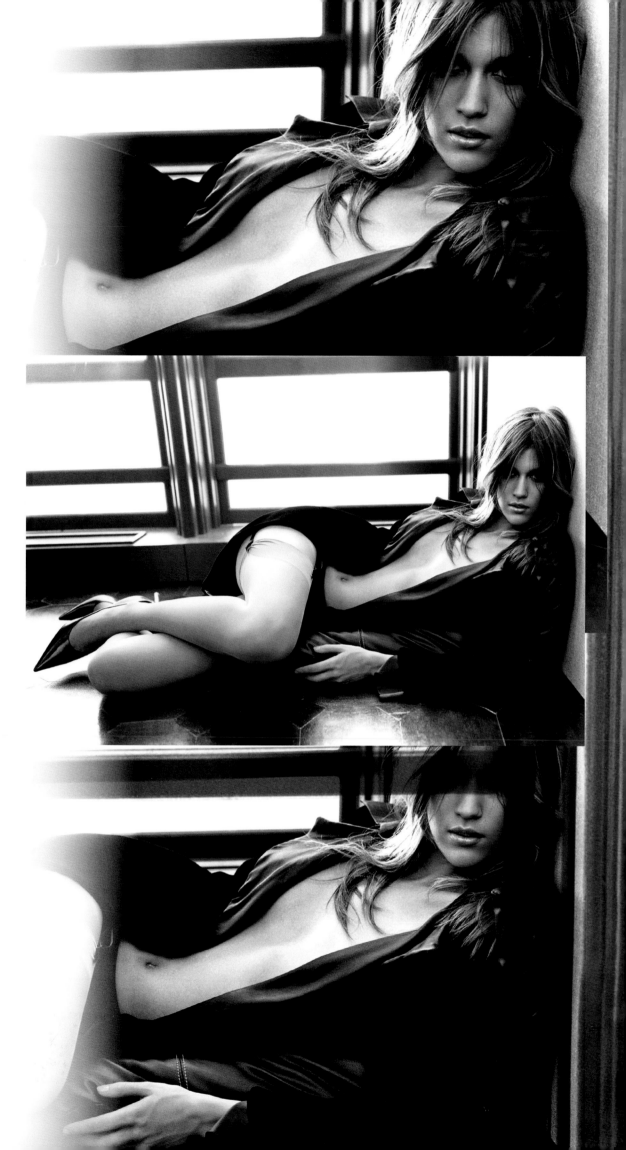

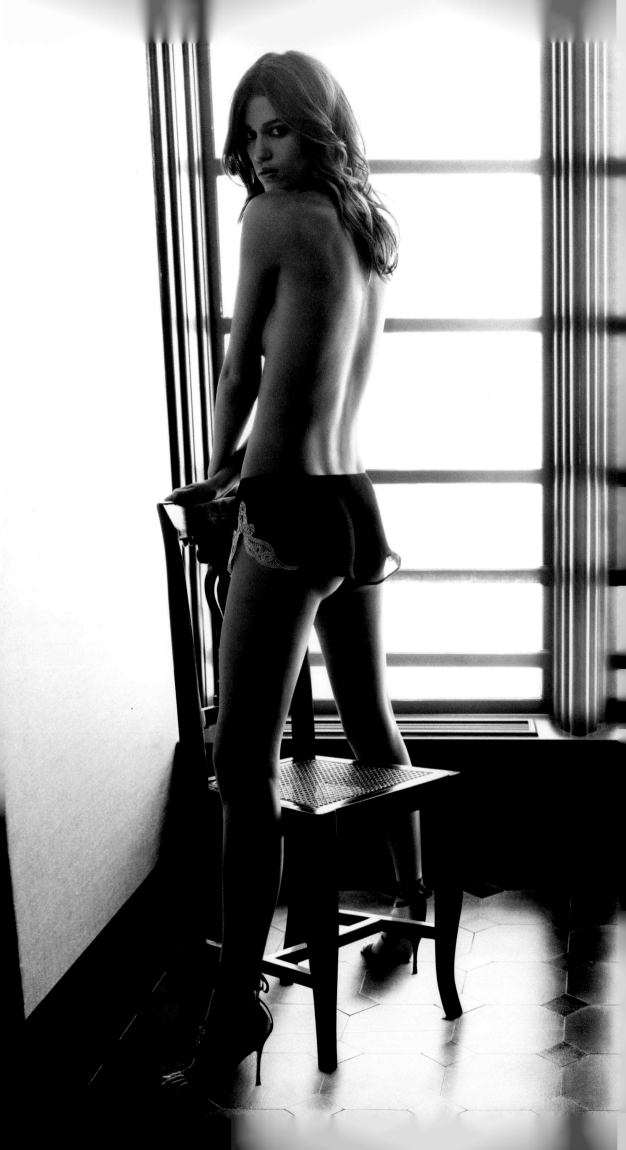

IT KNOWS NOTHING
OF INNOCENCE,
ONLY DIZZINESS AND MYSTERY.
HIGHLY SEDUCTIVE,
EVEN DANGEROUS,
WHEN IT MELTS IN THE WARM
LIGHT OF TRANSLUCENCY.
LOVE OF THE CENTURY
AND COLOR OF NIGHT,
BLACK REMAINS ALOOF
IN ITS ABSOLUTENESS.

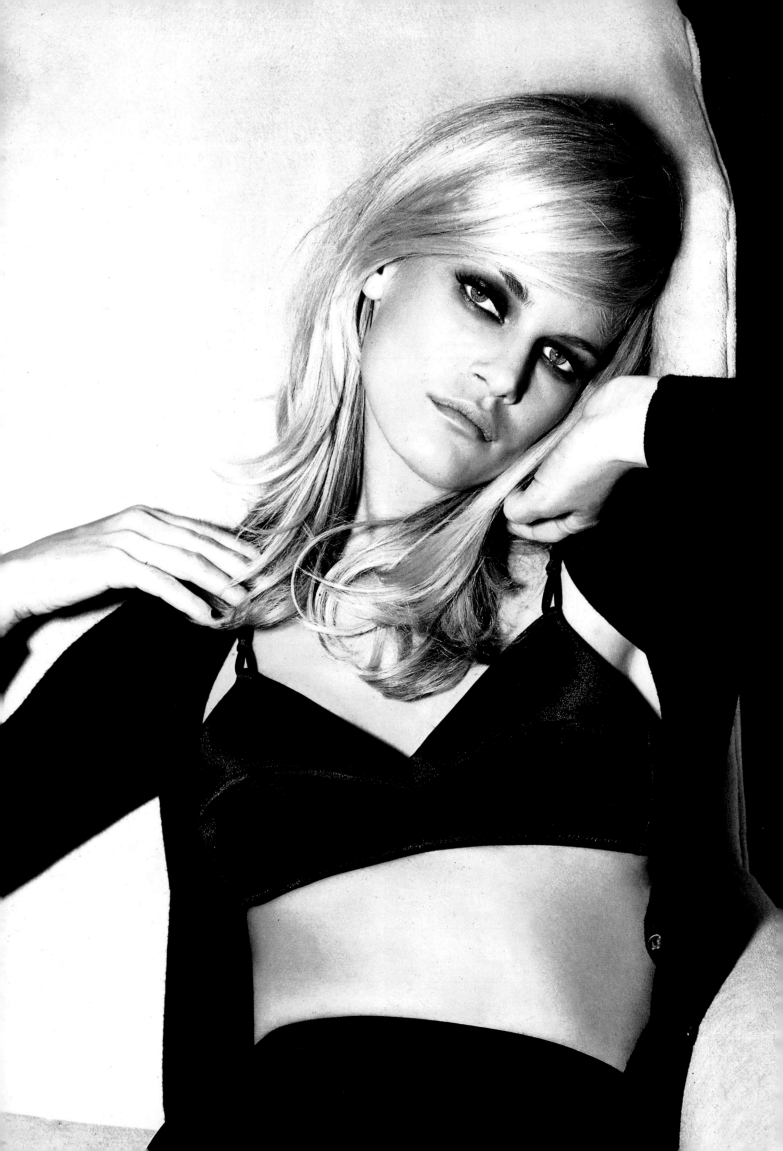

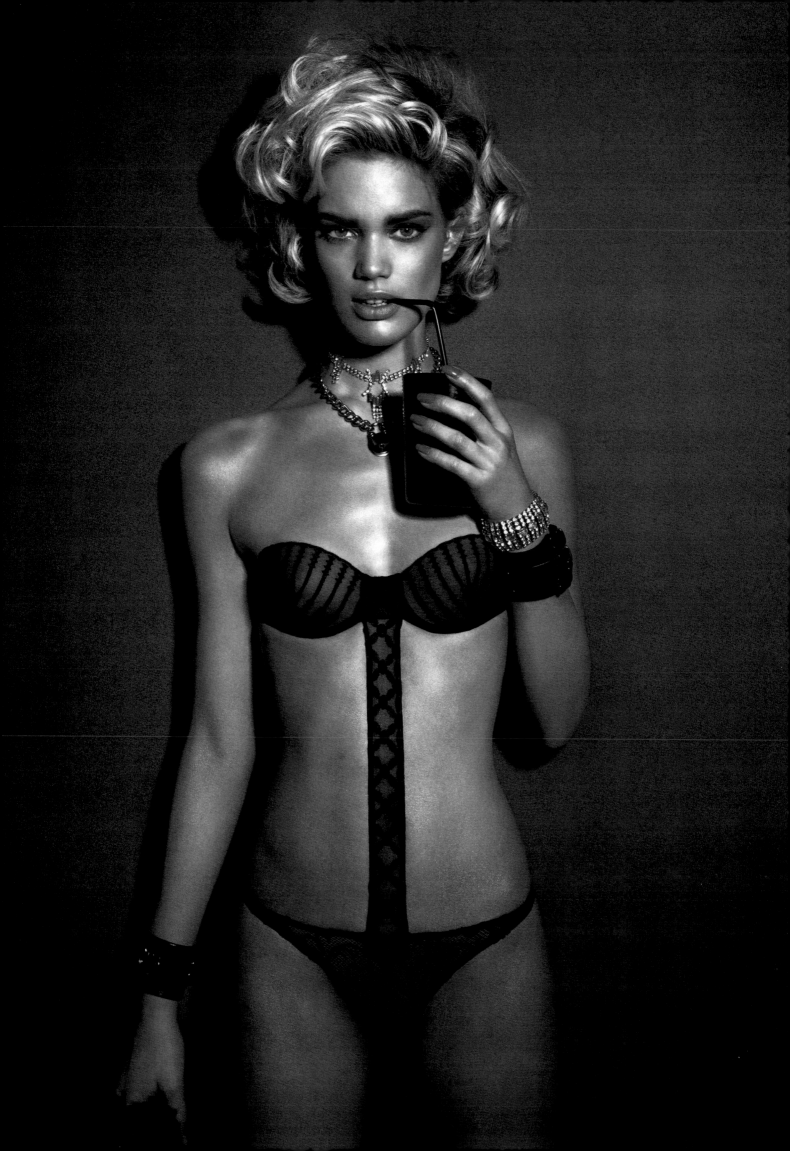

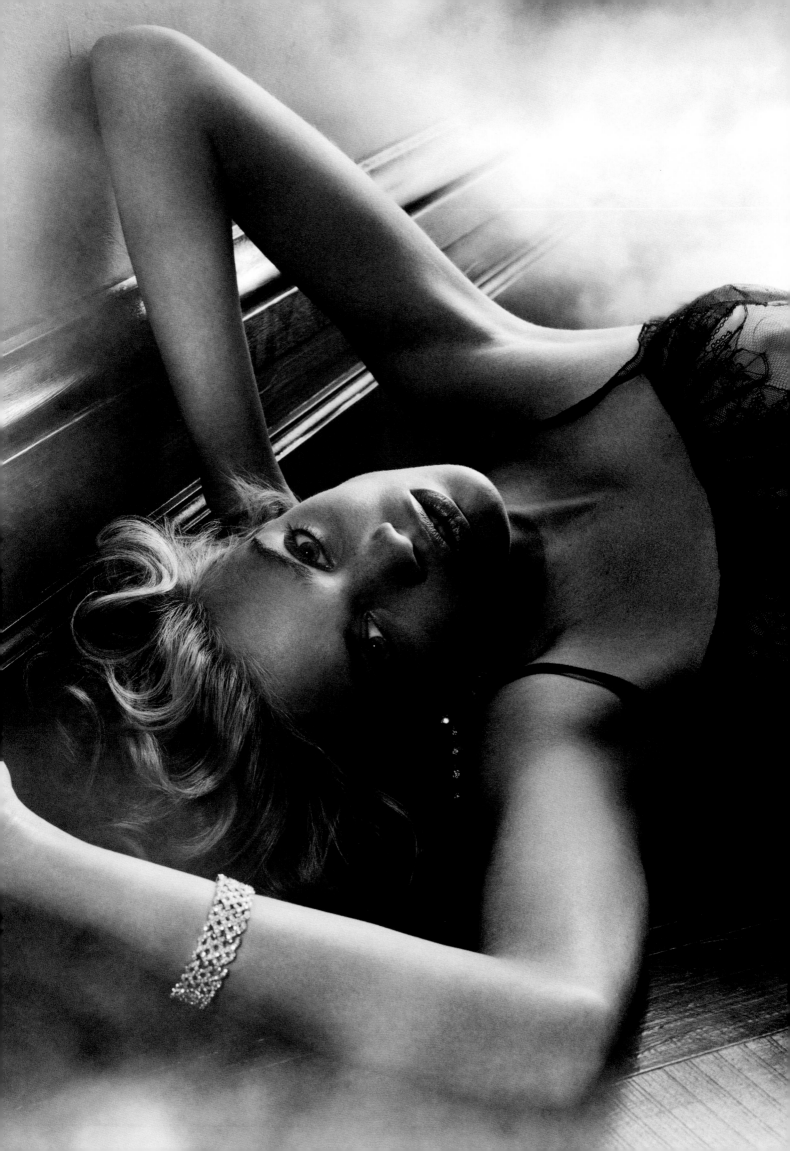

eighties

A decade of decadence and hedonism marked by the drive to succeed at all costs, the eighties represented a reaction to the committed idealism of the preceding years. Two apparently antithetical figures symbolized this new lifestyle: the yuppie and the rock star with Wall Street and Madonna as its icons. Women's fashion embraced the extremes: the daytime suits of a growing army of career women stood in sharp contrast to extravagant eveningwear characterized by pouf skirts, puffy sleeves, shoulder pads, and ultra-bright colors. Fashion designers focused on physical "perfection"; a new body shape sculpted by hours at the gym, rigorous beauty regimens, and cosmetic treatment. When women began to realize the primacy of undergarments, no less important than the outerwear that concealed them, a full-fledged lingerie boom ensued. By this time, La Perla had become world famous, with collections in the most prestigious markets. Emphasizing its commitment to uniqueness, the house chose a new path for its image, staging a refined, elegant, and seductive woman as the star of a dream. It was on these very values that the brand founded its communication strategy. Luxury was to become emotion.

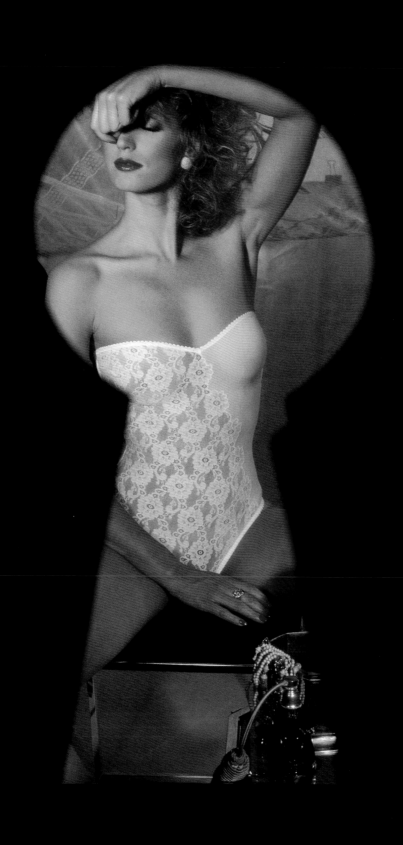

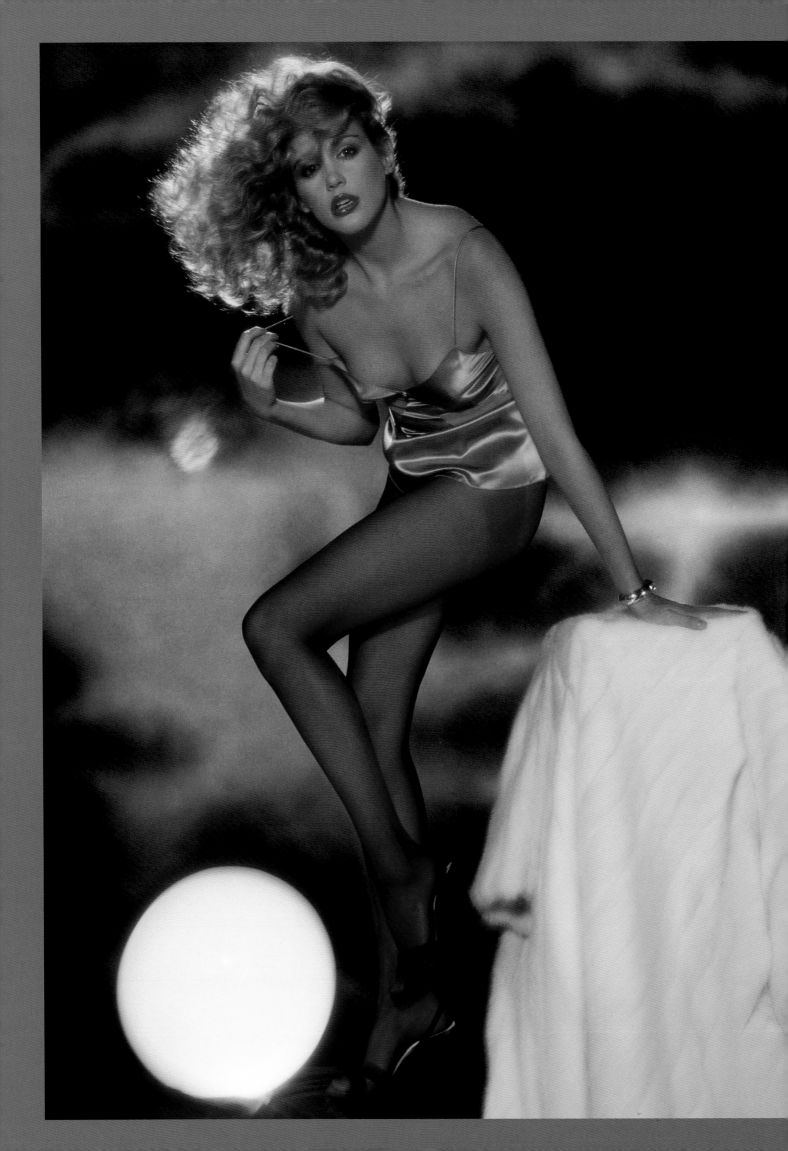

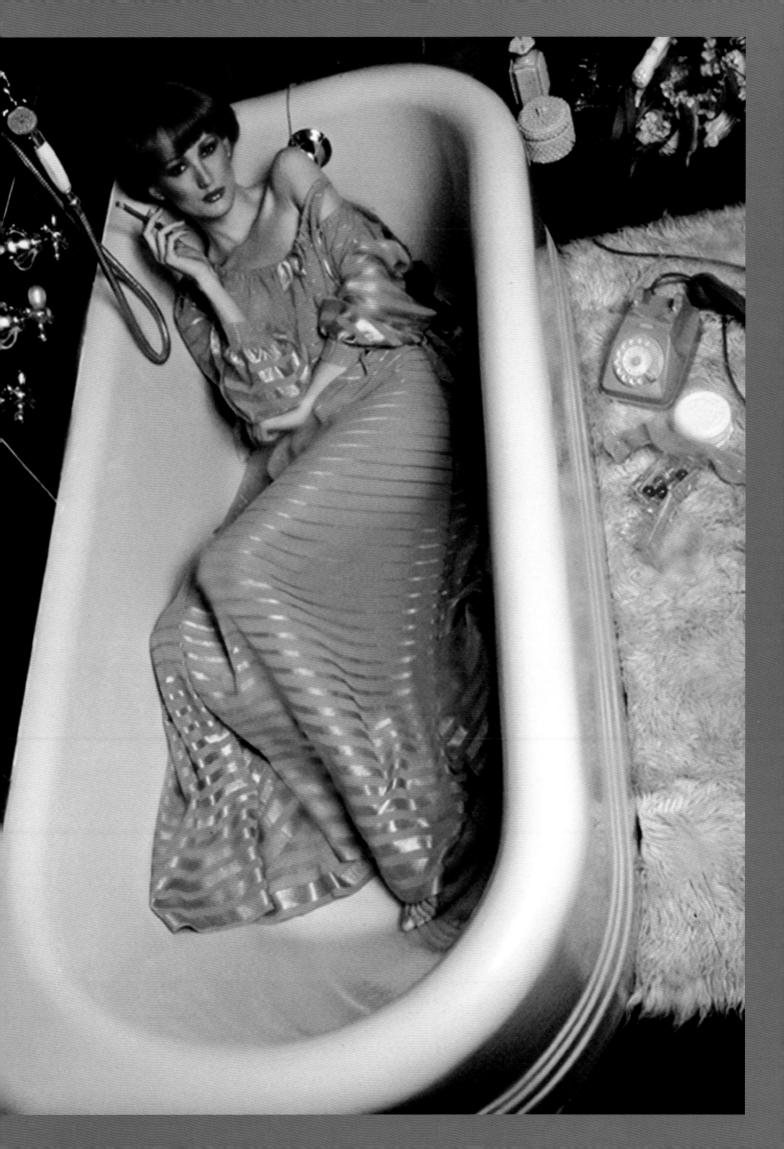

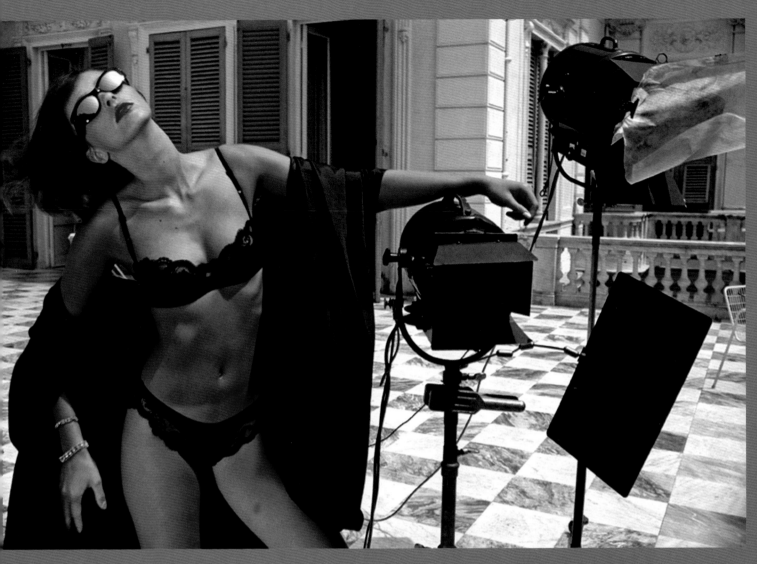

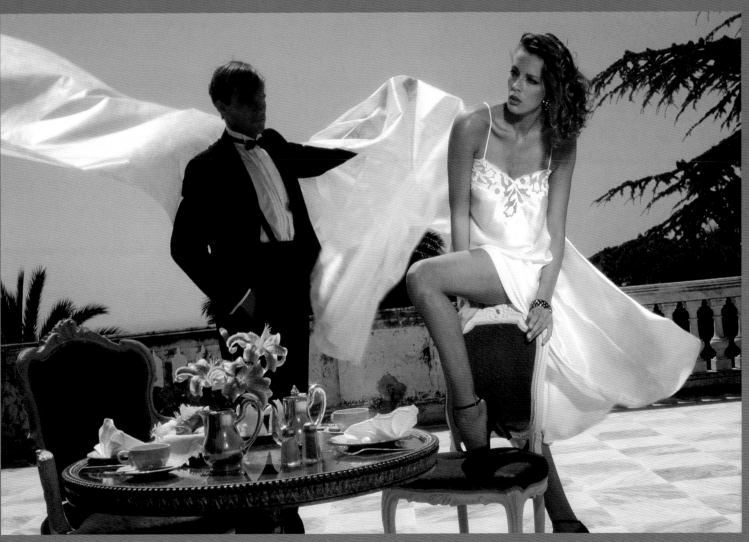

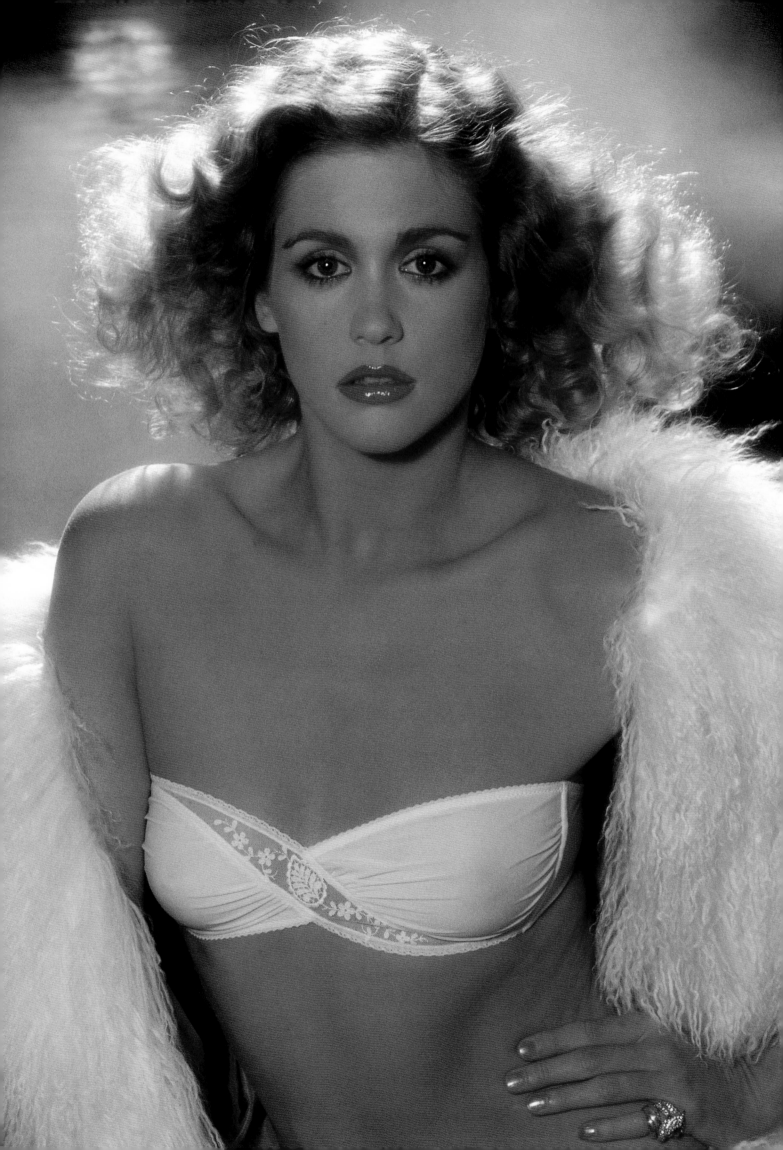

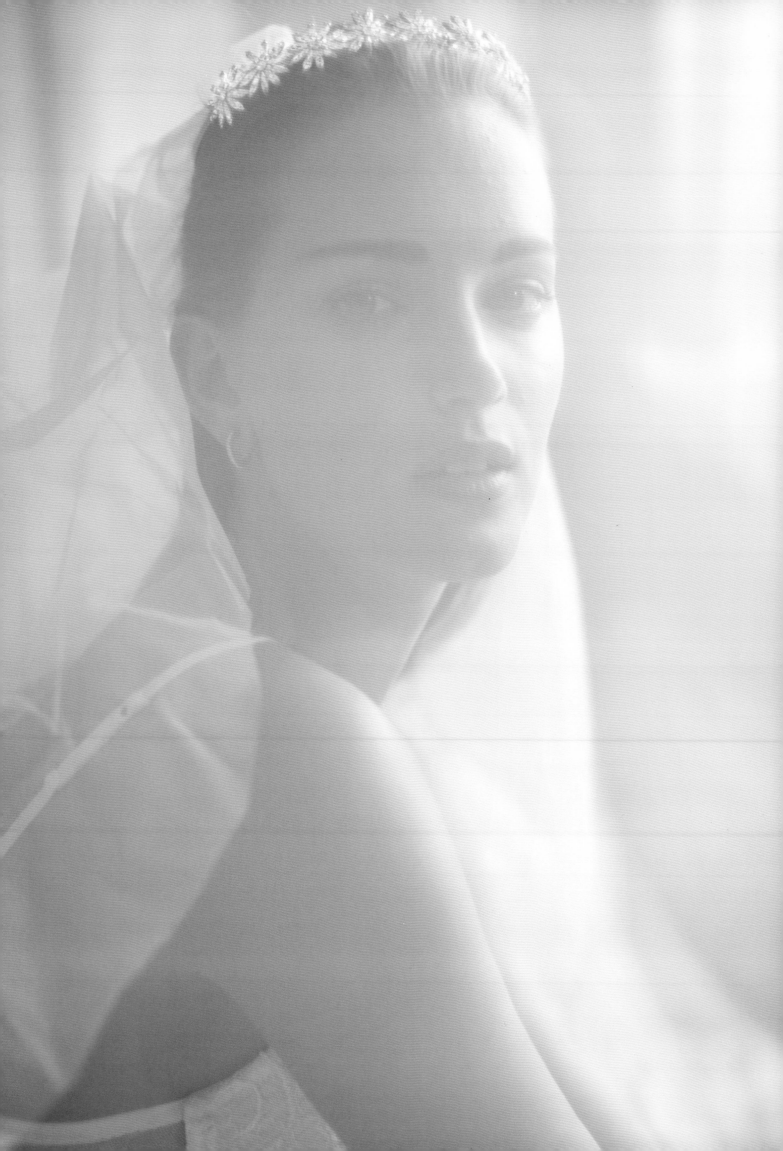

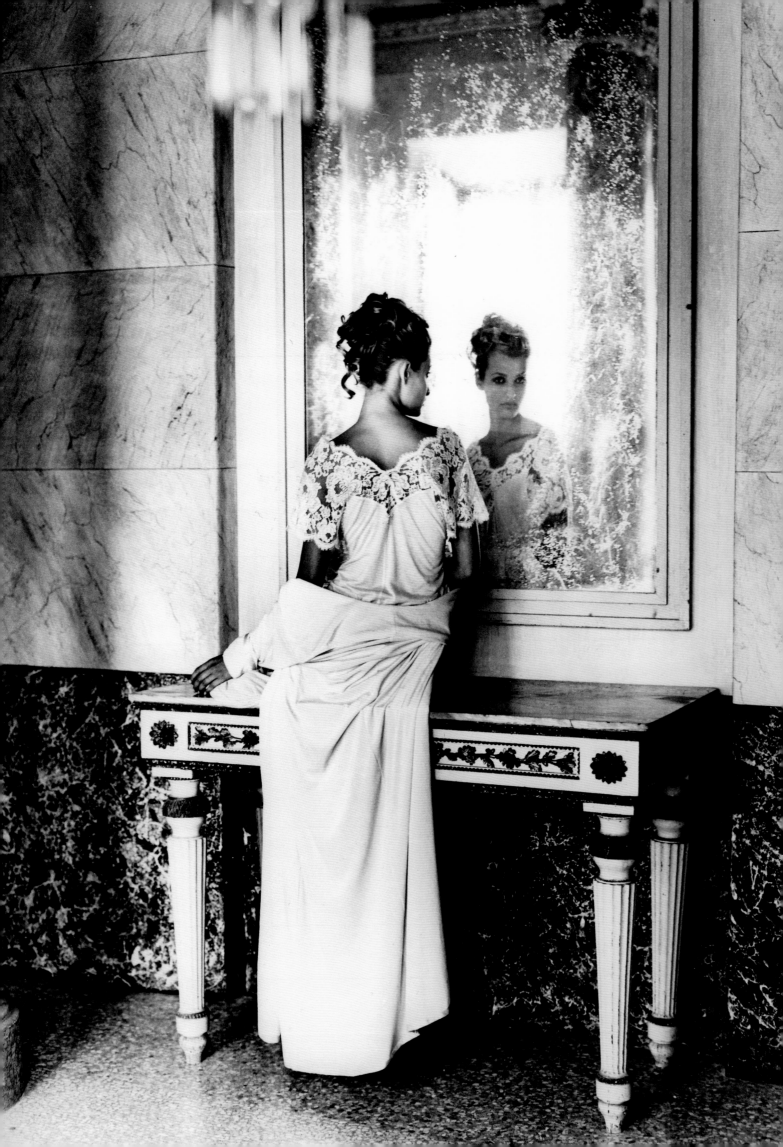

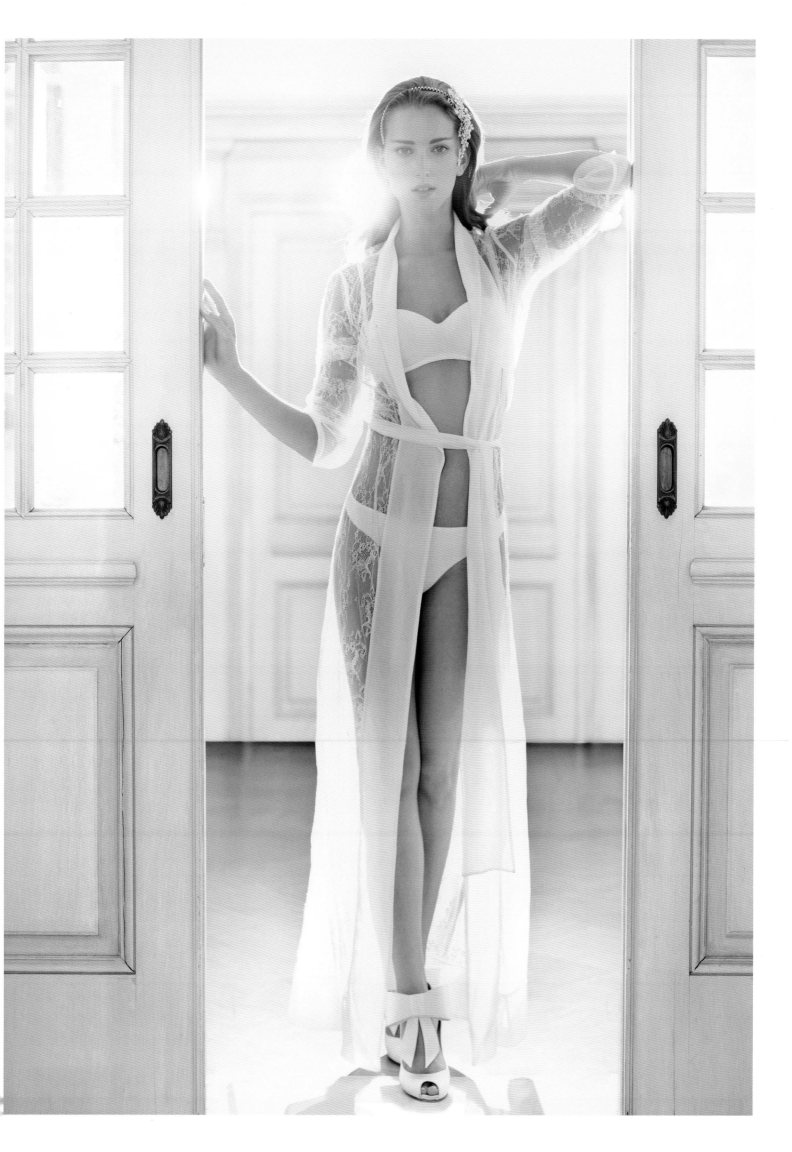

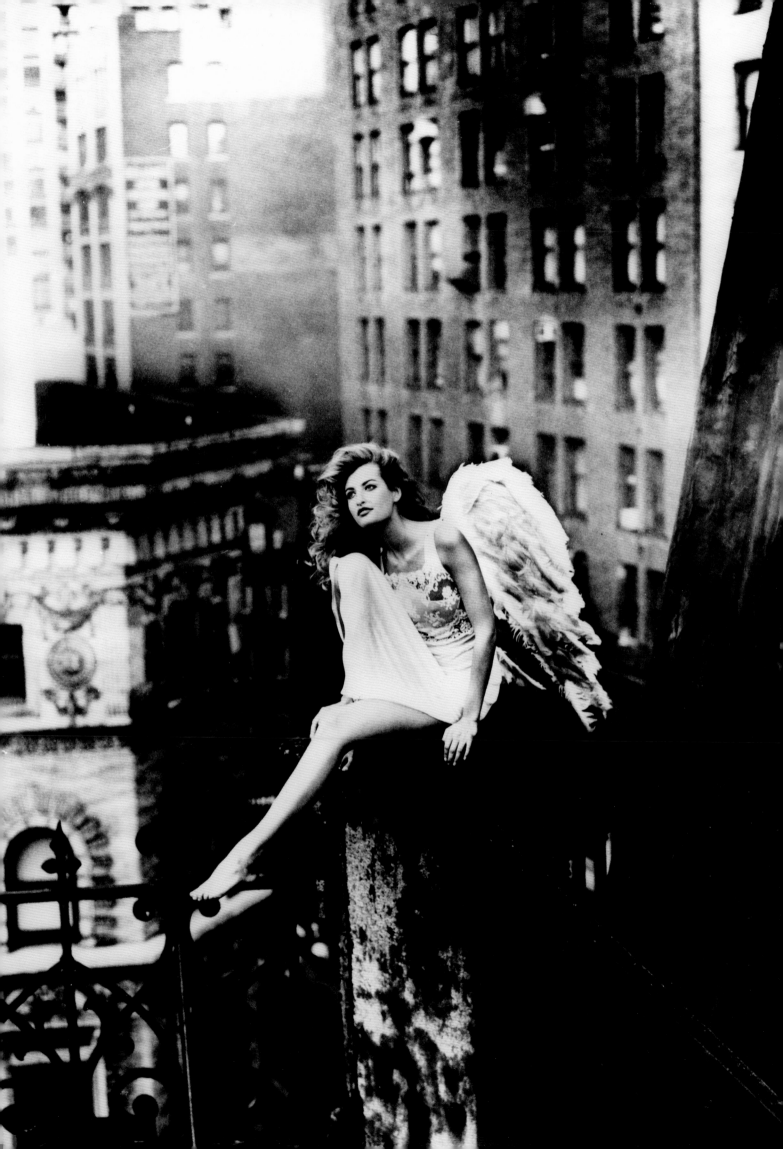

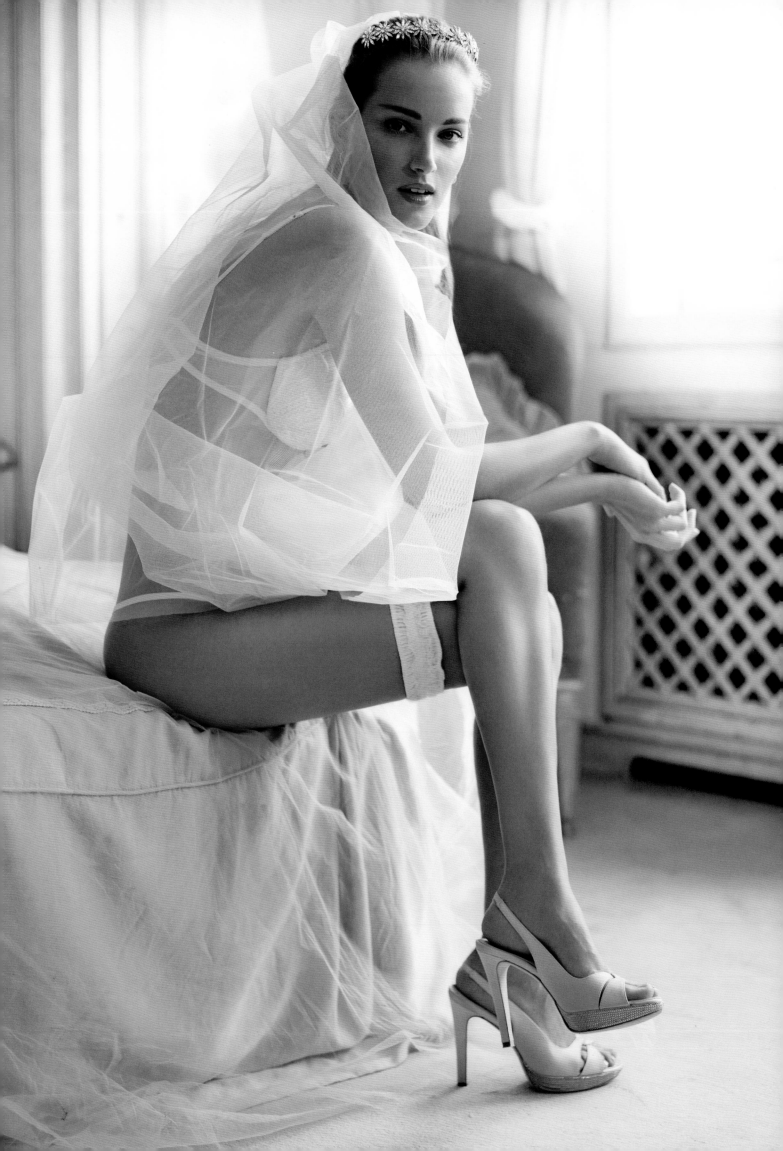

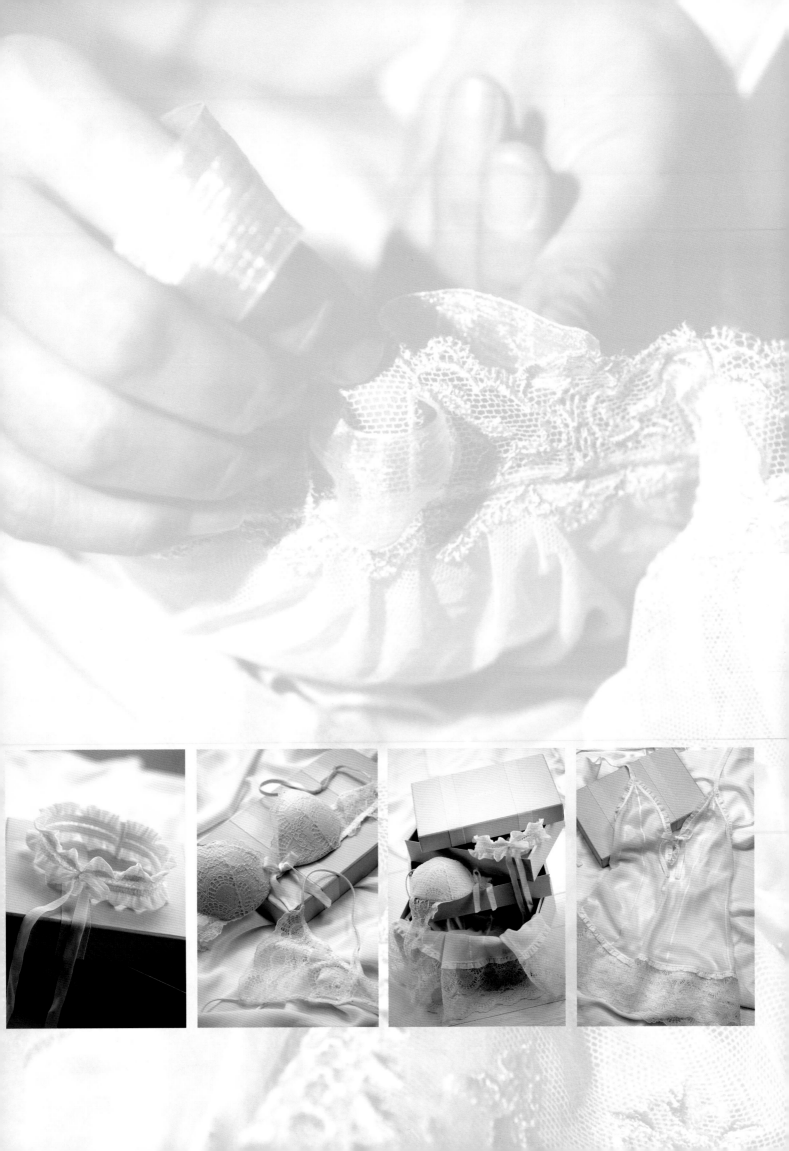

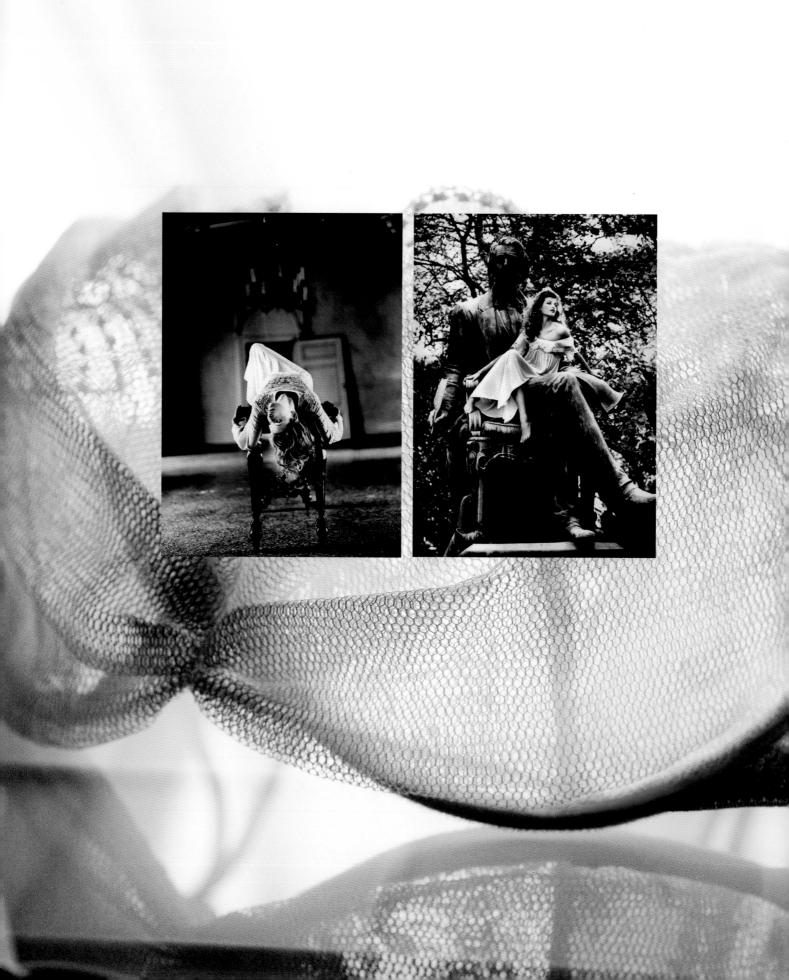

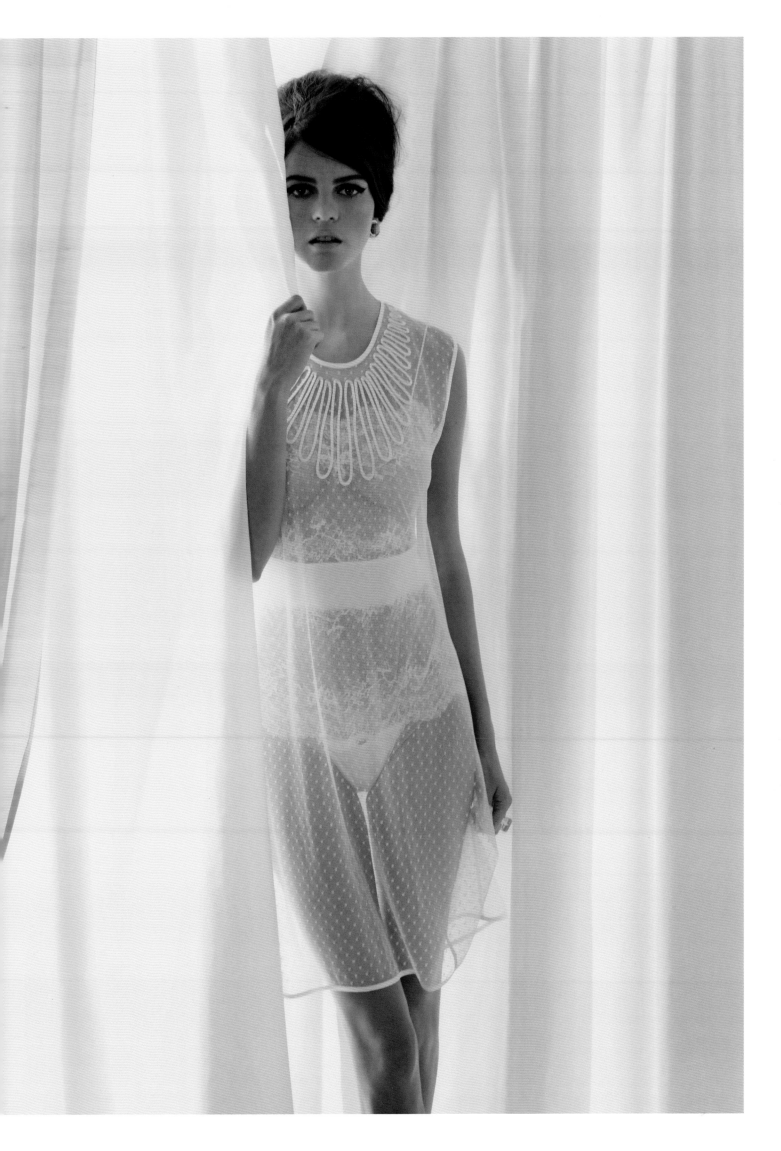

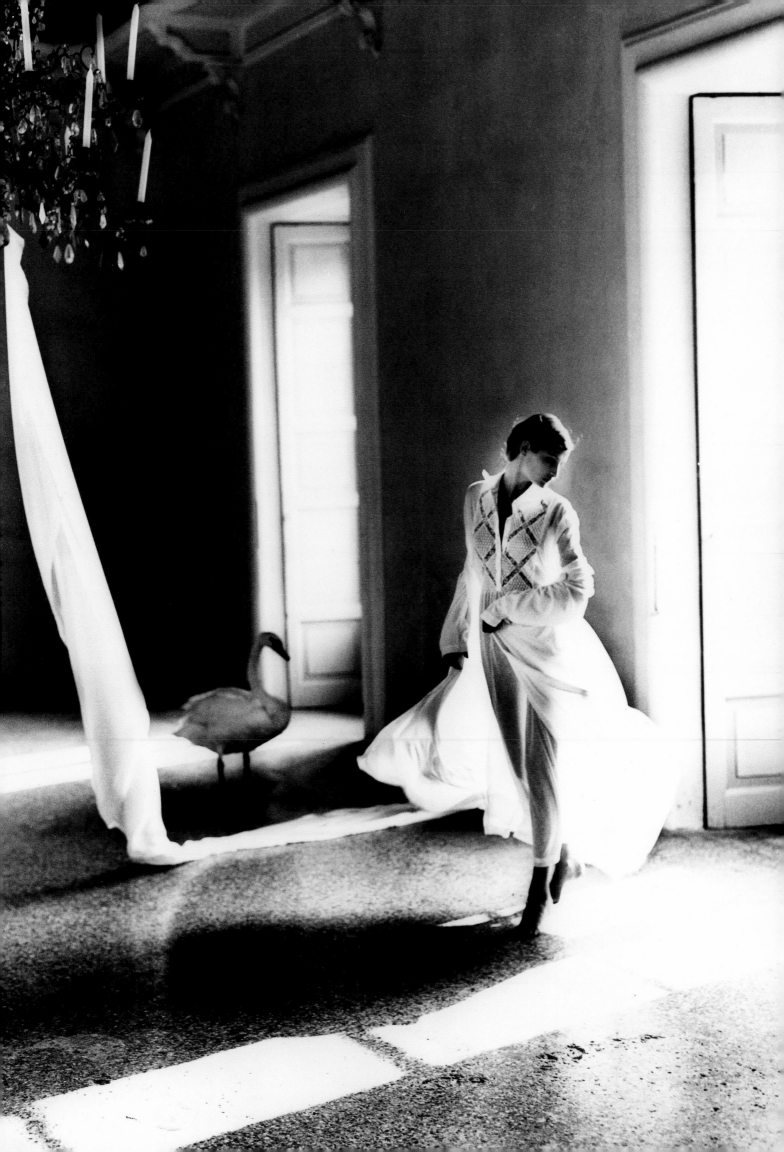

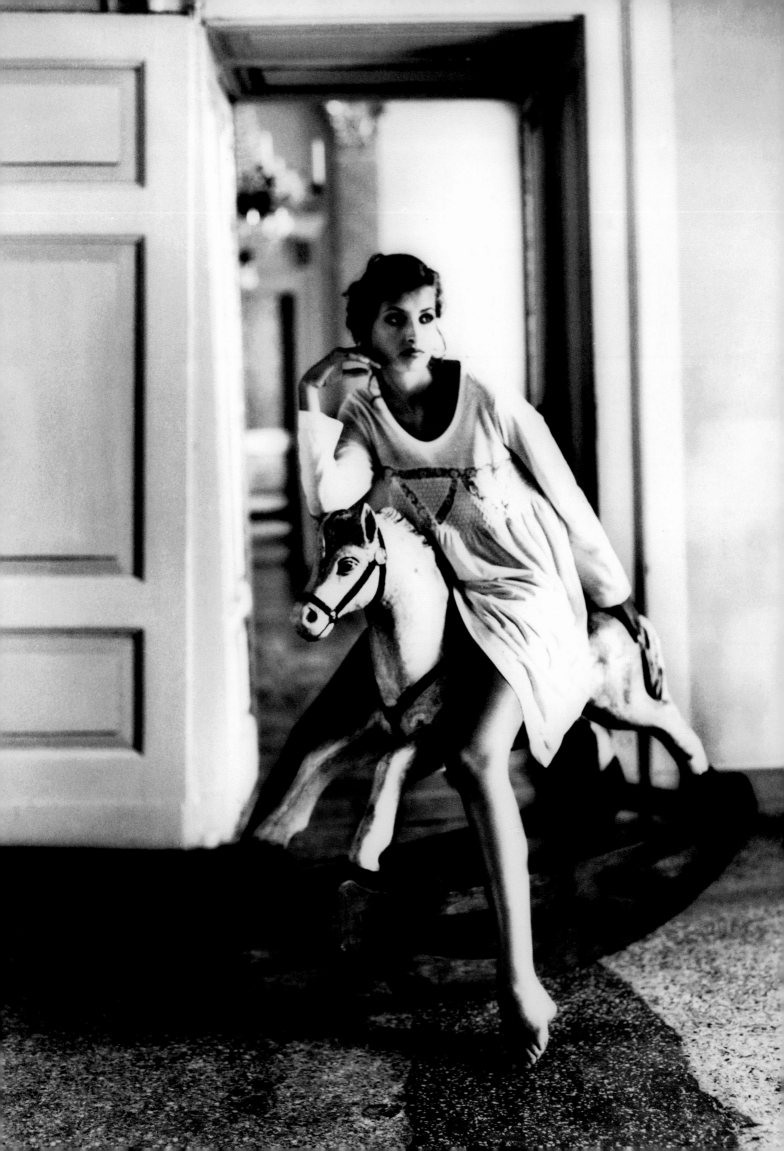

THE COLOR OF ANGELS
AND BRIDES, IT GLISTENS
LIKE FRESHLY FALLEN SNOW
AND GLOWS WITH THE
PROMISE OF A BLANK SLATE.
WHITE BATHES THE BODY
IN AN ETHEREAL LIGHT AND
SEDUCES WITH THE NUANCE
OF CANDOR.

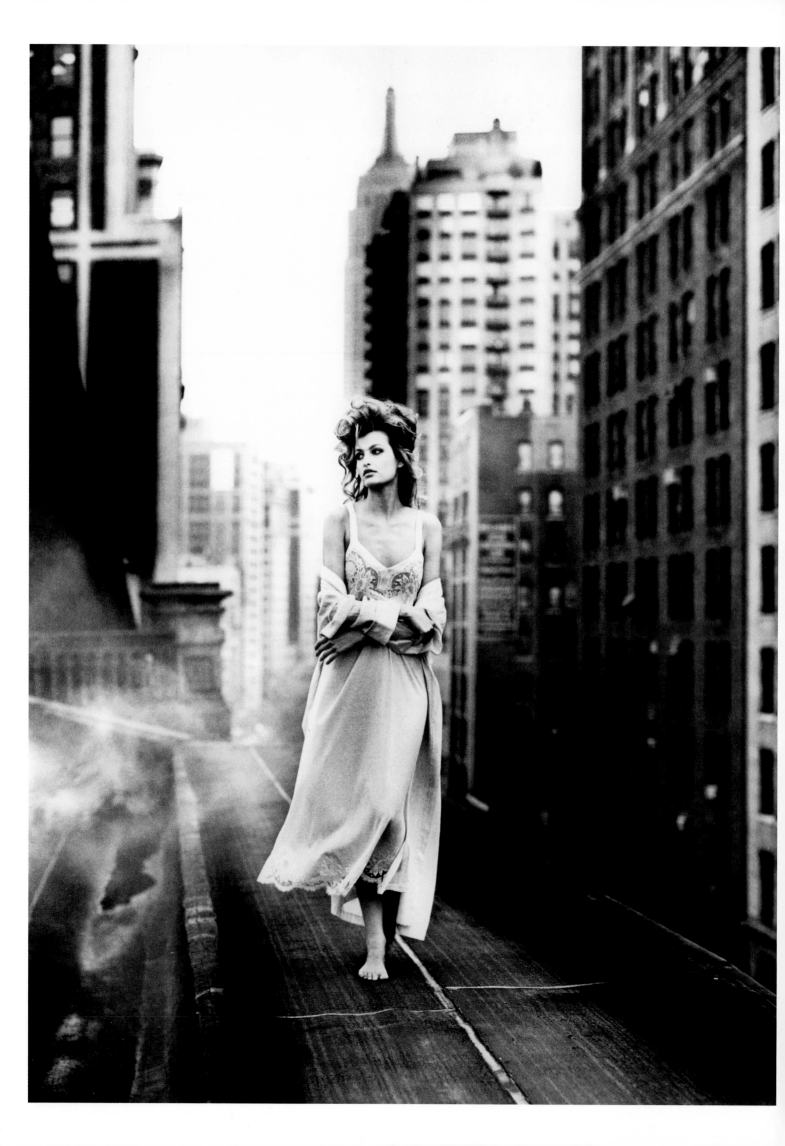

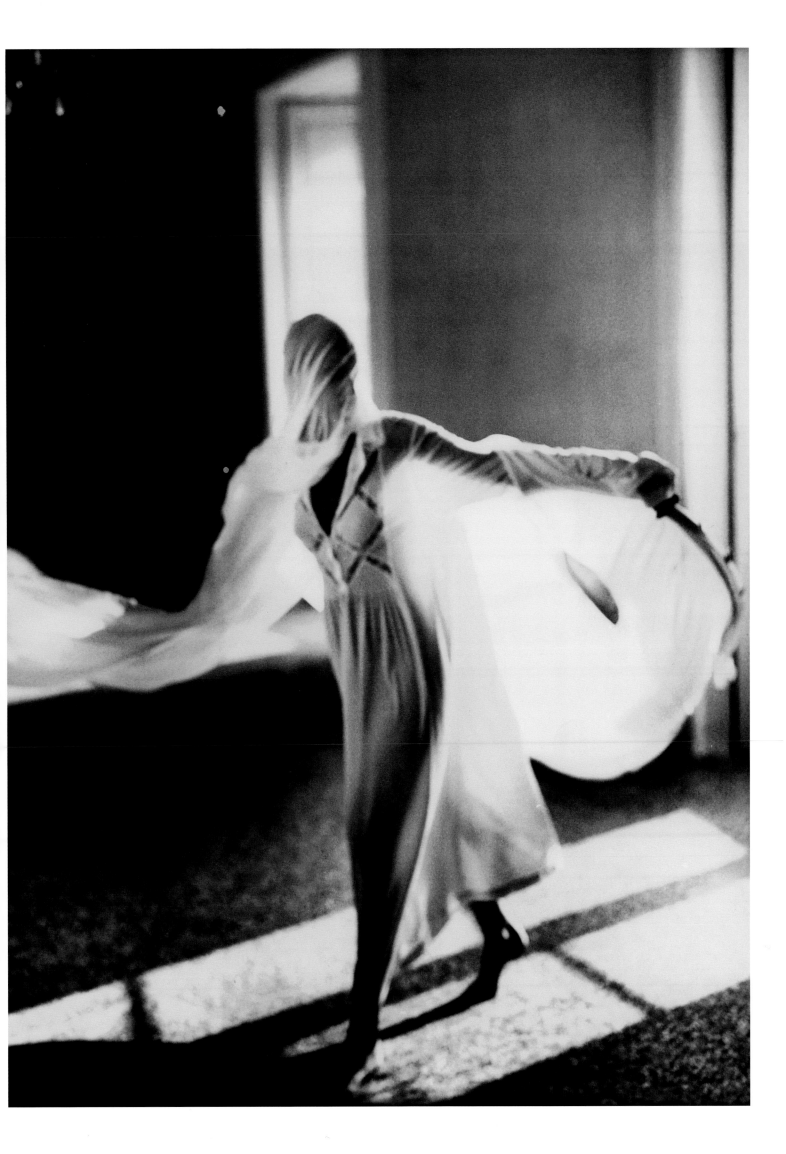

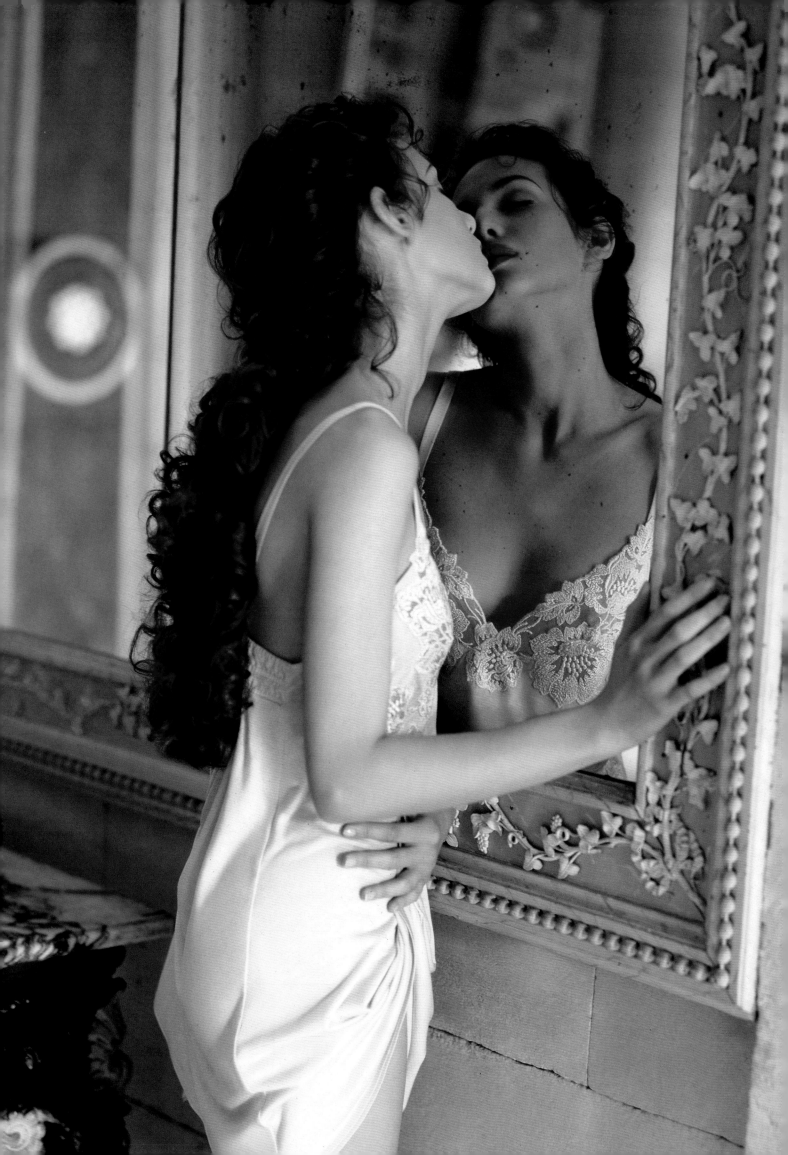

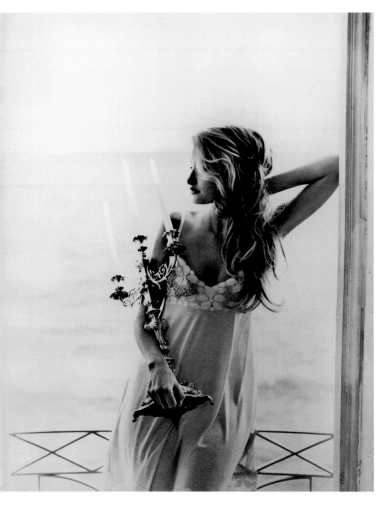

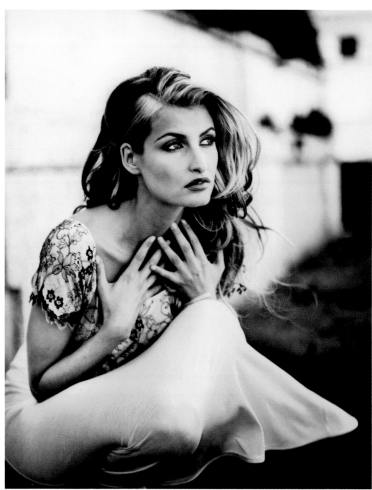

nineties

In the wake of the glittering eighties, fashion in the early nineties favored rich fabrics with elaborate lines and luxury shown off with glamorous nonchalance. La Perla photo shoots portrayed a dramatic woman, dynamic and intensely seductive in lingerie that matched her shoes, jewelry, jackets, and even hats. Having abandoned the private space of the bedroom, she moved seamlessly from living rooms to lofts and from balconies to gardens. The trend of blurring boundaries between public and private emphasized the gradual ascent of lingerie to the world of fashion. The decade was complex and multifarious in terms of stylistic codes: the triumph of color alternated with a trend toward minimalism in which linear, sober clothing represented the essence of elegance. The novelty was that lingerie could be exposed—as long as the look was unequivocally couture. One of the leading designs in this revolution was Sculpture, the brassiere introduced in 1994 that became the cornerstone of a new type of La Perla lingerie: essential yet sartorial.

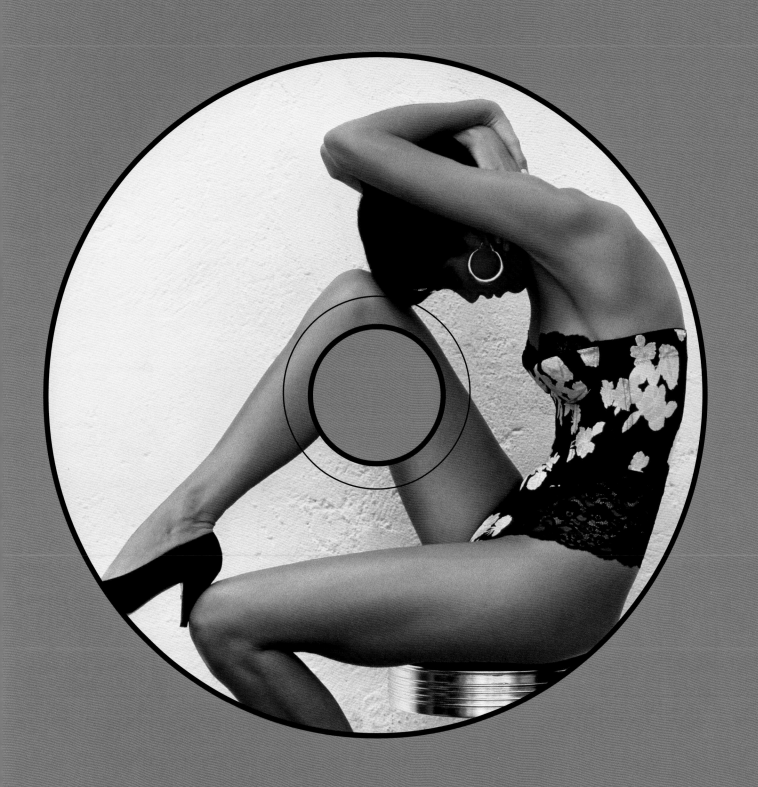

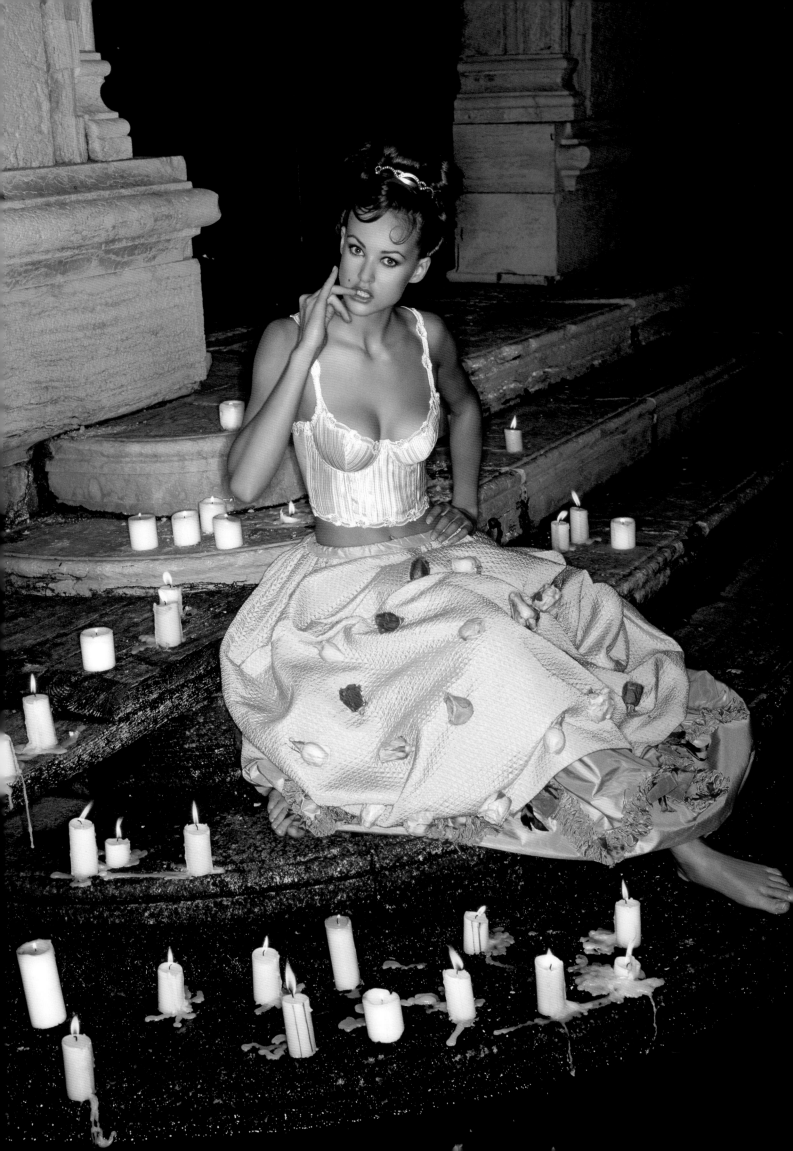

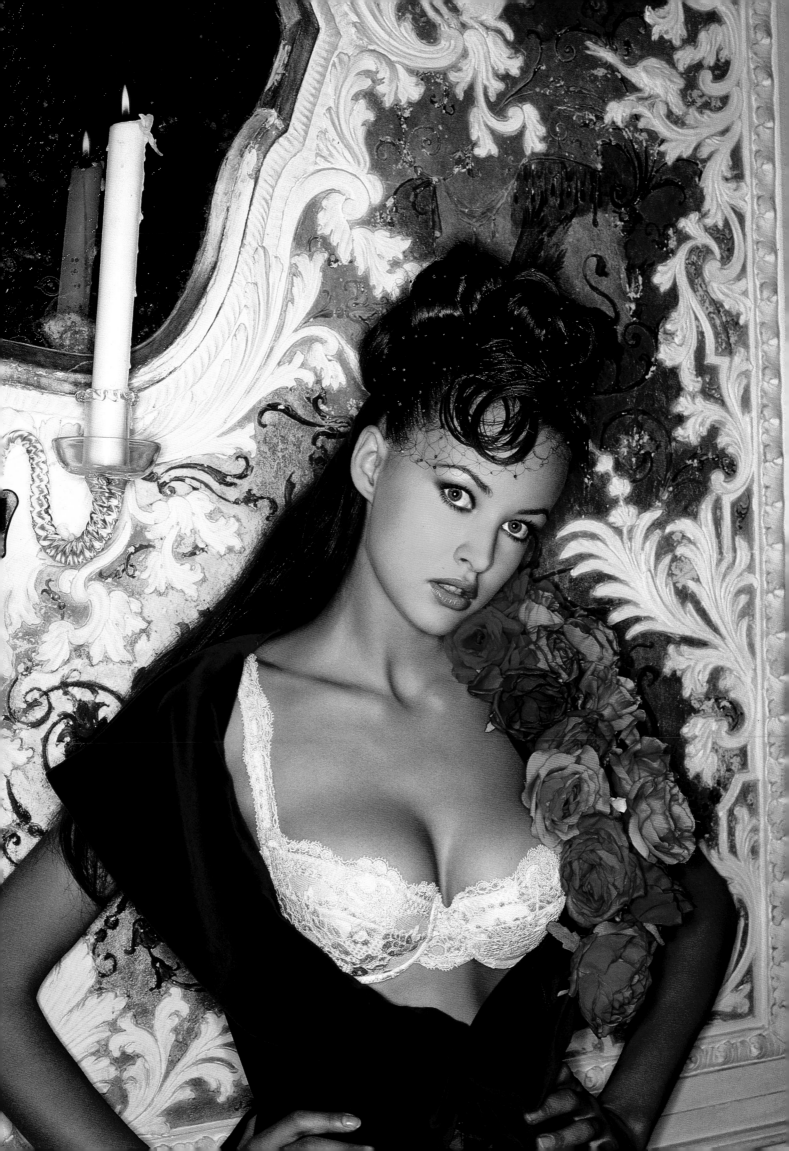

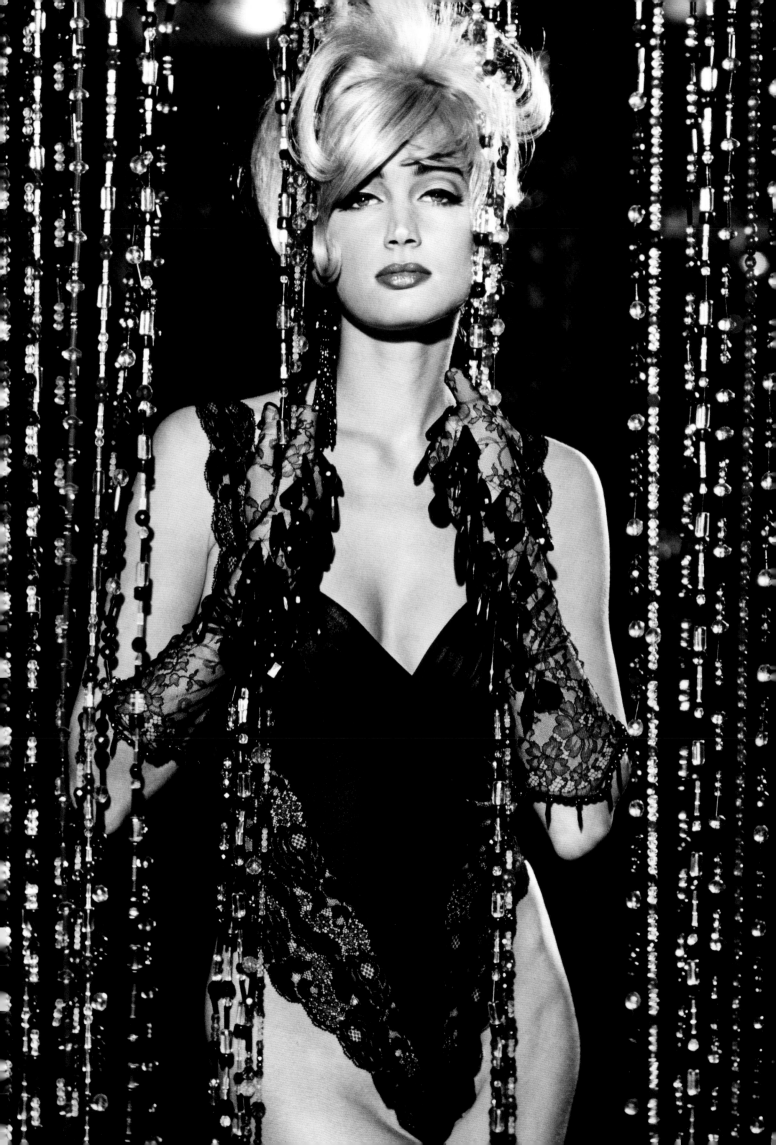

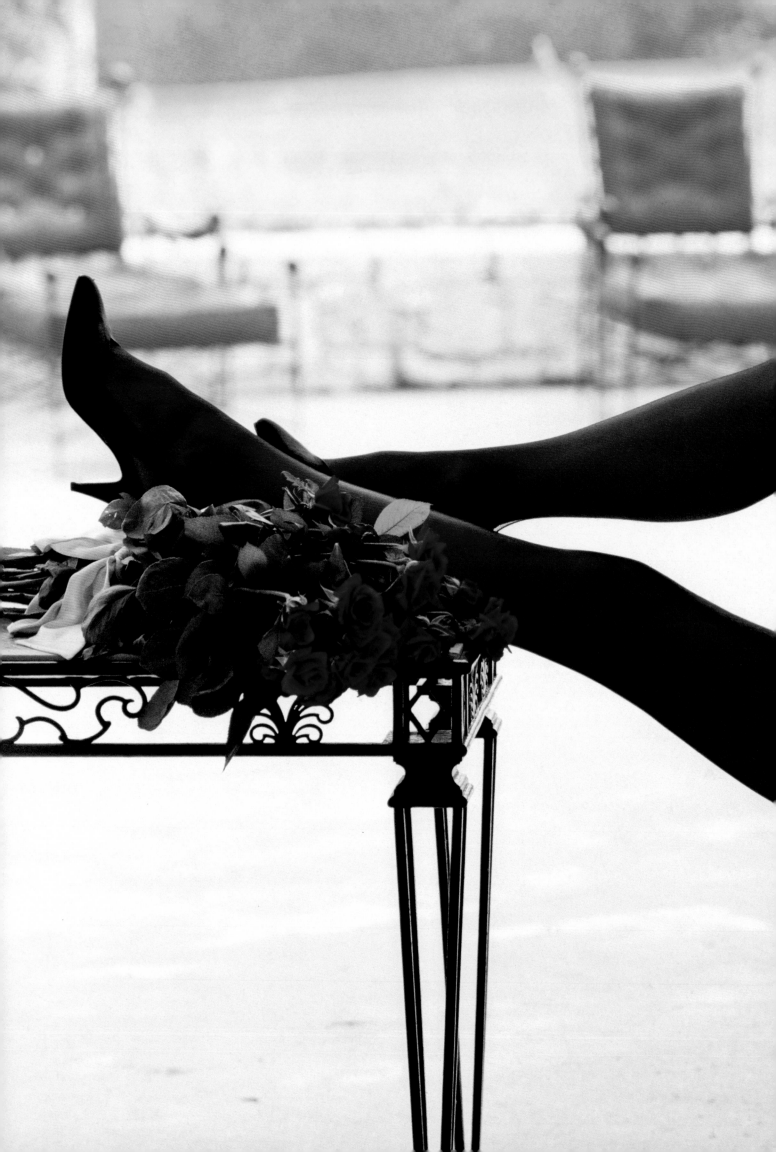

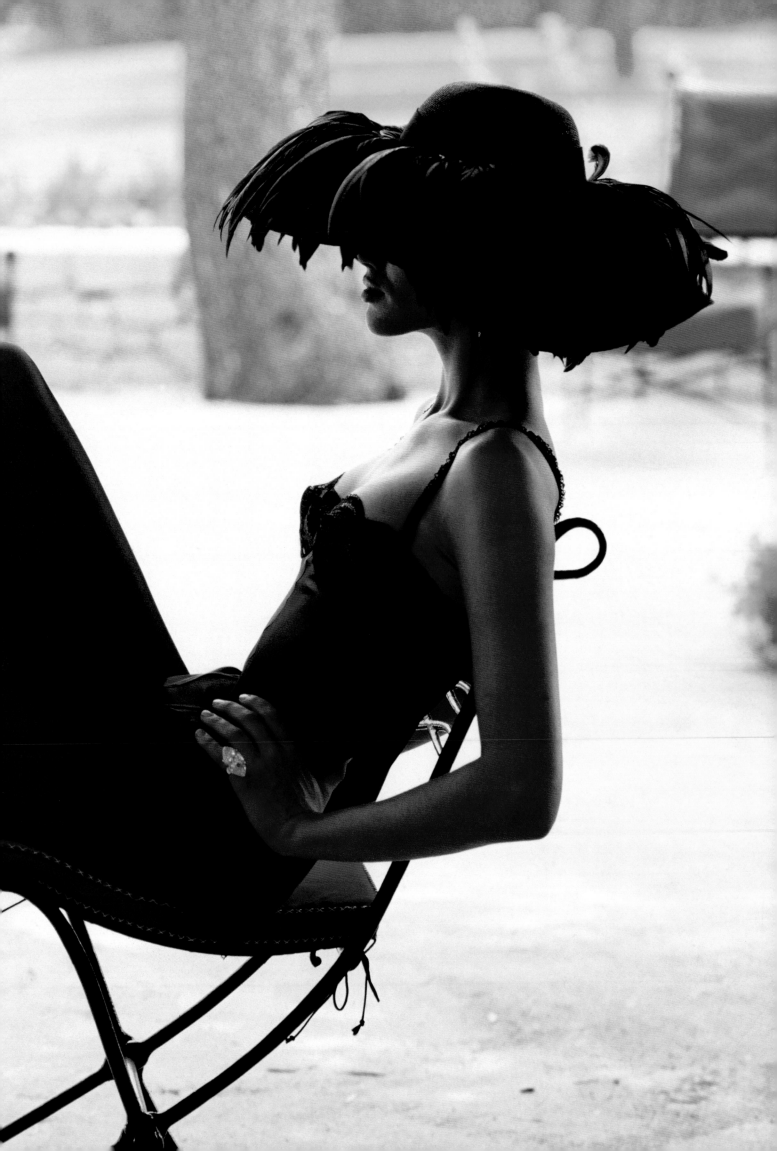

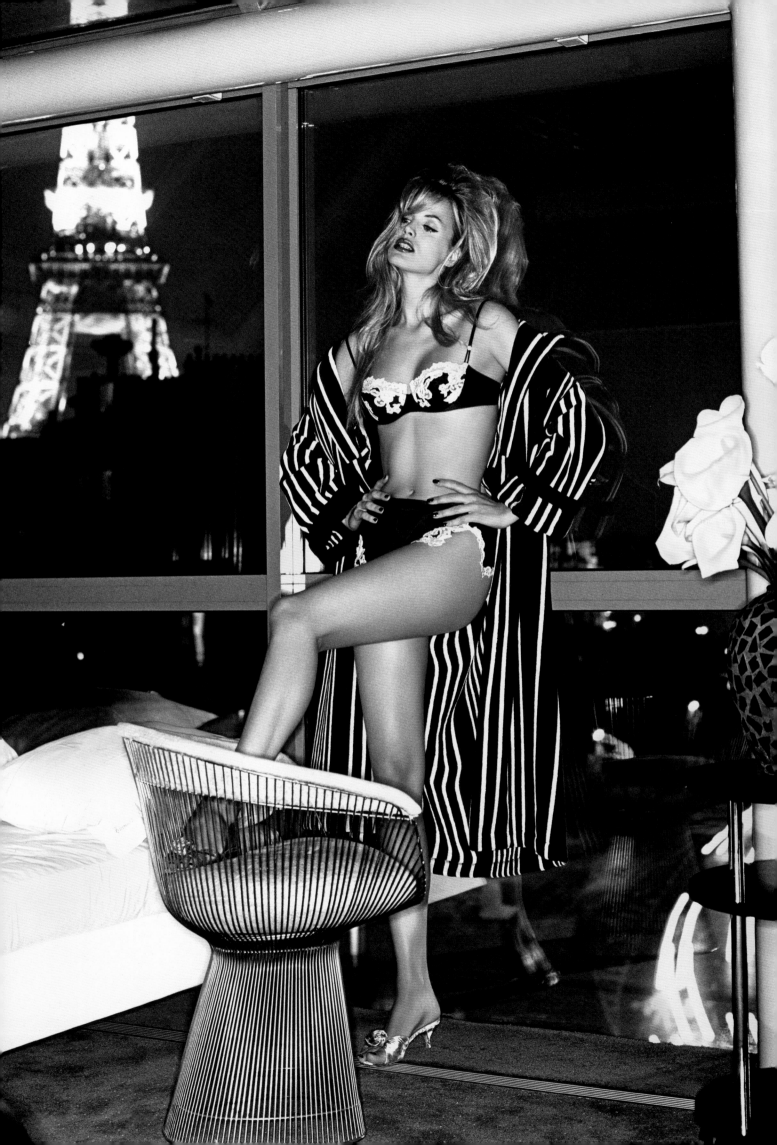

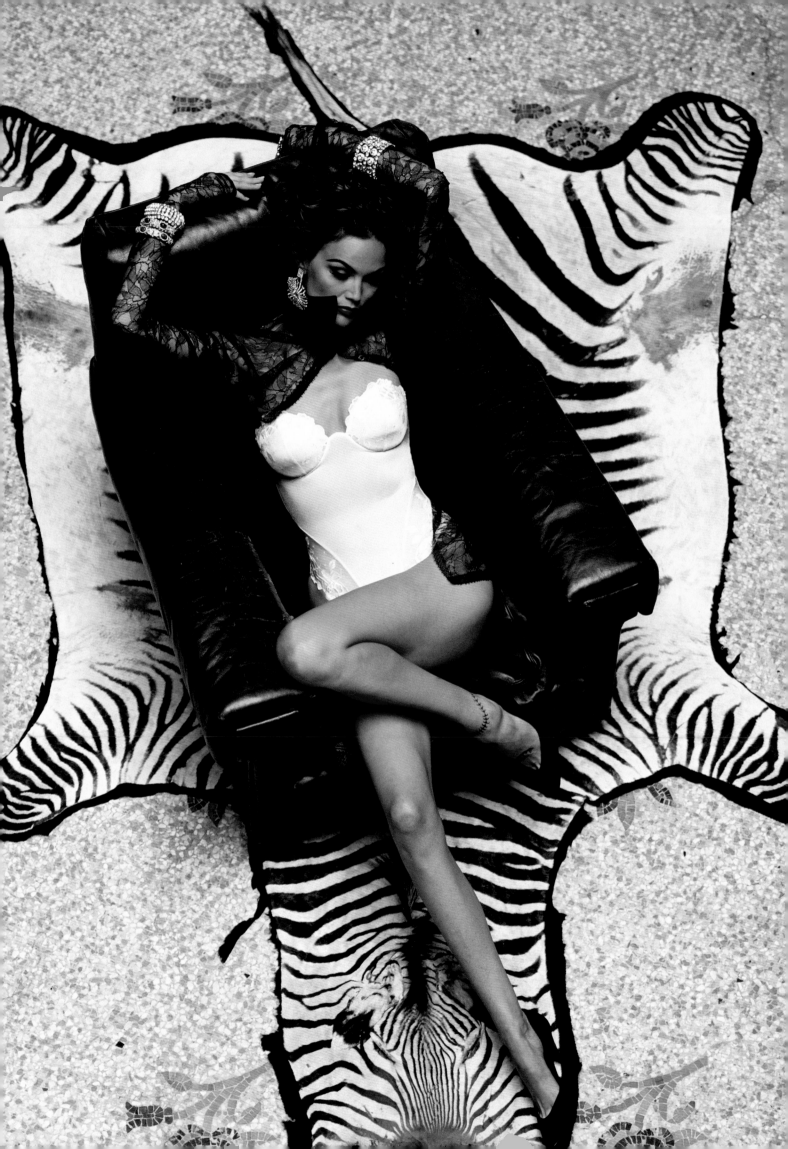

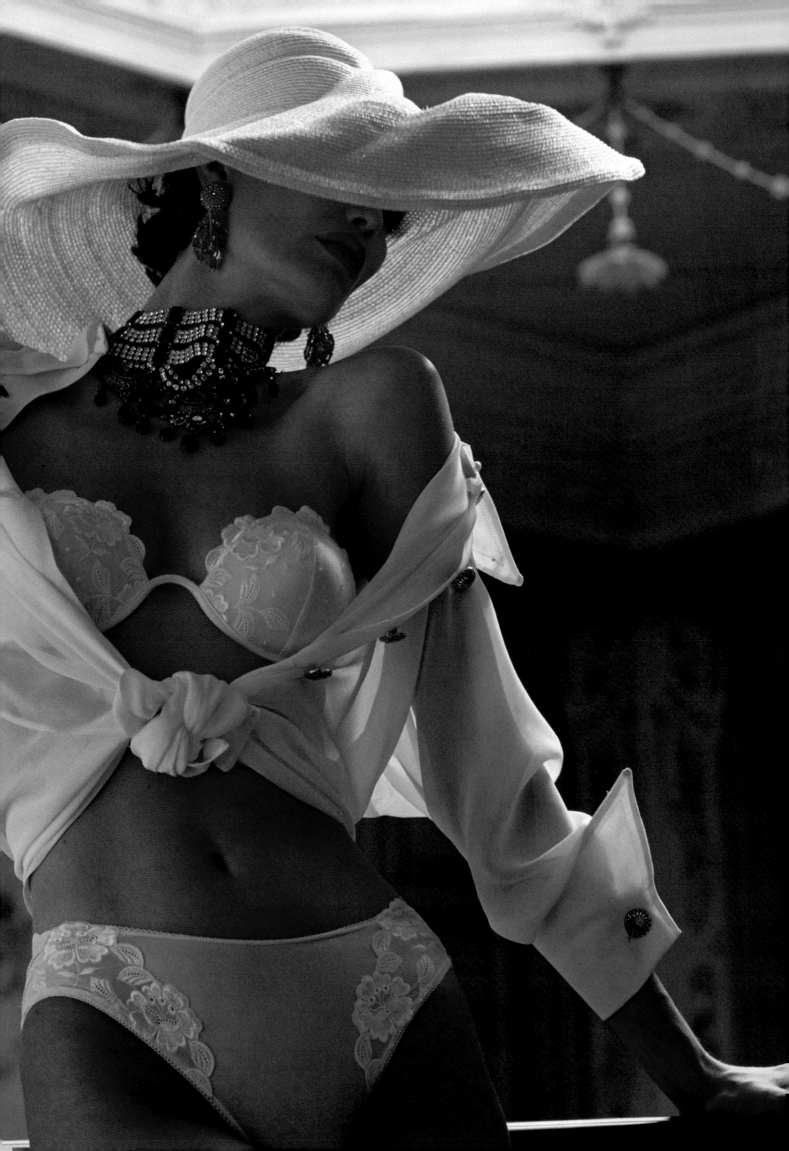

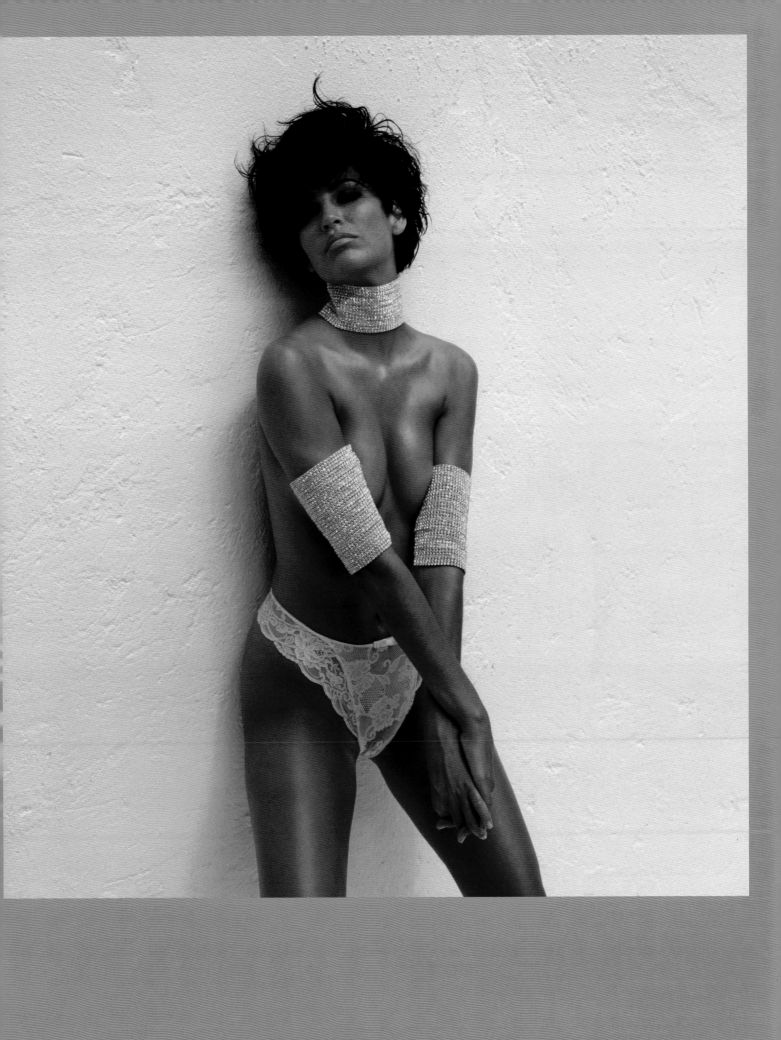

precious

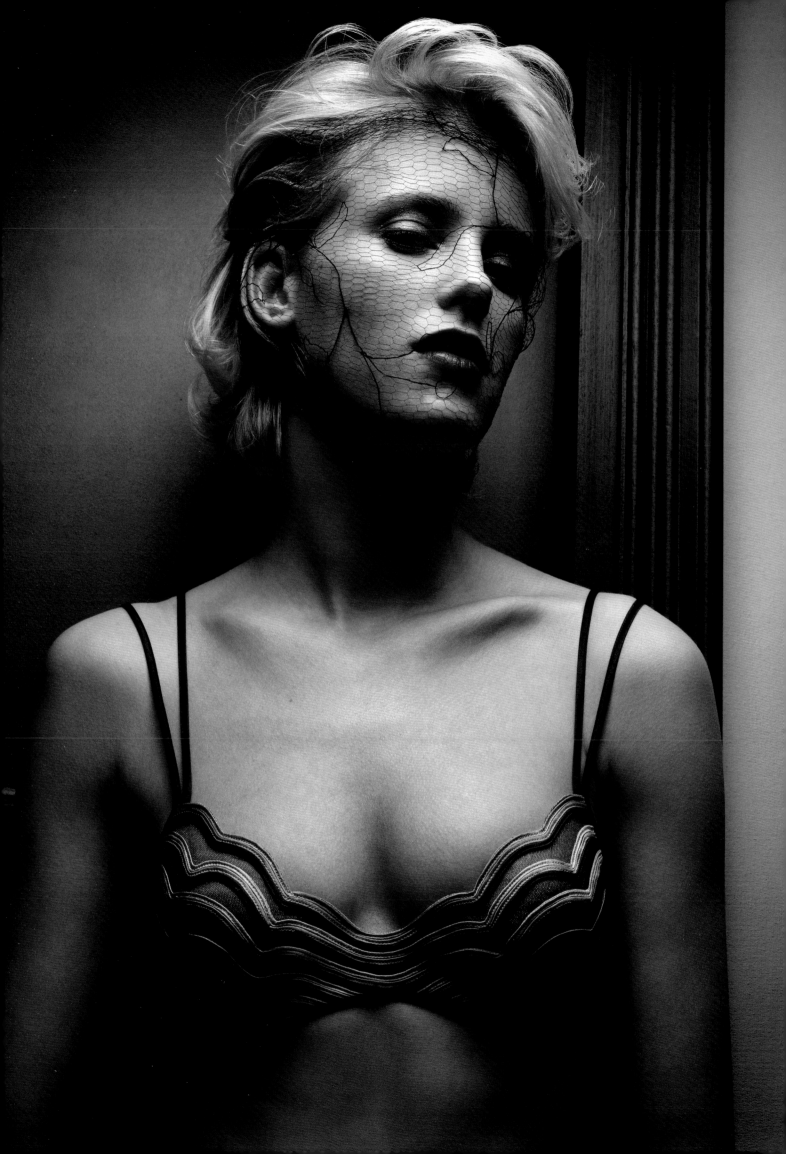

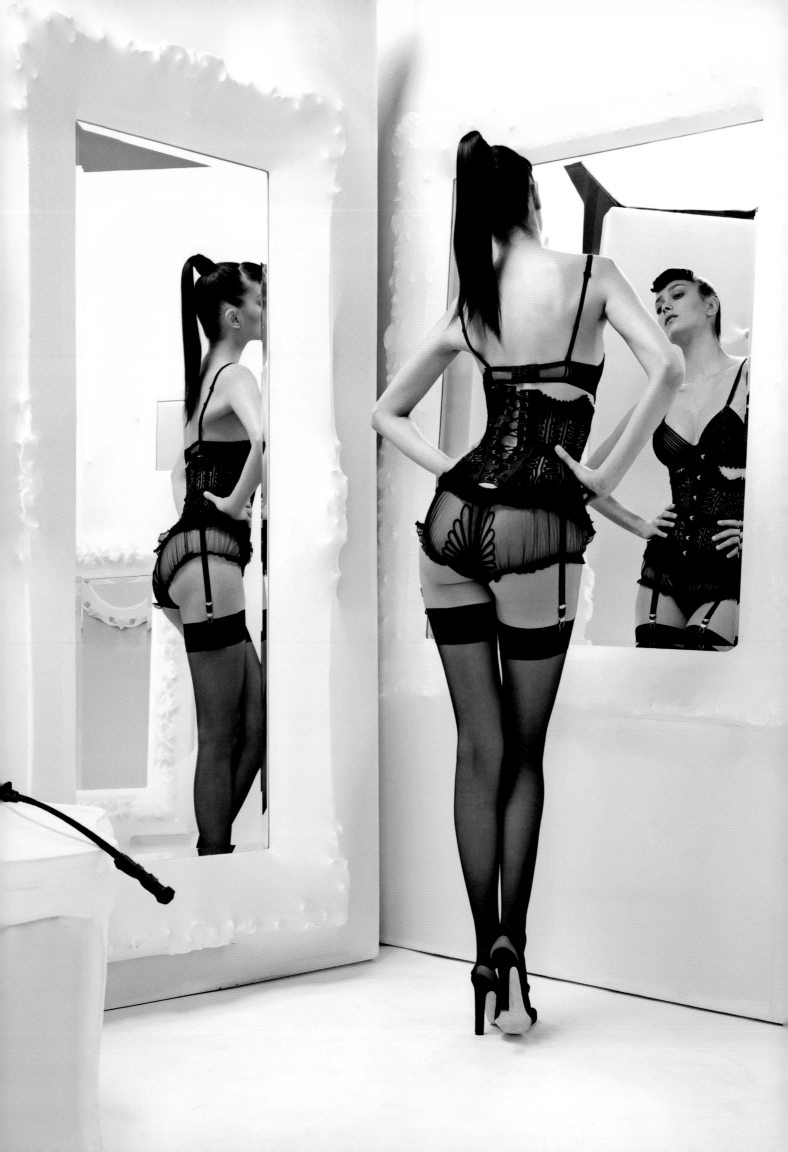

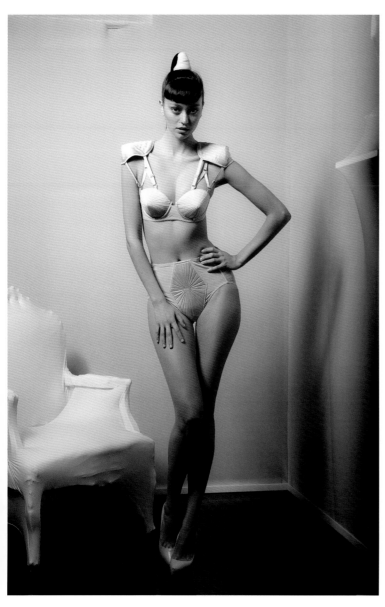
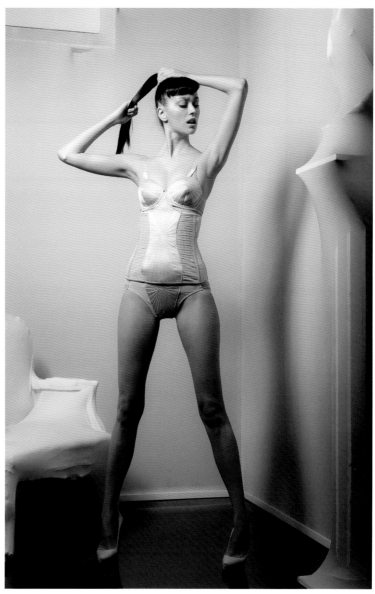

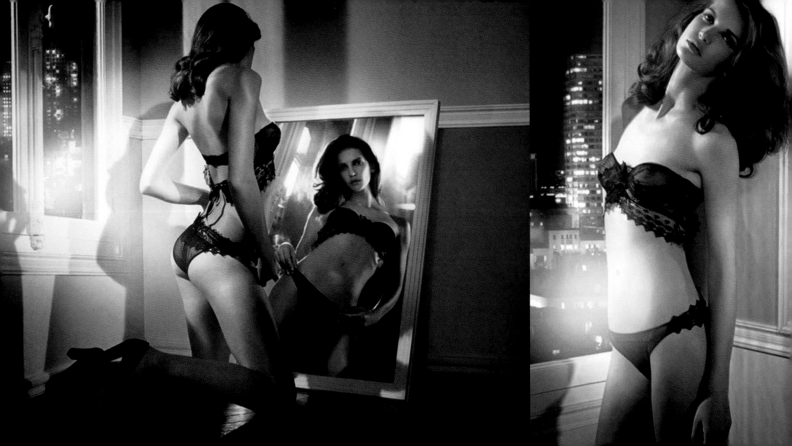

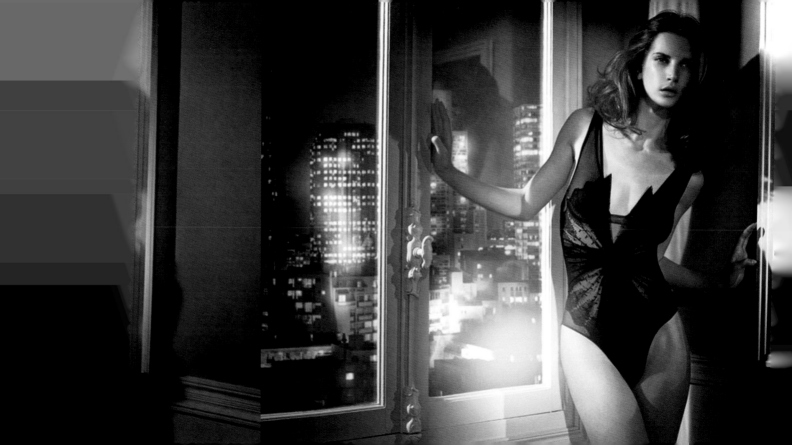

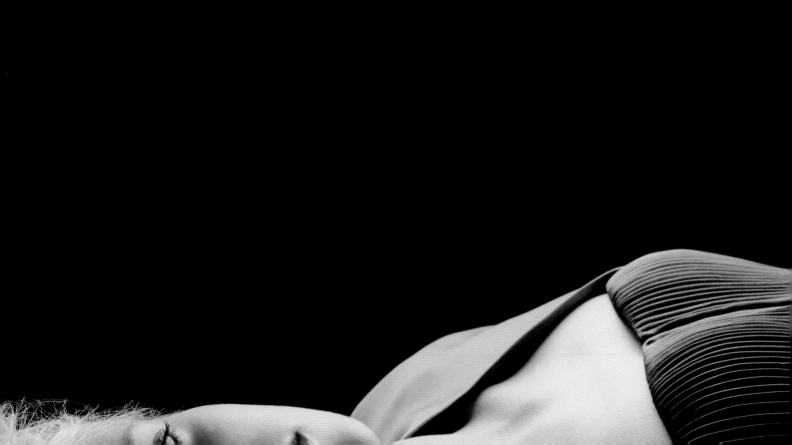

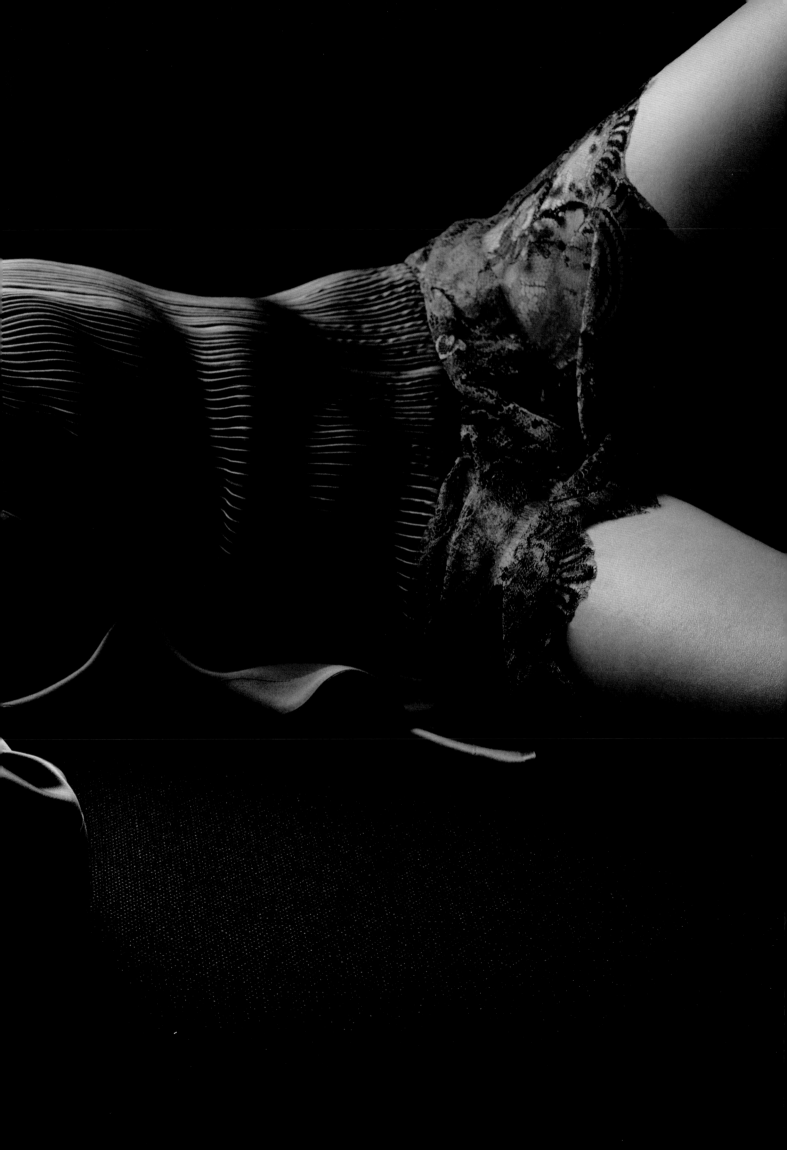

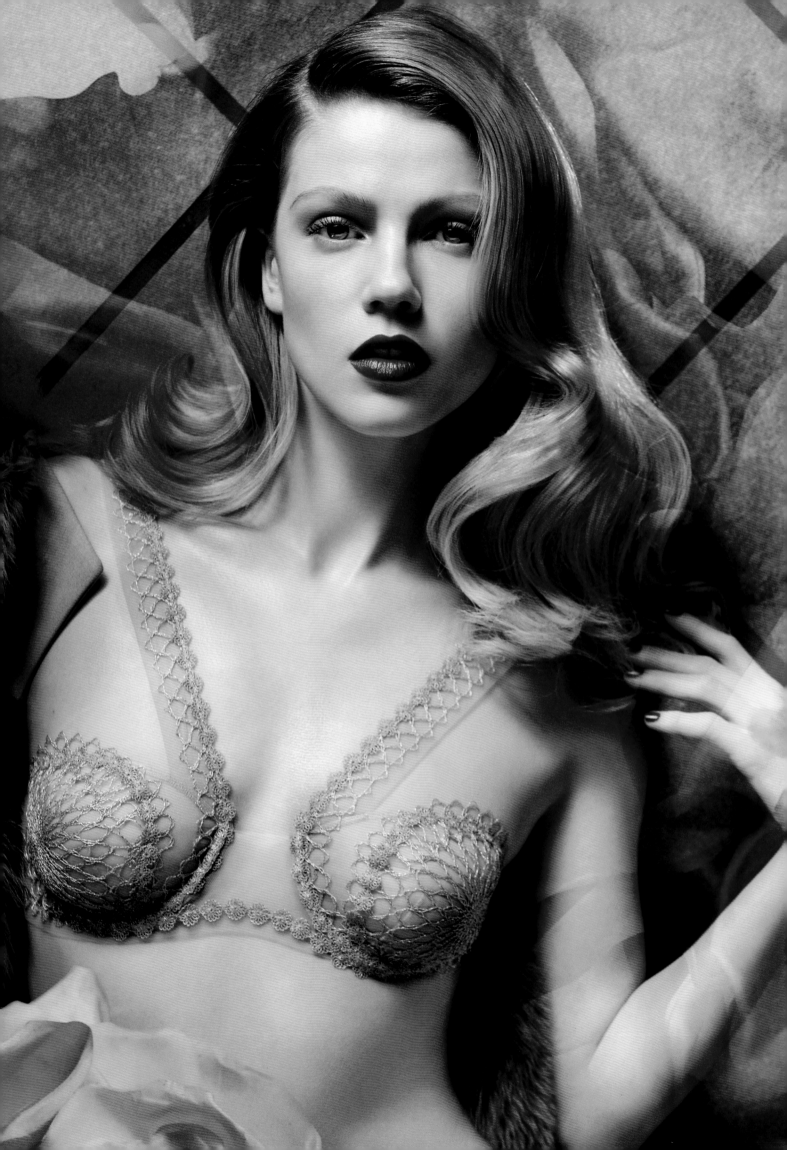

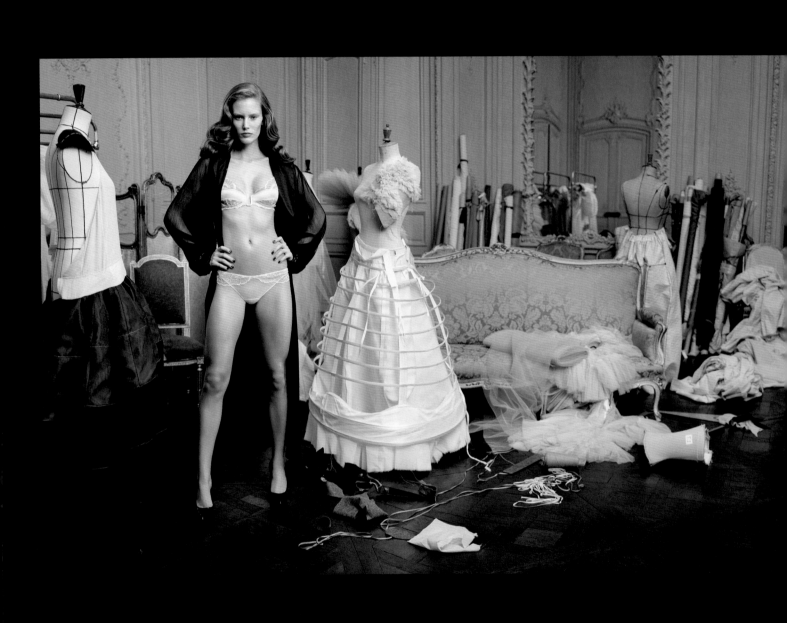

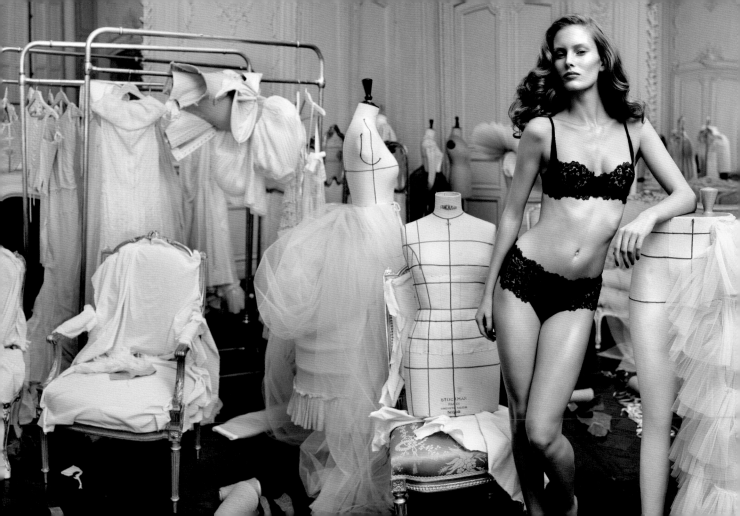

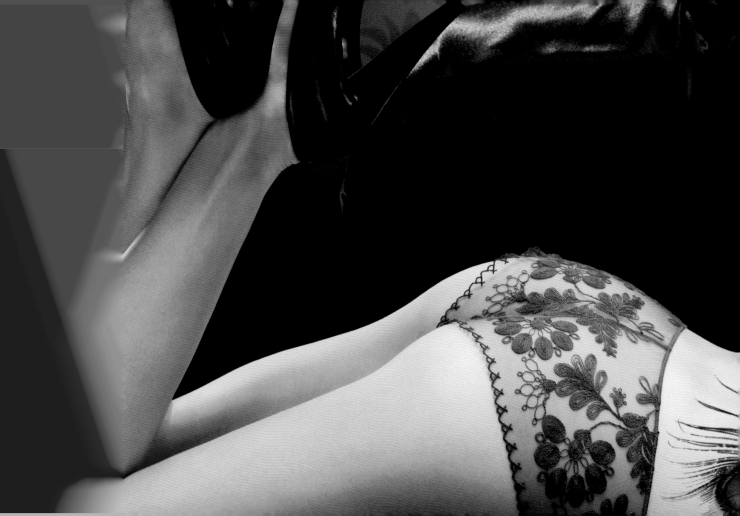

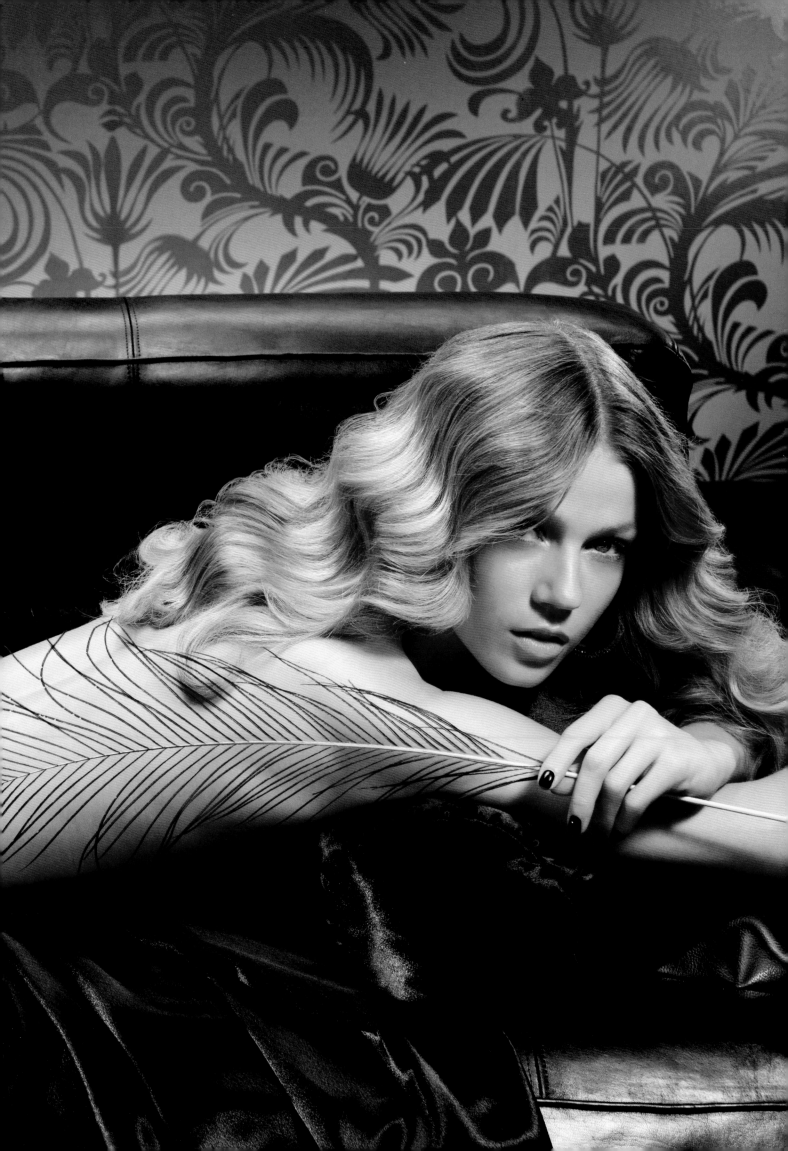

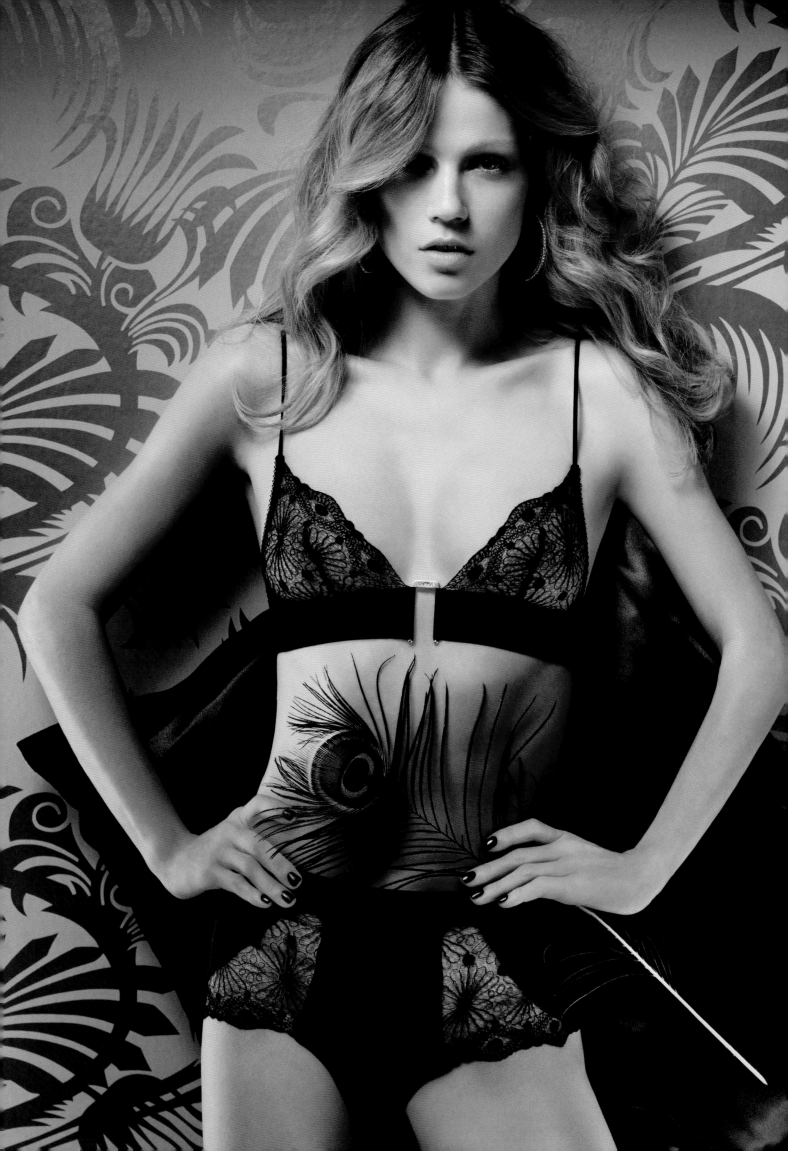

DESIRE FOR THE COLLECTOR. BORNE OF THE DIALOGUE BETWEEN THE LANGUAGE OF INTIMACY AND THAT OF APPEARANCE, THESE COUTURE CREATIONS WERE INVOKED IN THE NAME OF UNIQUENESS.

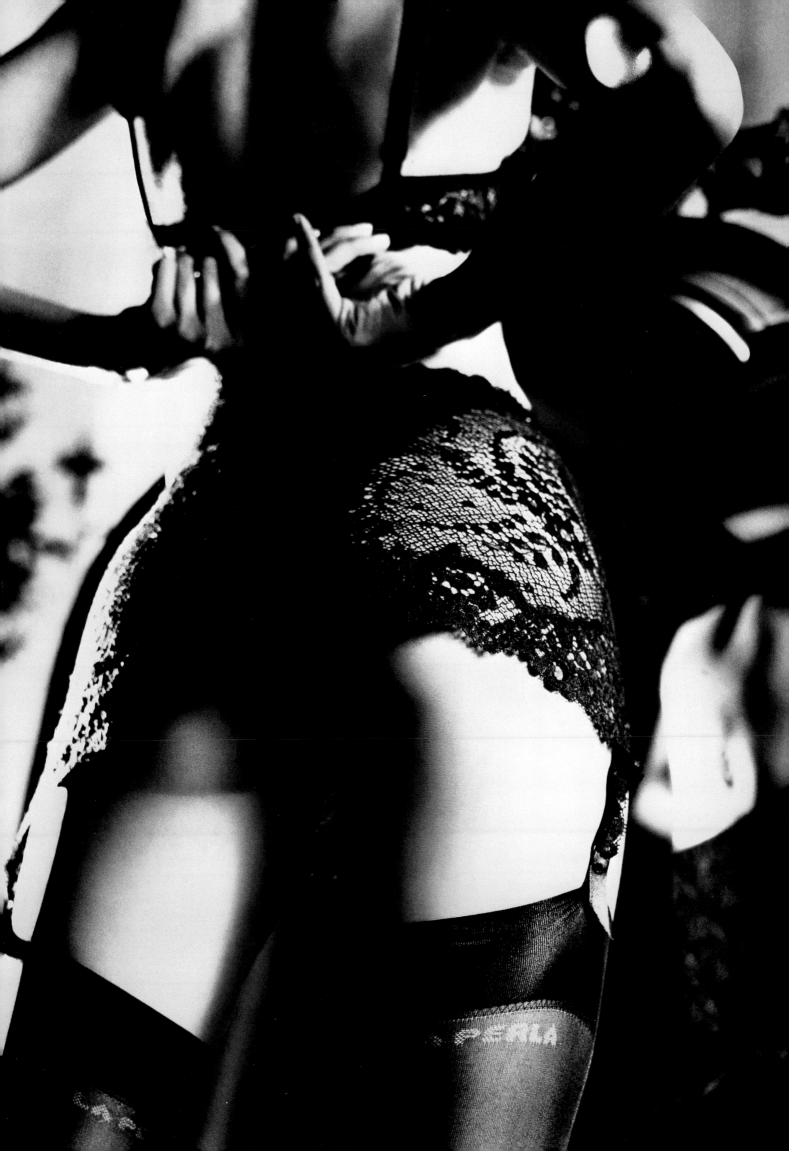

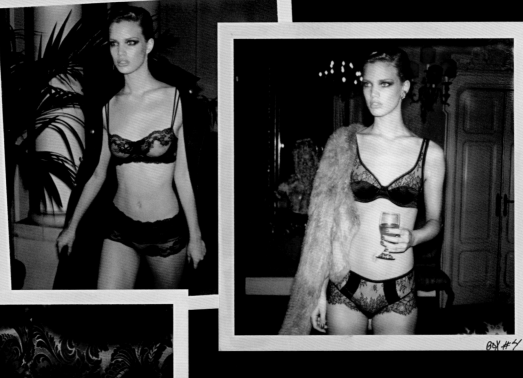

BOX #4

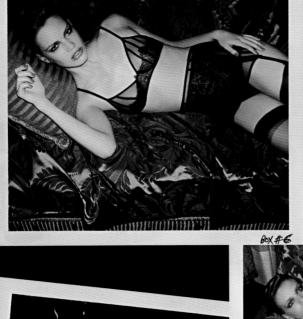

BOX #6

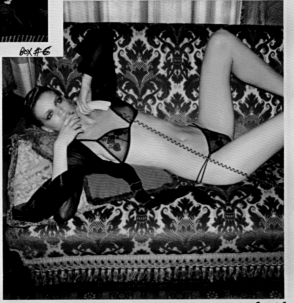

BOX #2

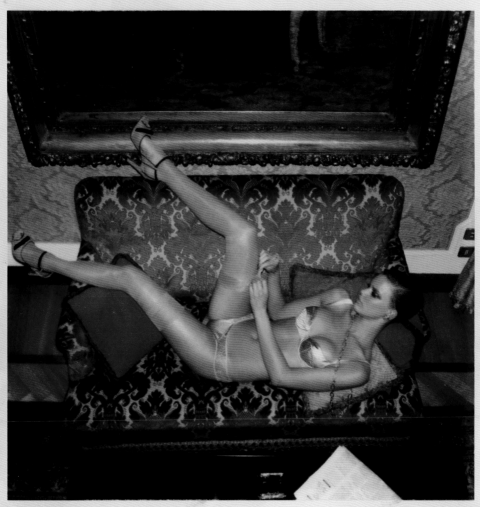

BOX #6

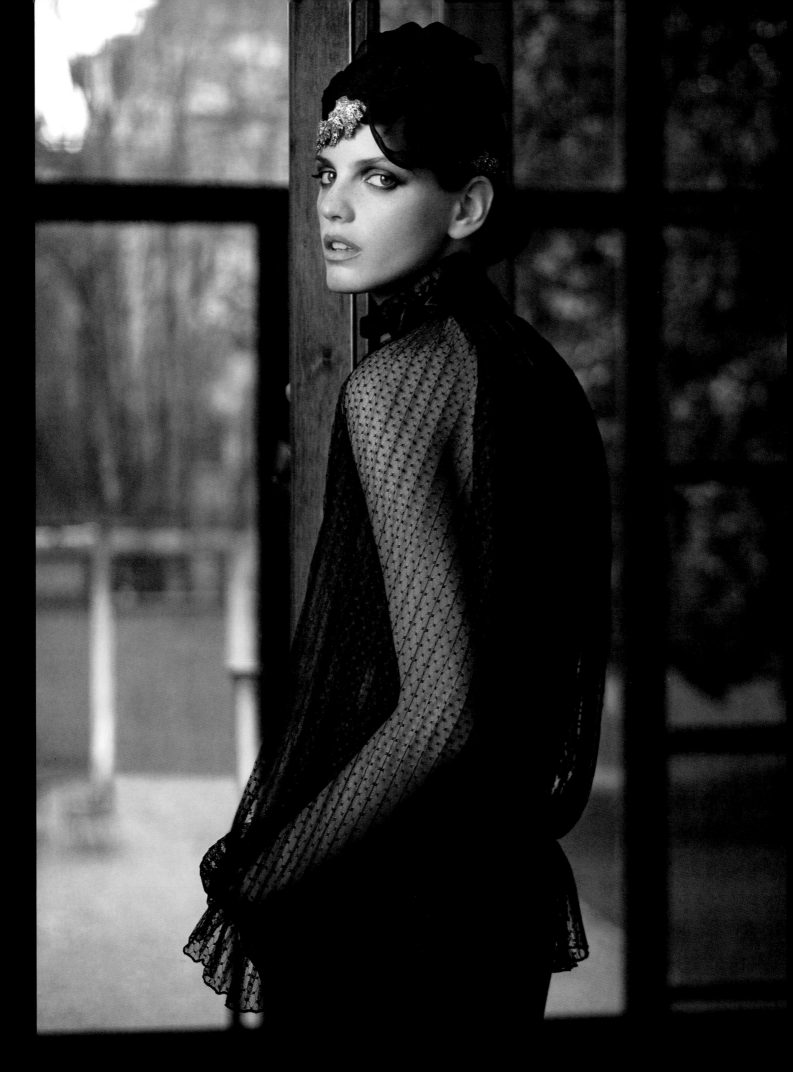

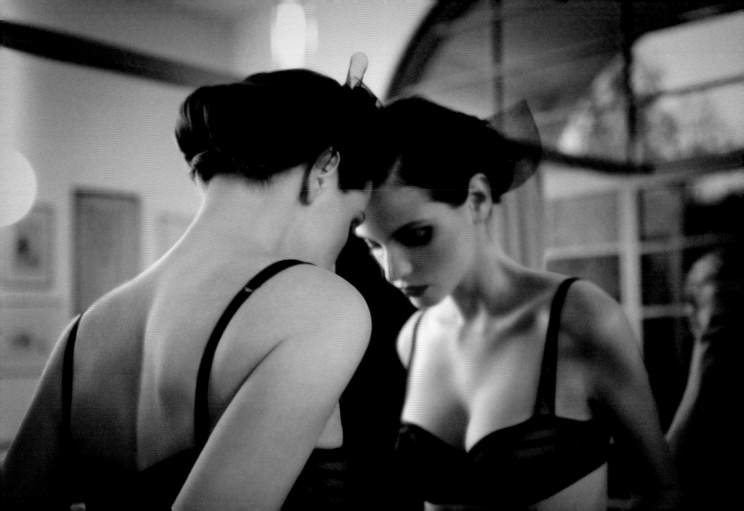

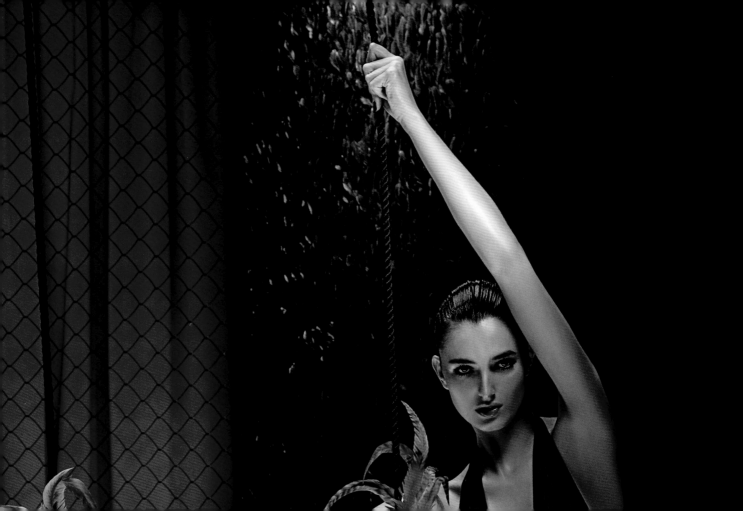

Inspiration

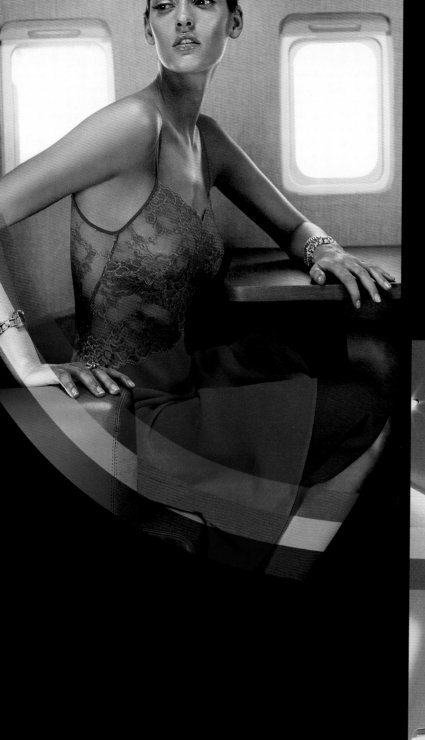

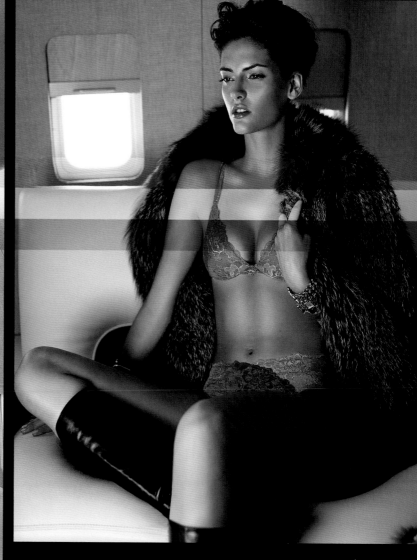

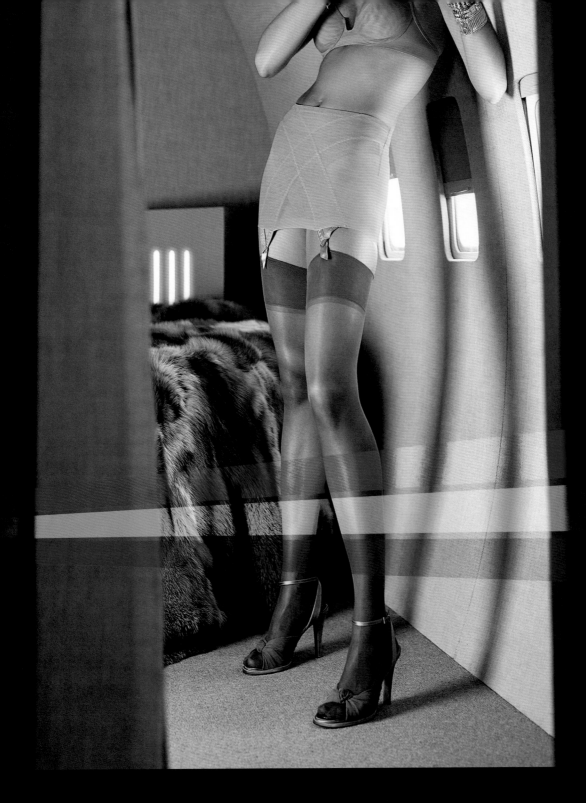

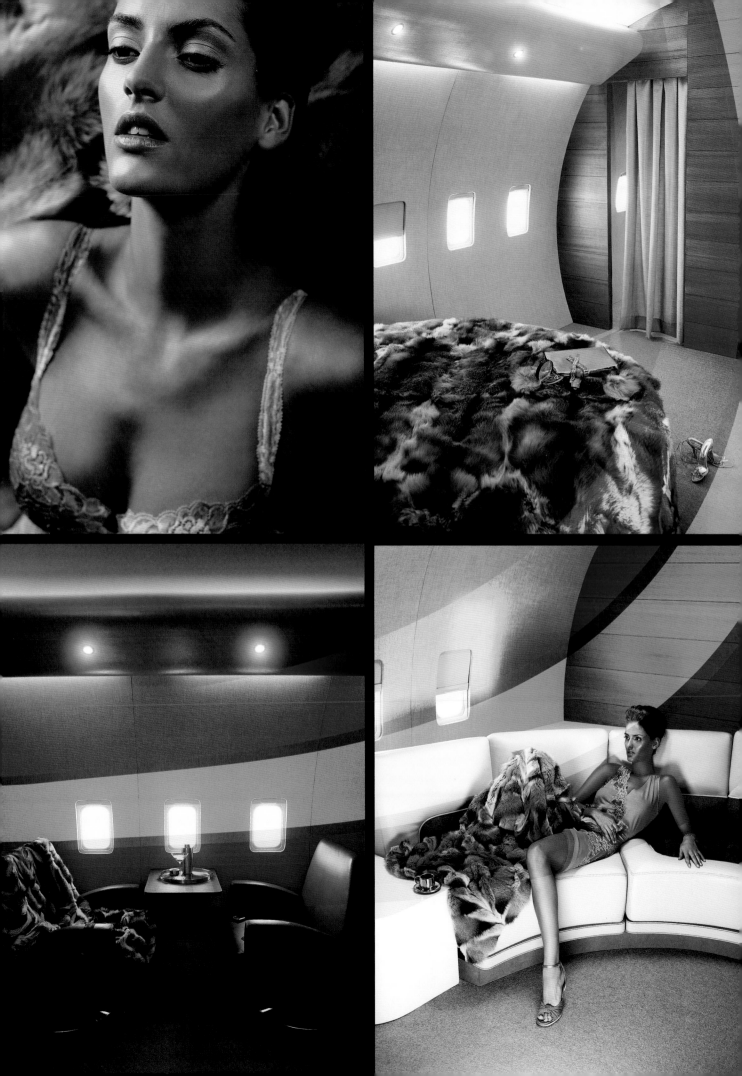

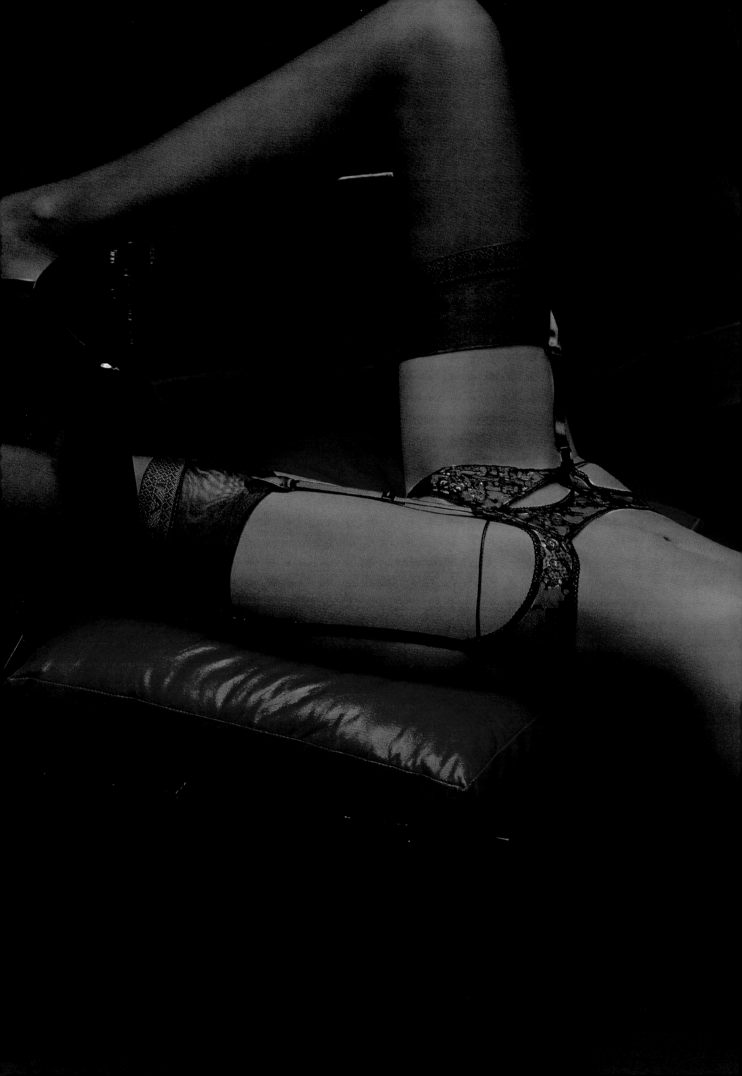

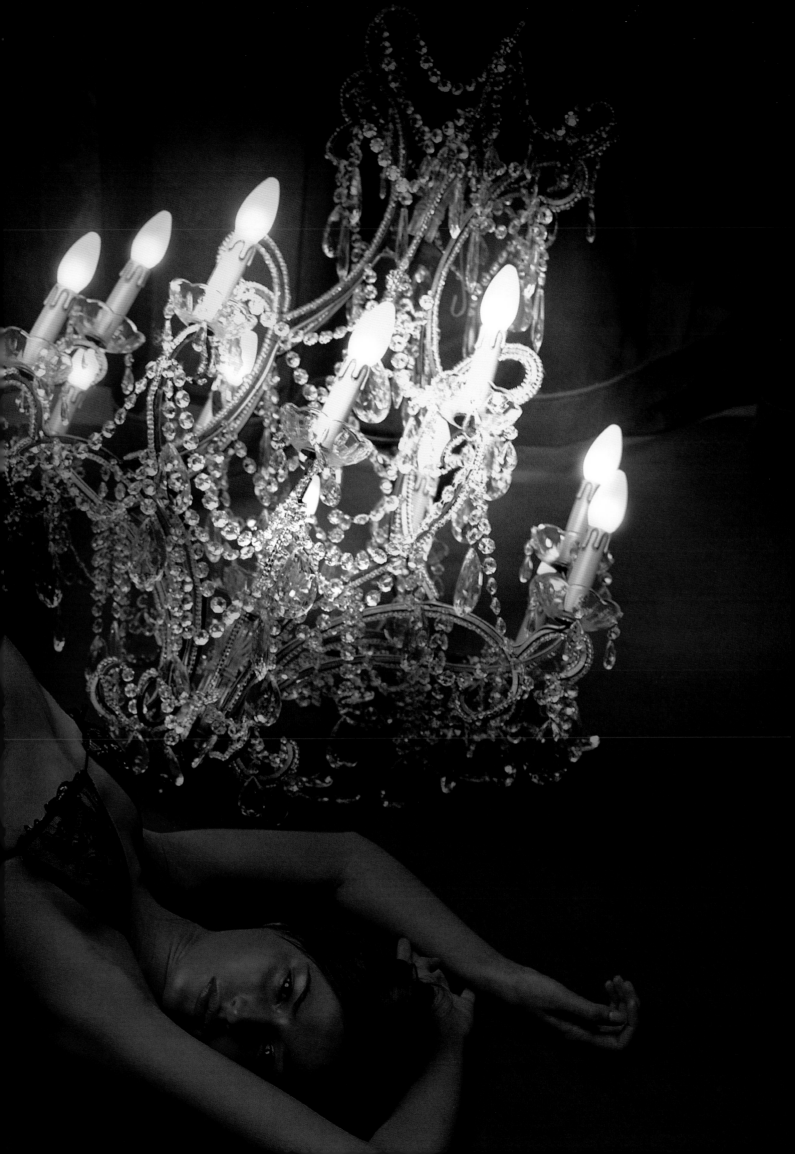

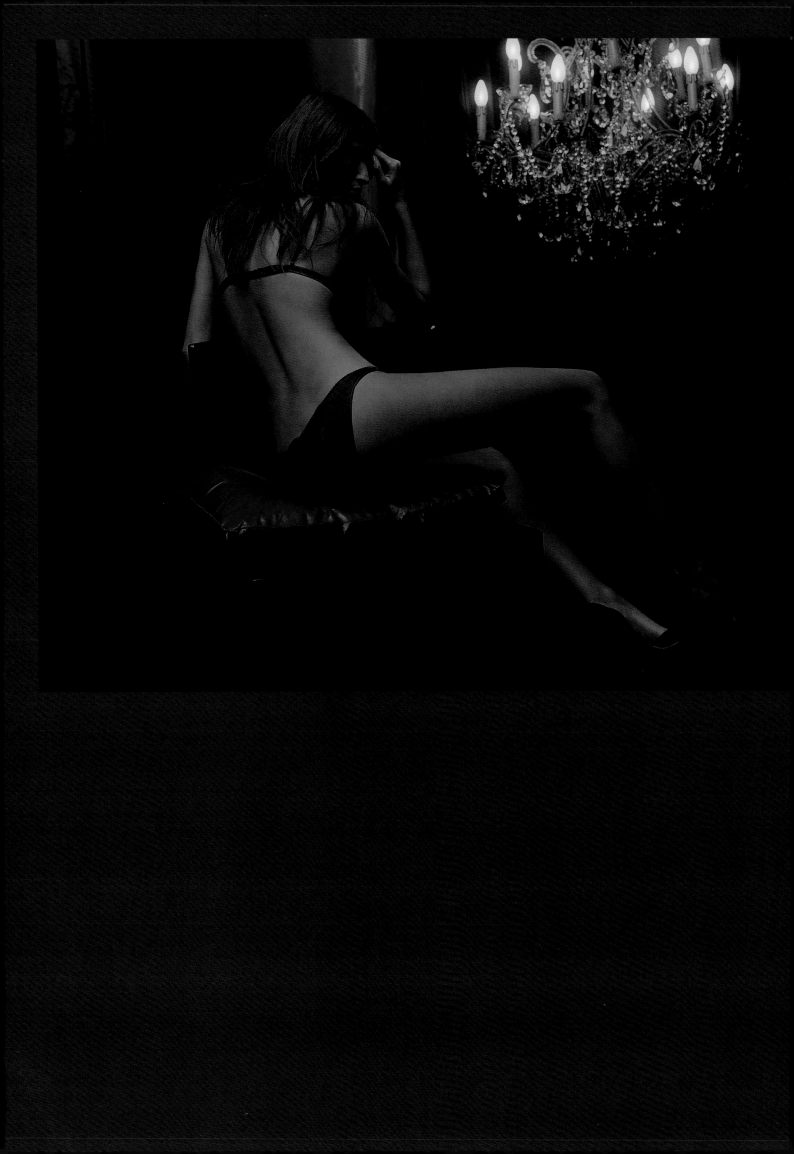

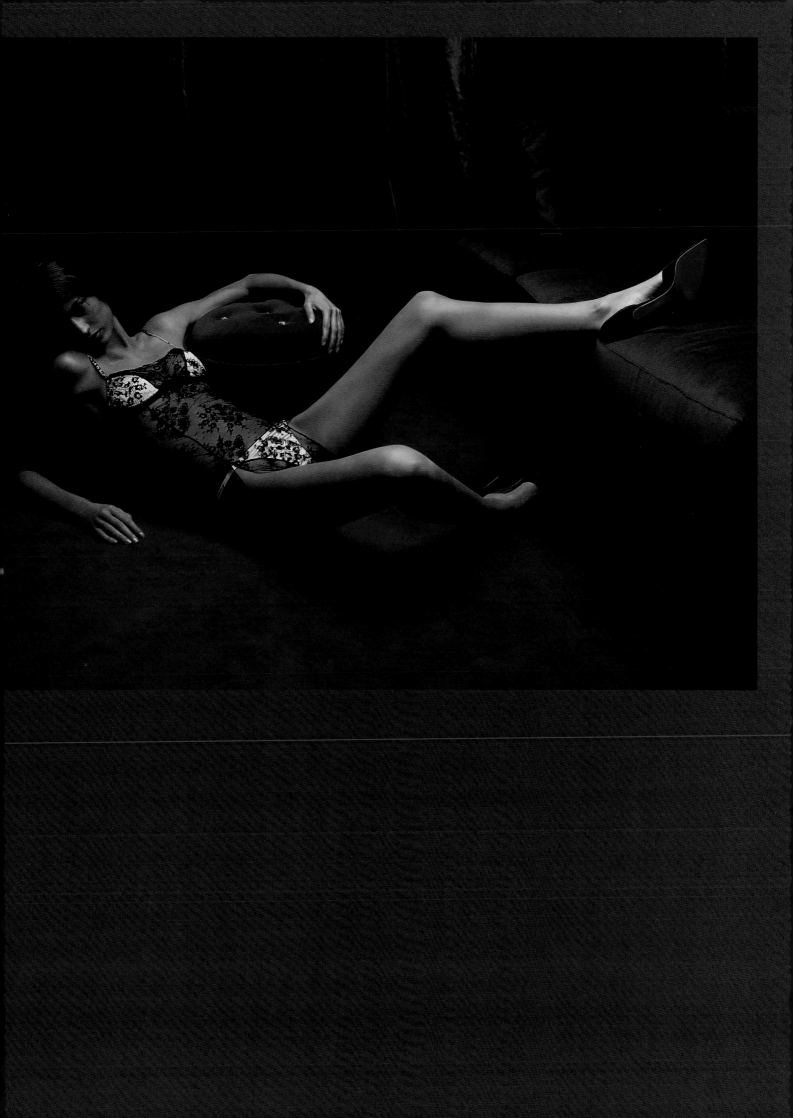

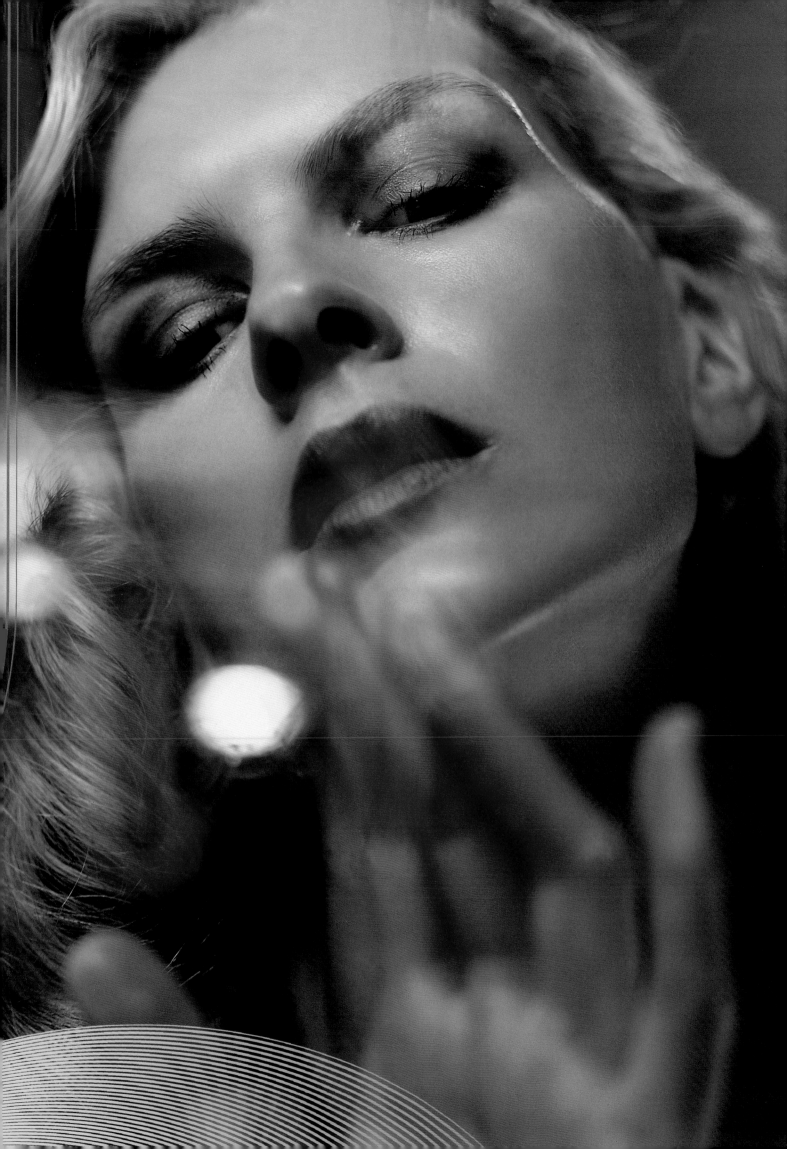

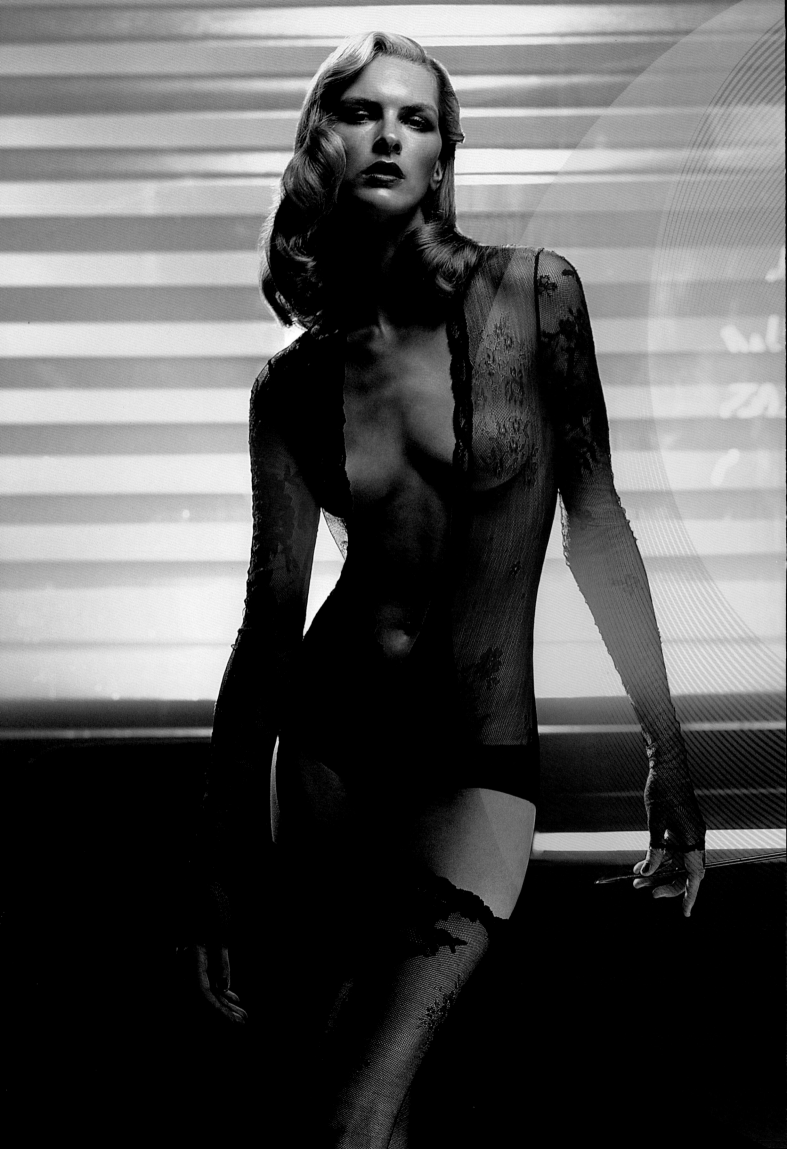

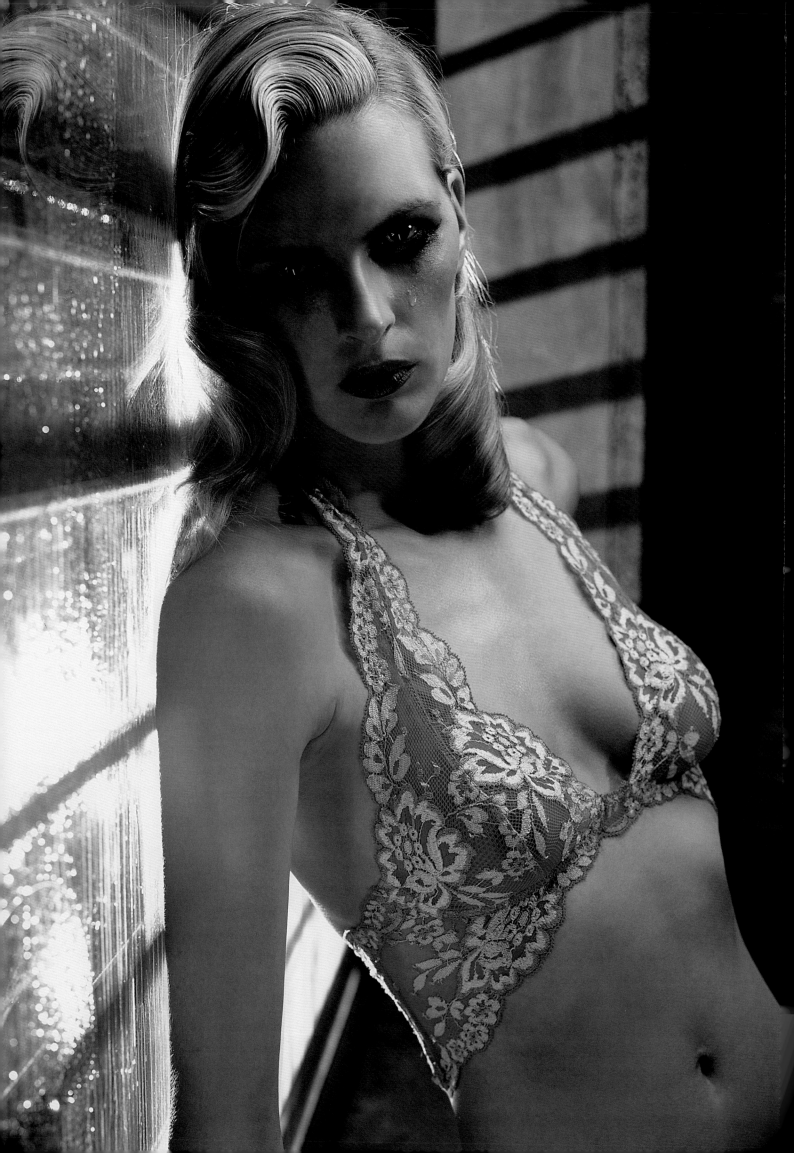

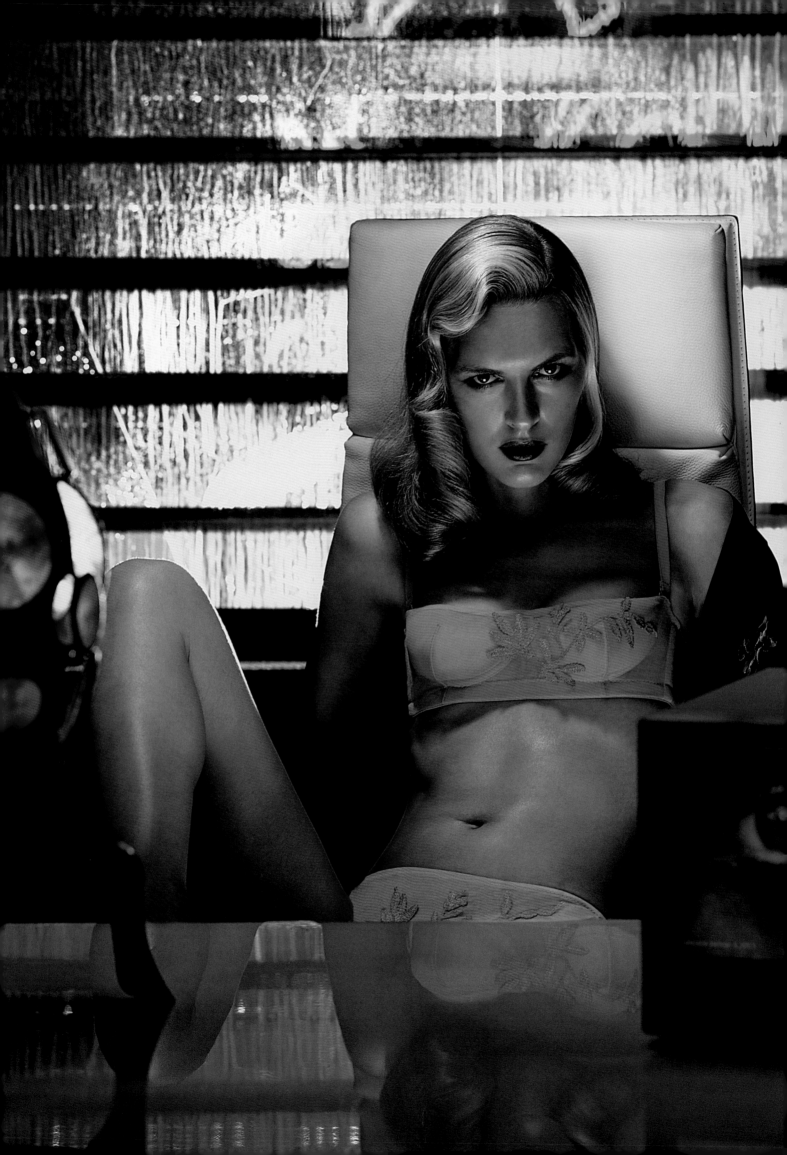

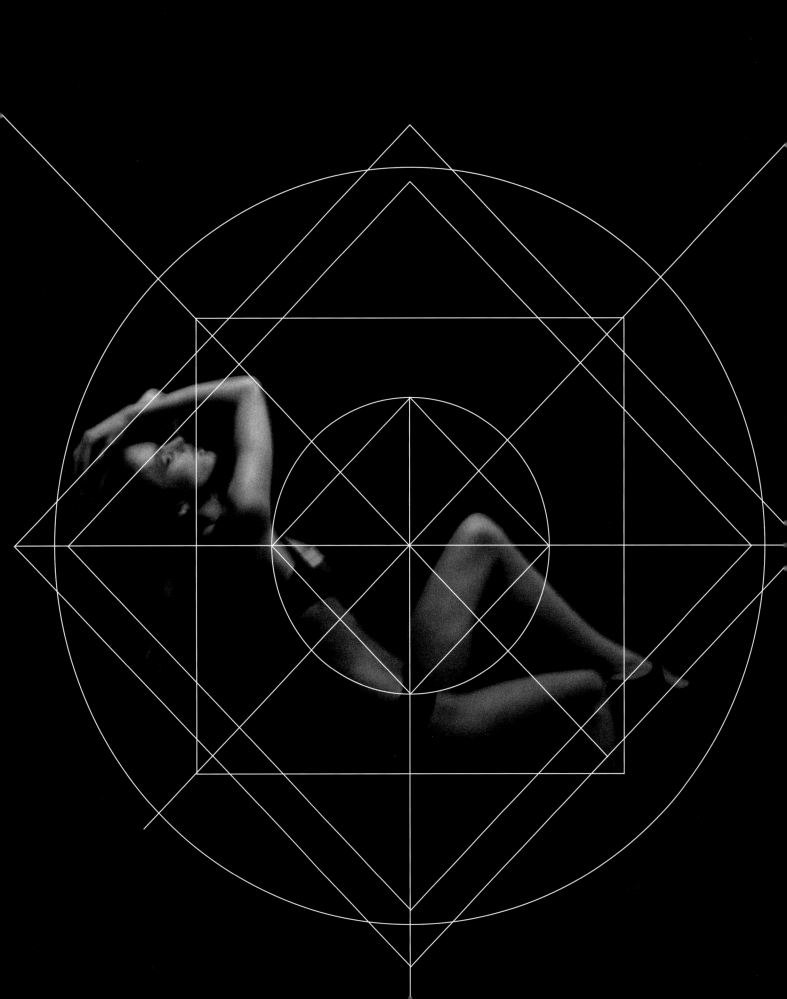

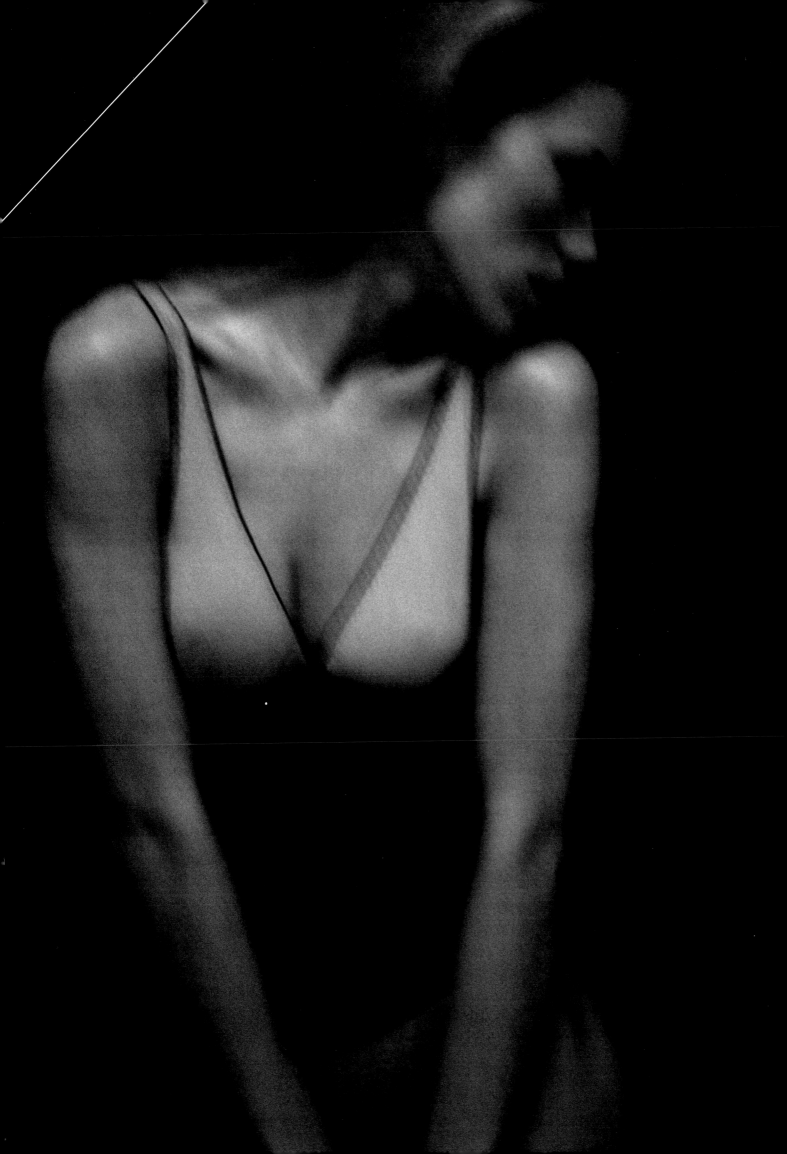

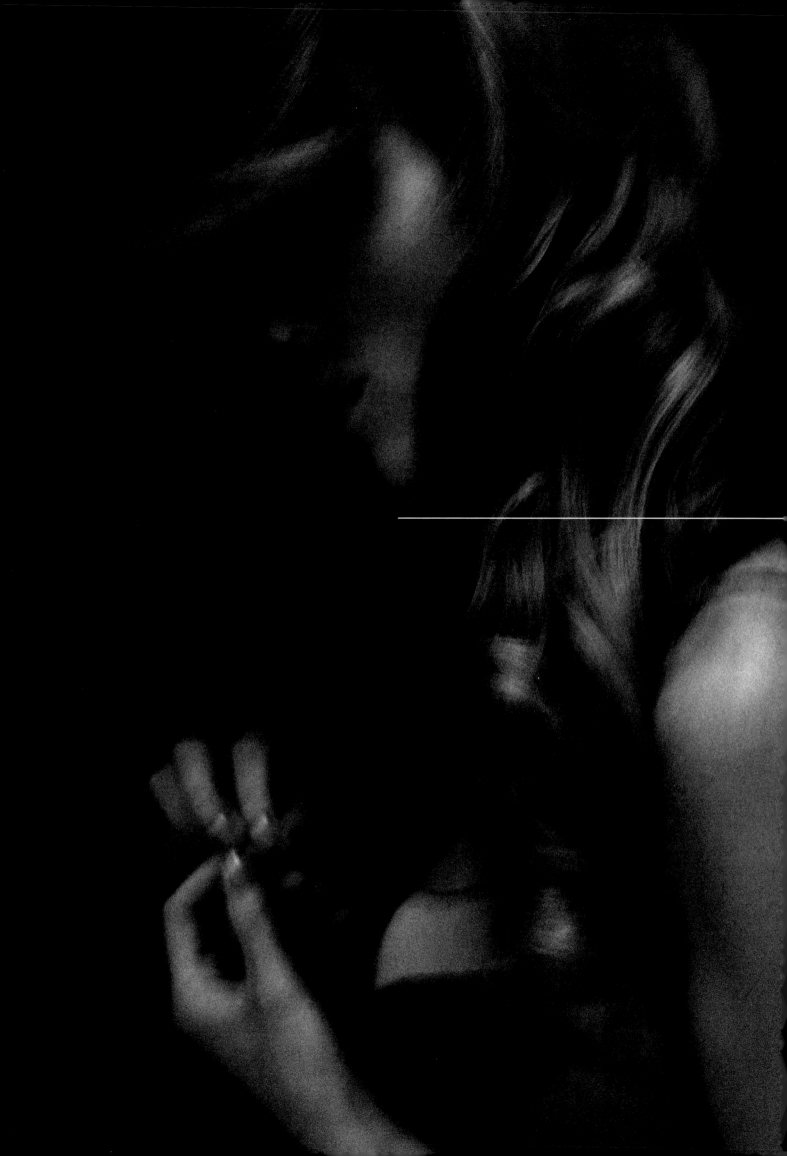

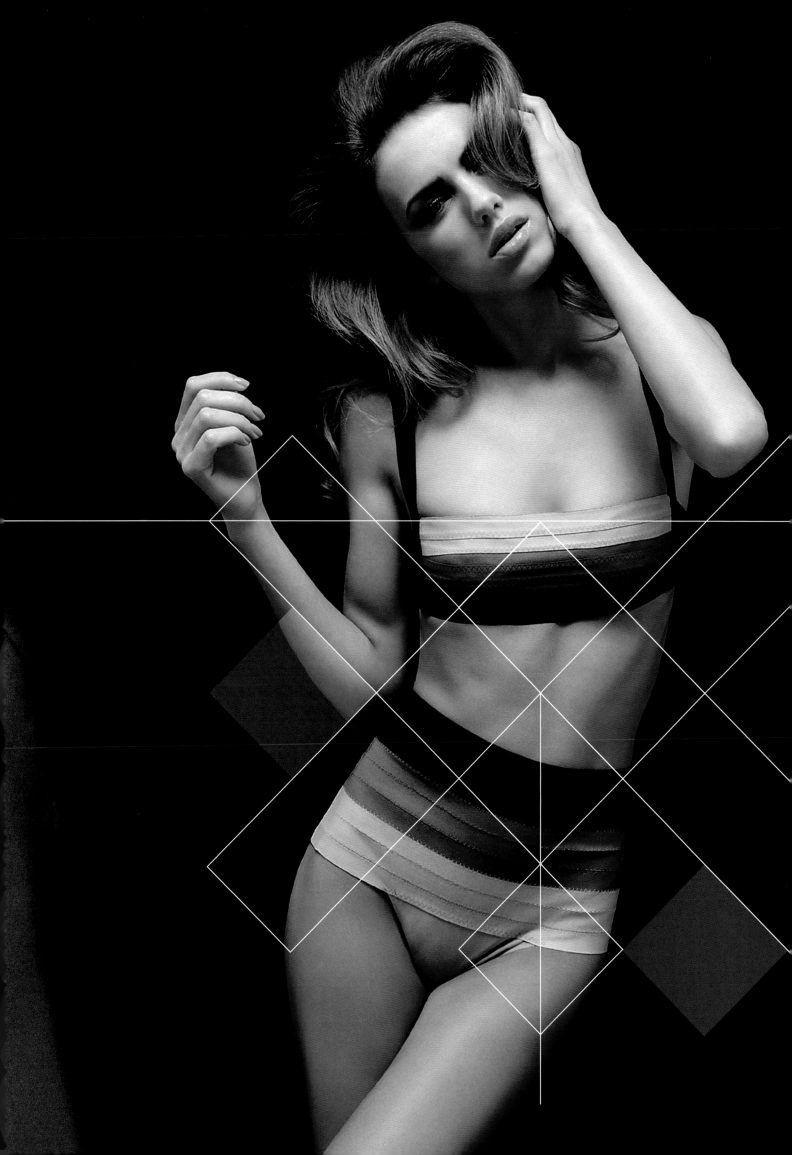

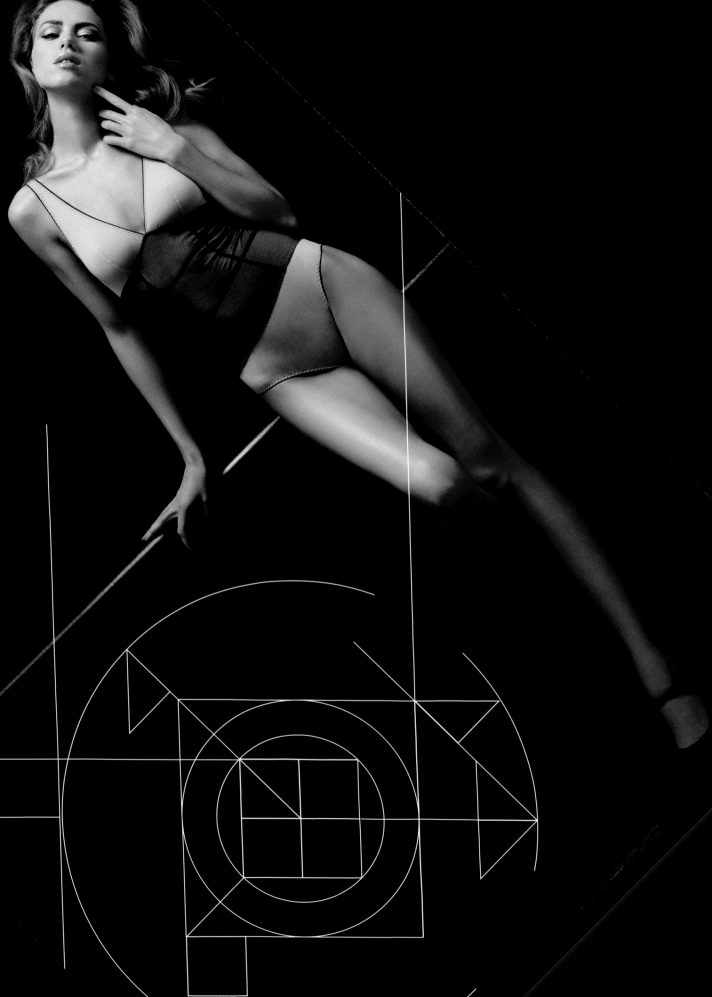

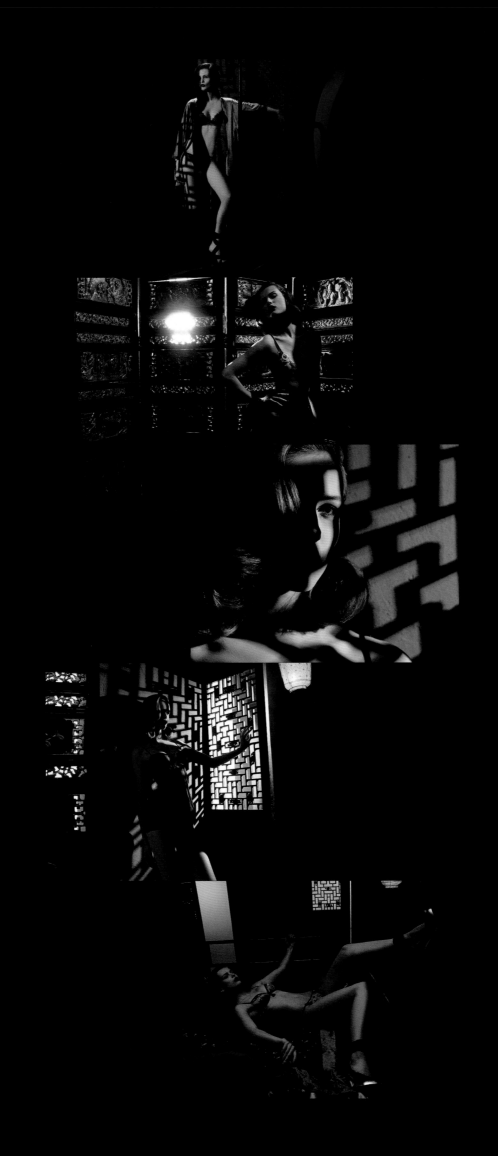

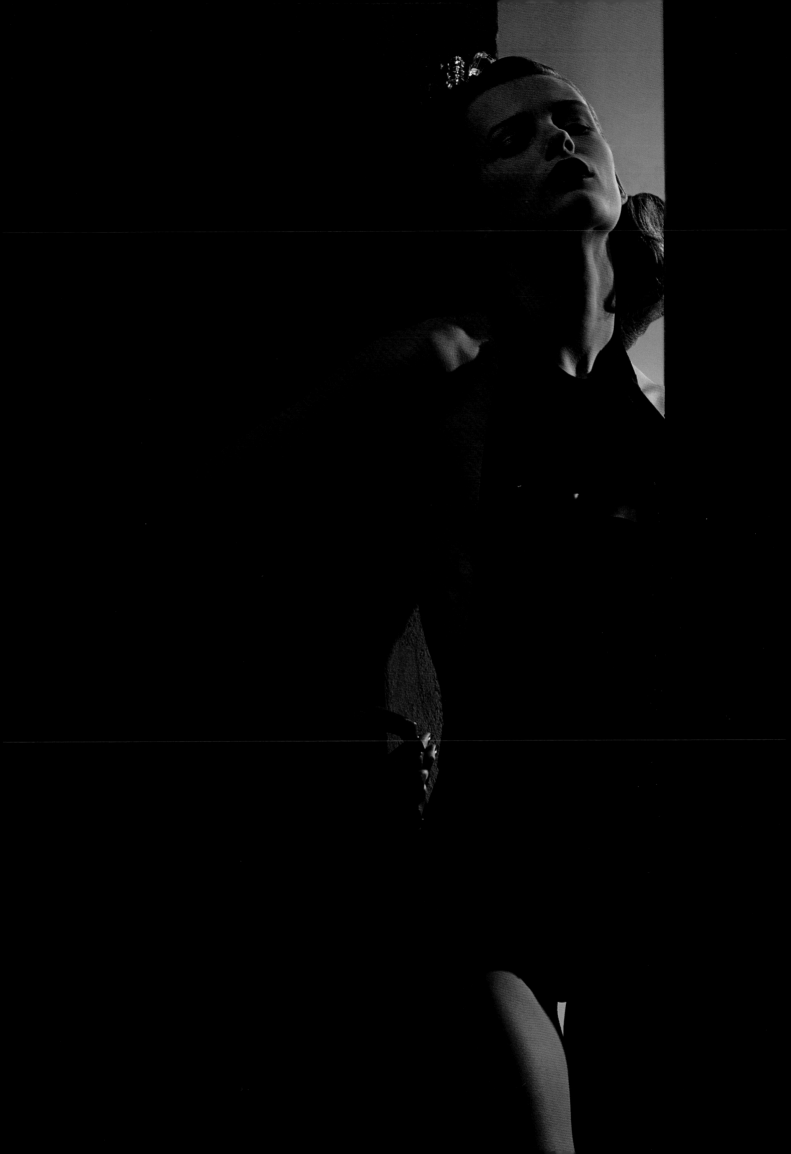

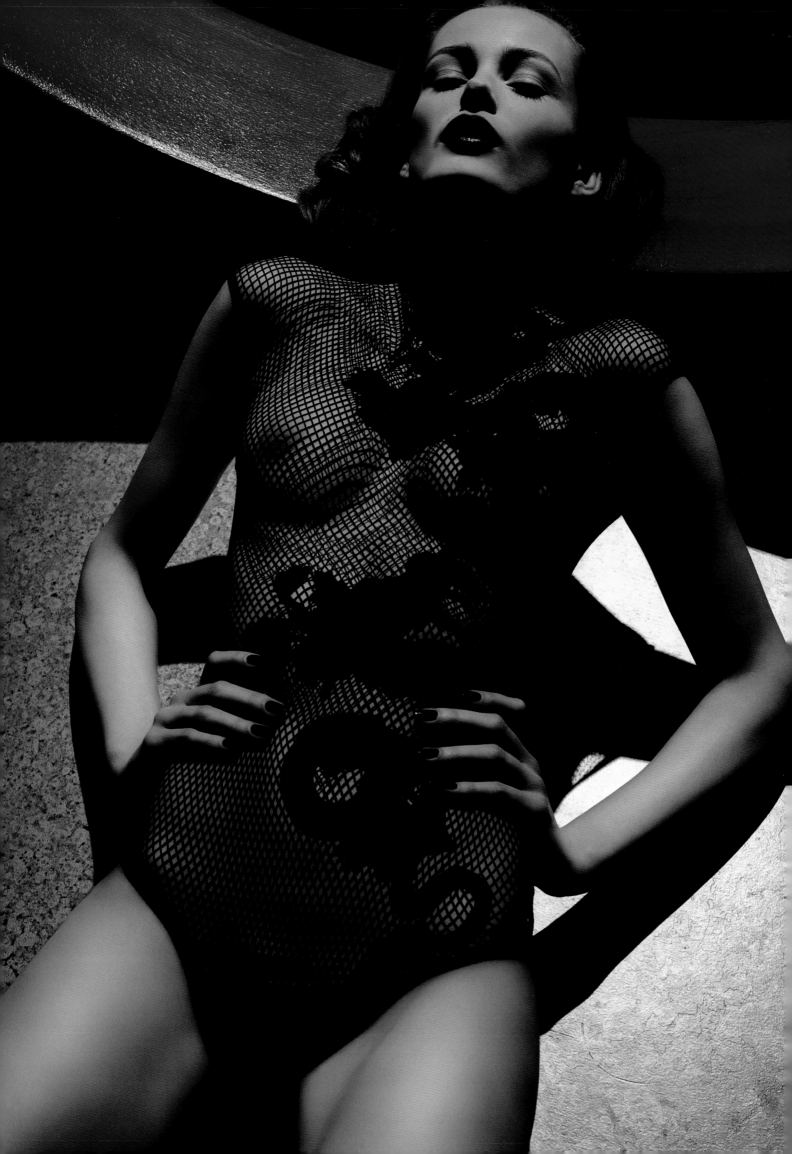

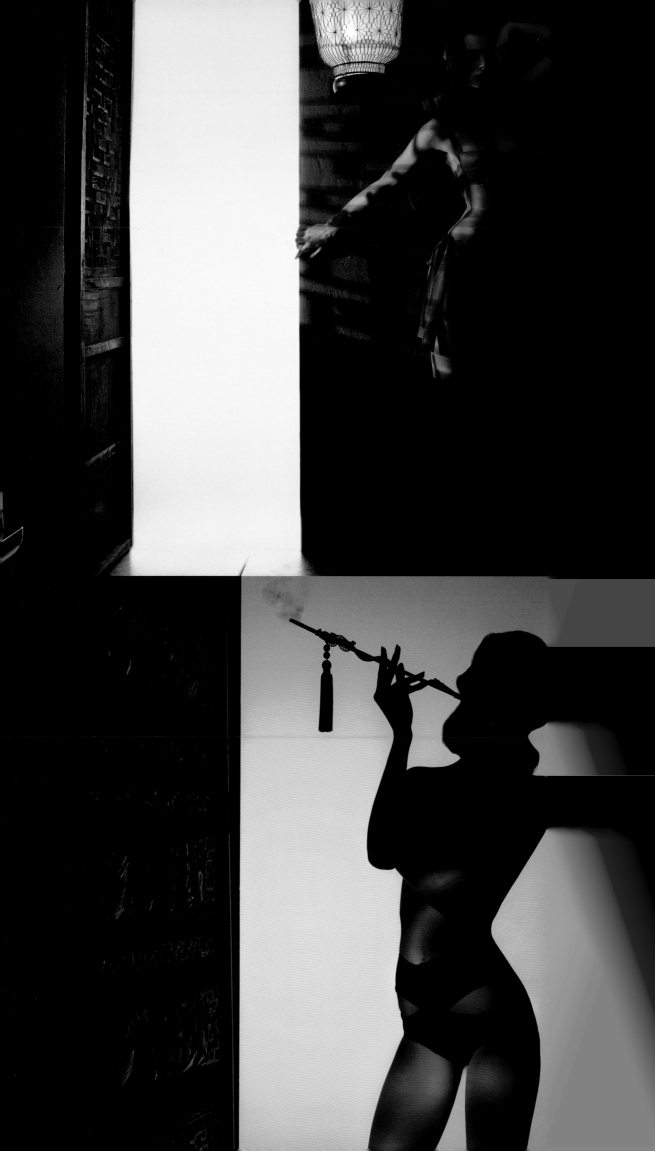

F ON A MOVIE SET
EMBEDDED IN A NOVEL,
ARROW OF TIME
CILLATES BETWEEN PAST
O FUTURE. MEMORIES,
OTES, FRAGMENTS
THE COLLECTIVE
GINATION TELL ONE
A THOUSAND TALES.
KES A MERE SPARK TO
BARK ON THE JOURNEY.

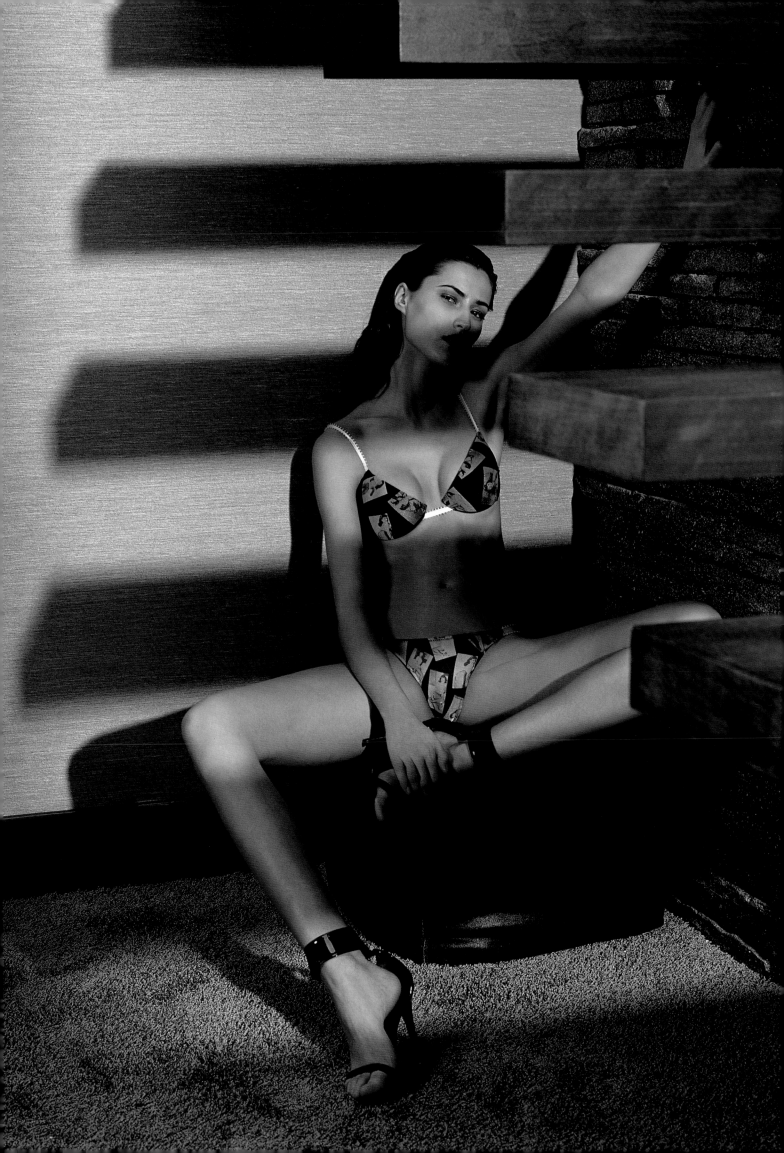

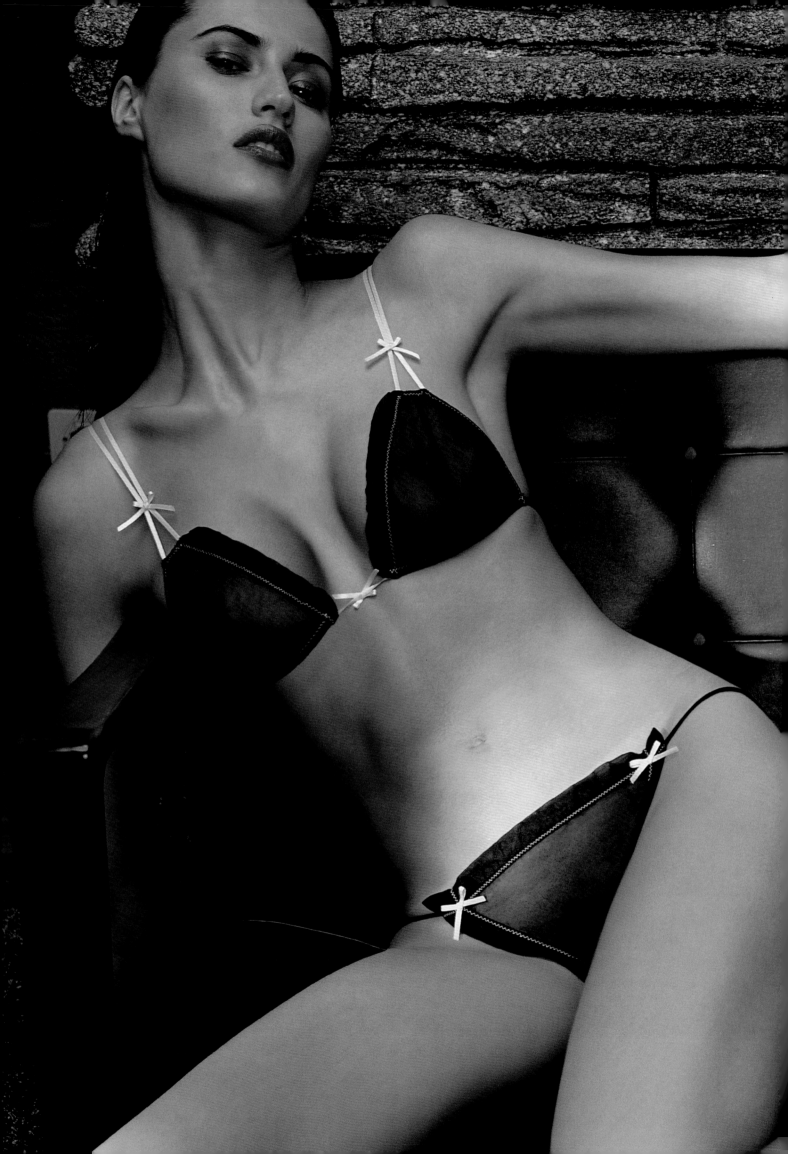

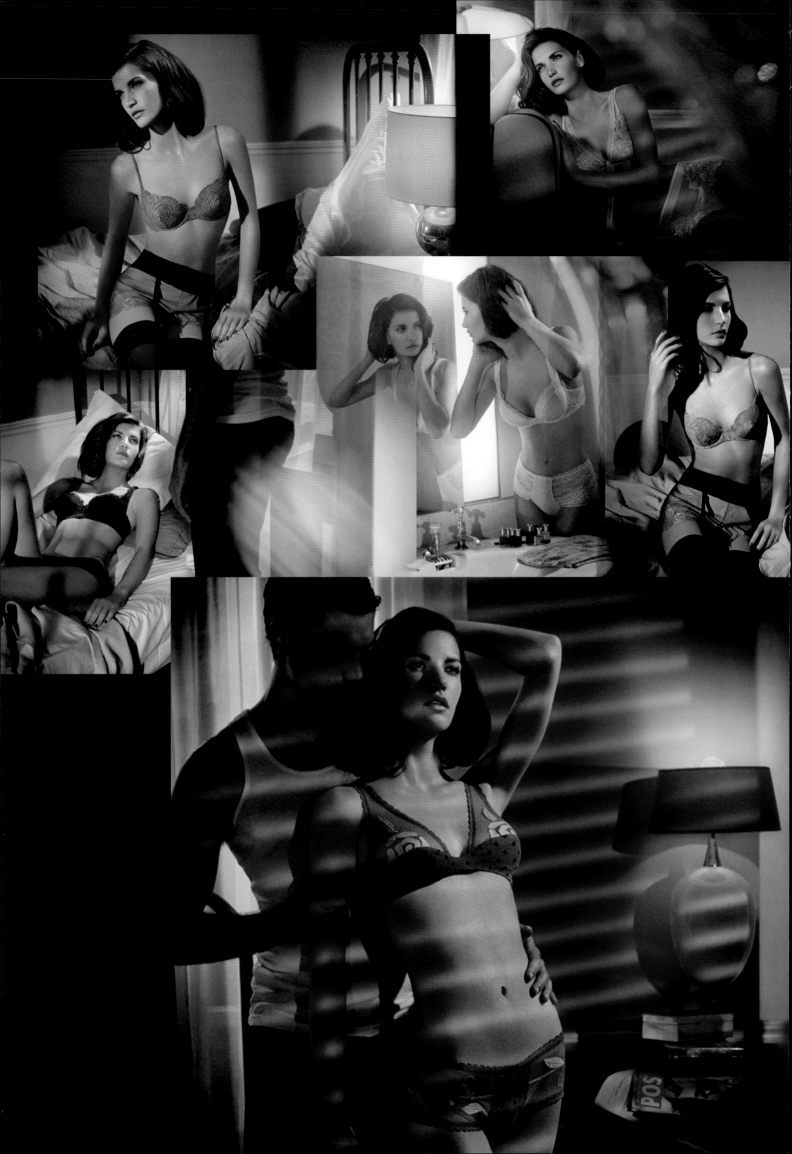

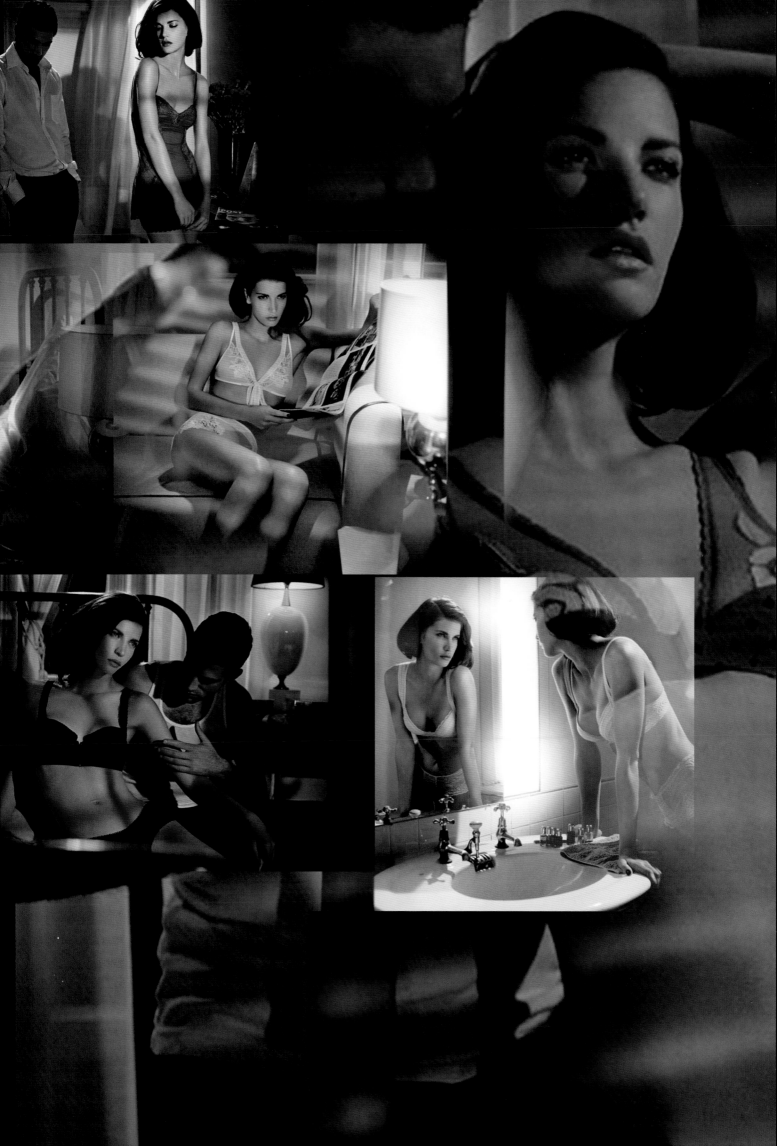

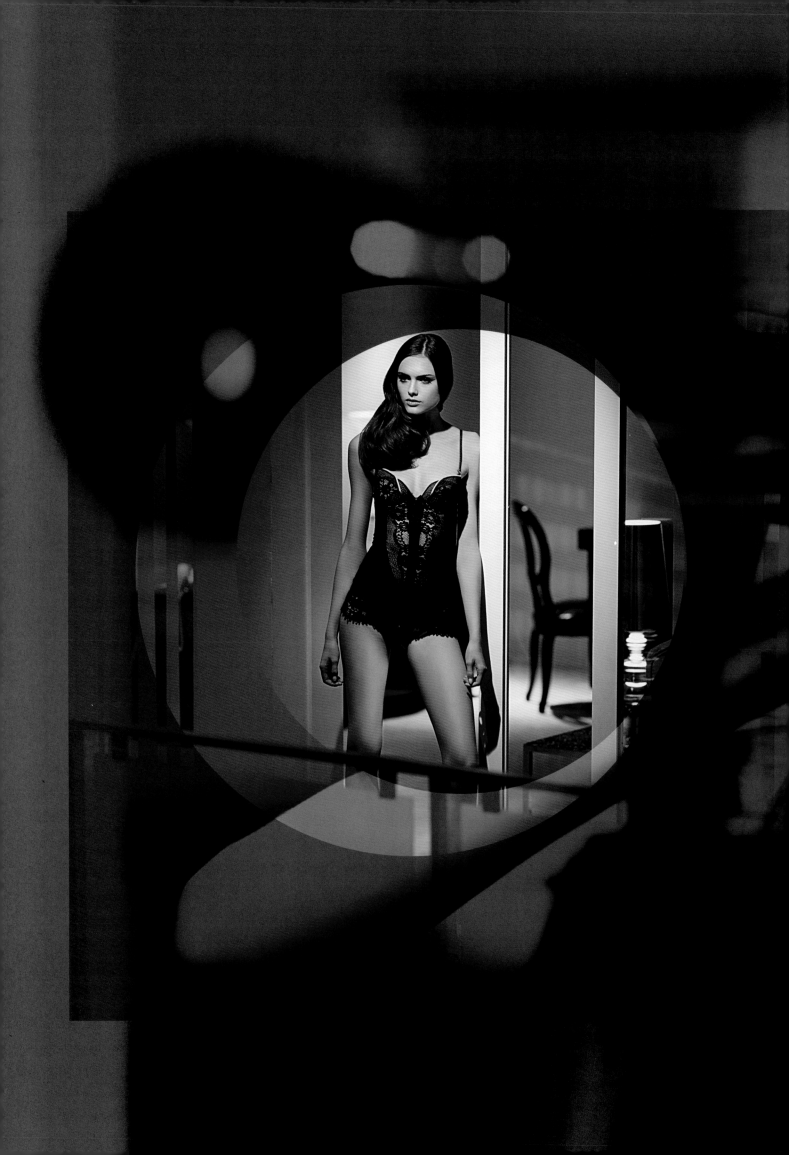

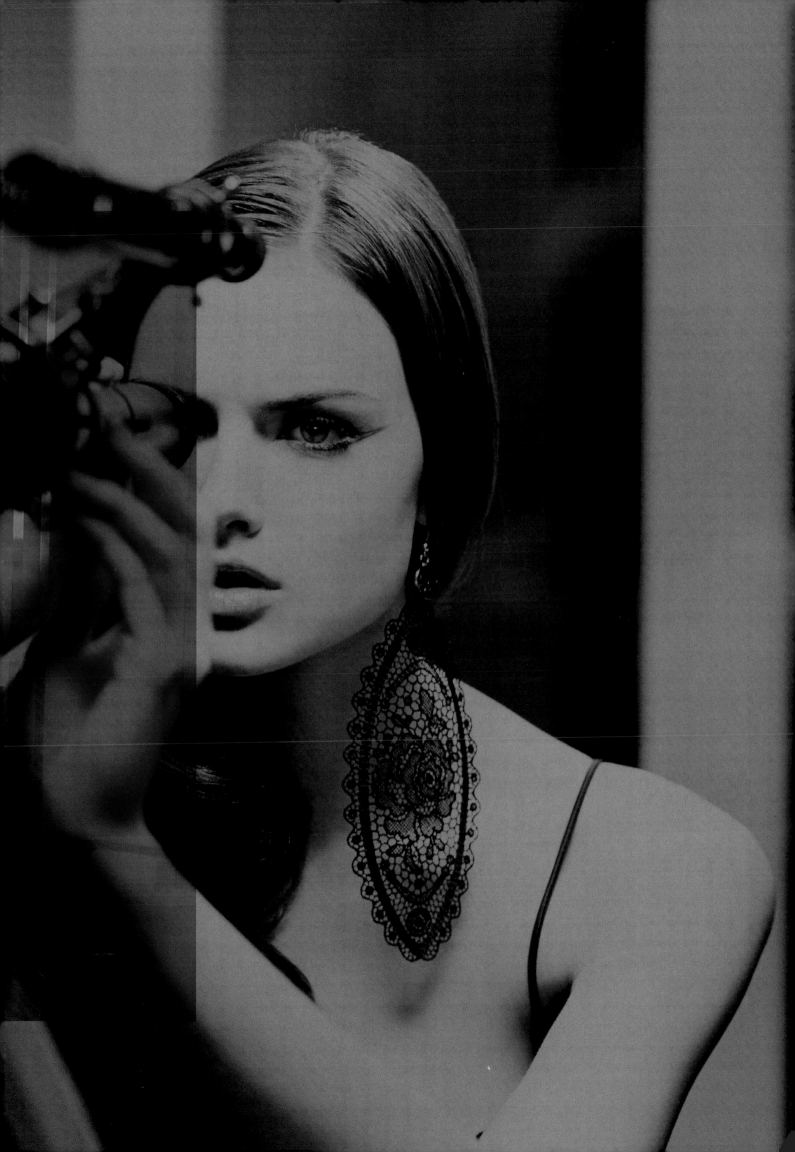

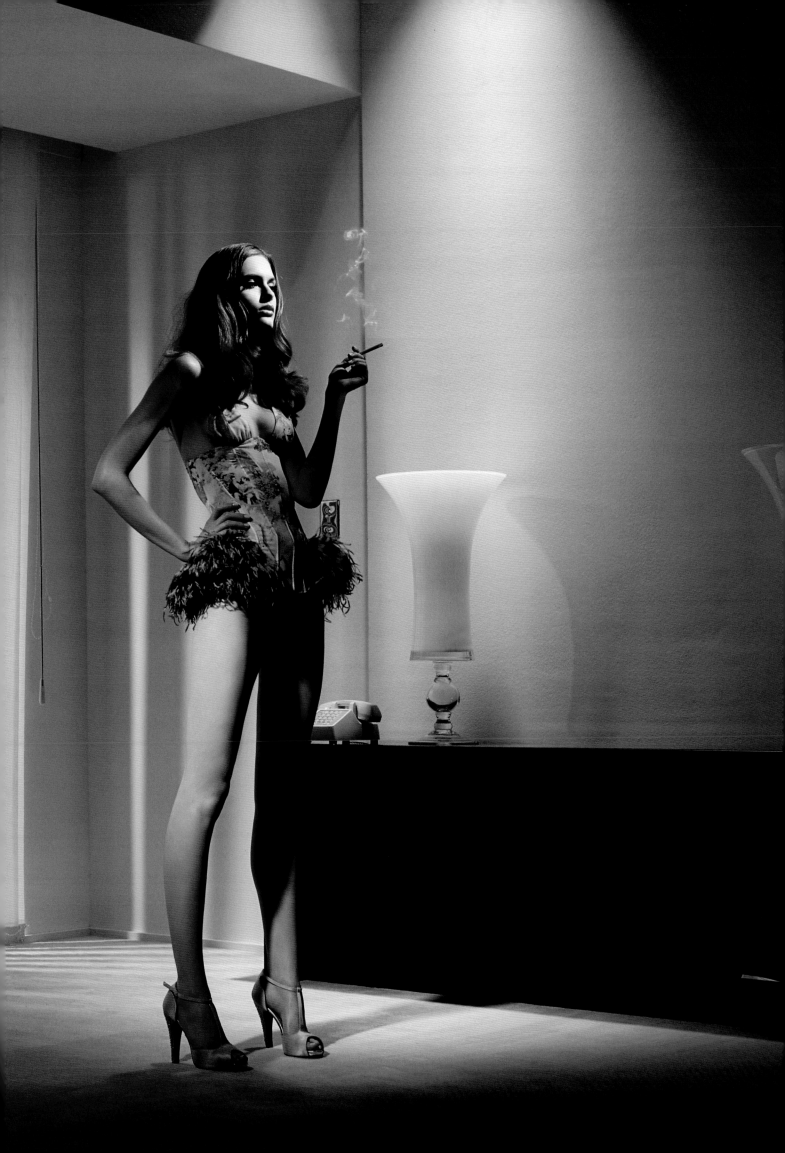

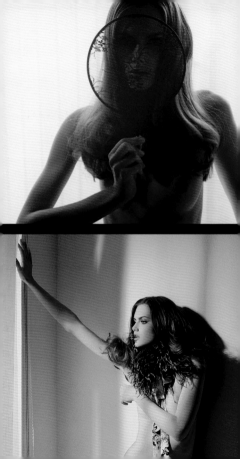

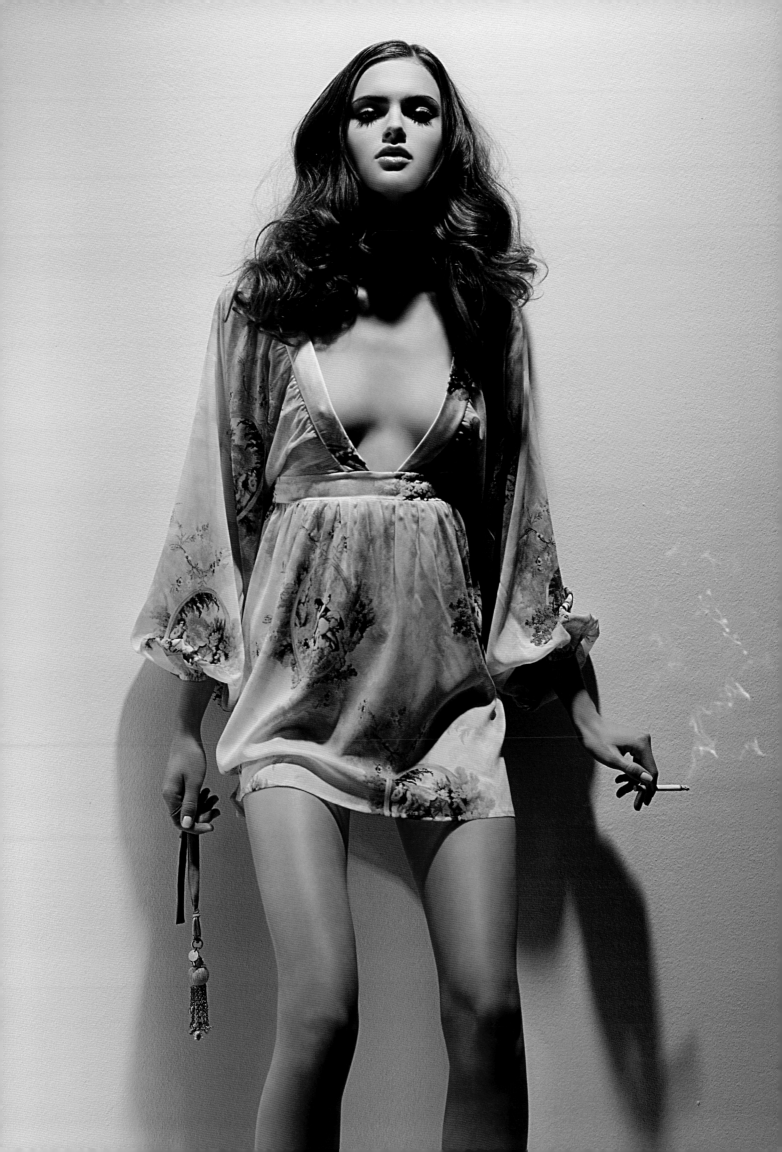

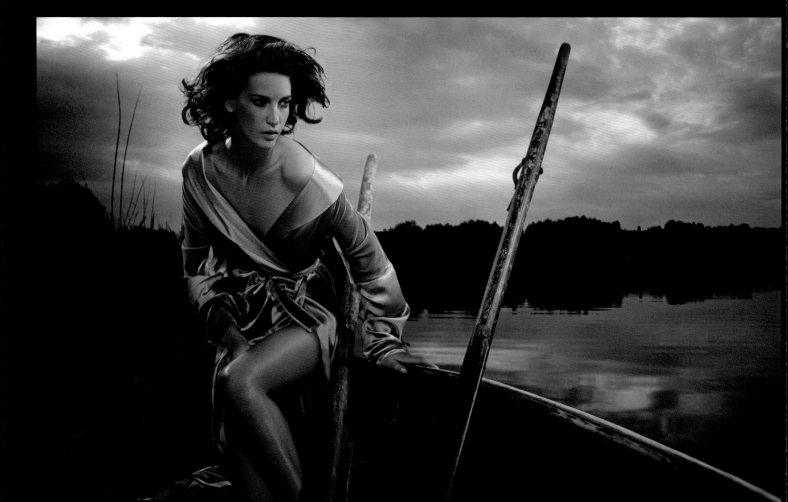

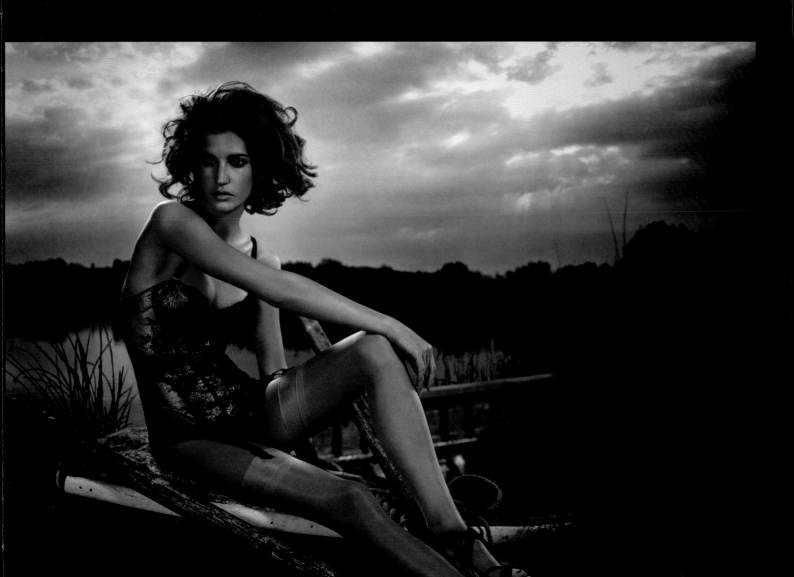

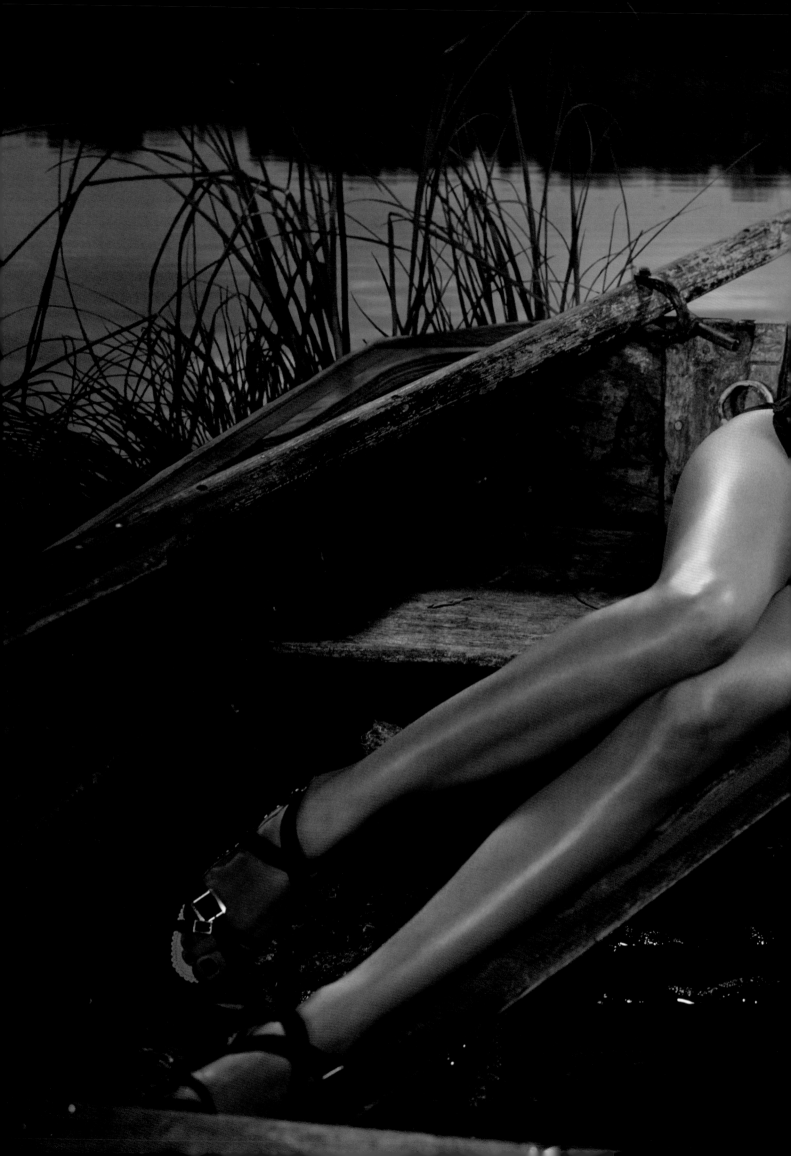

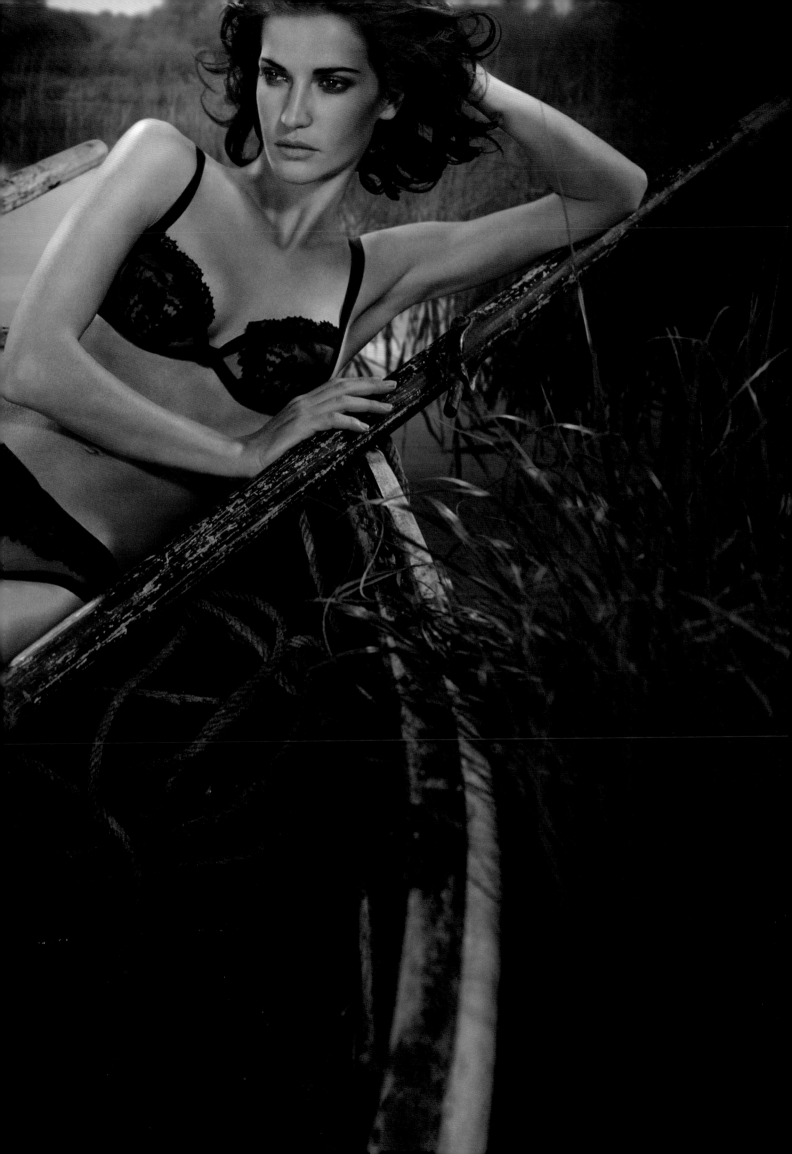

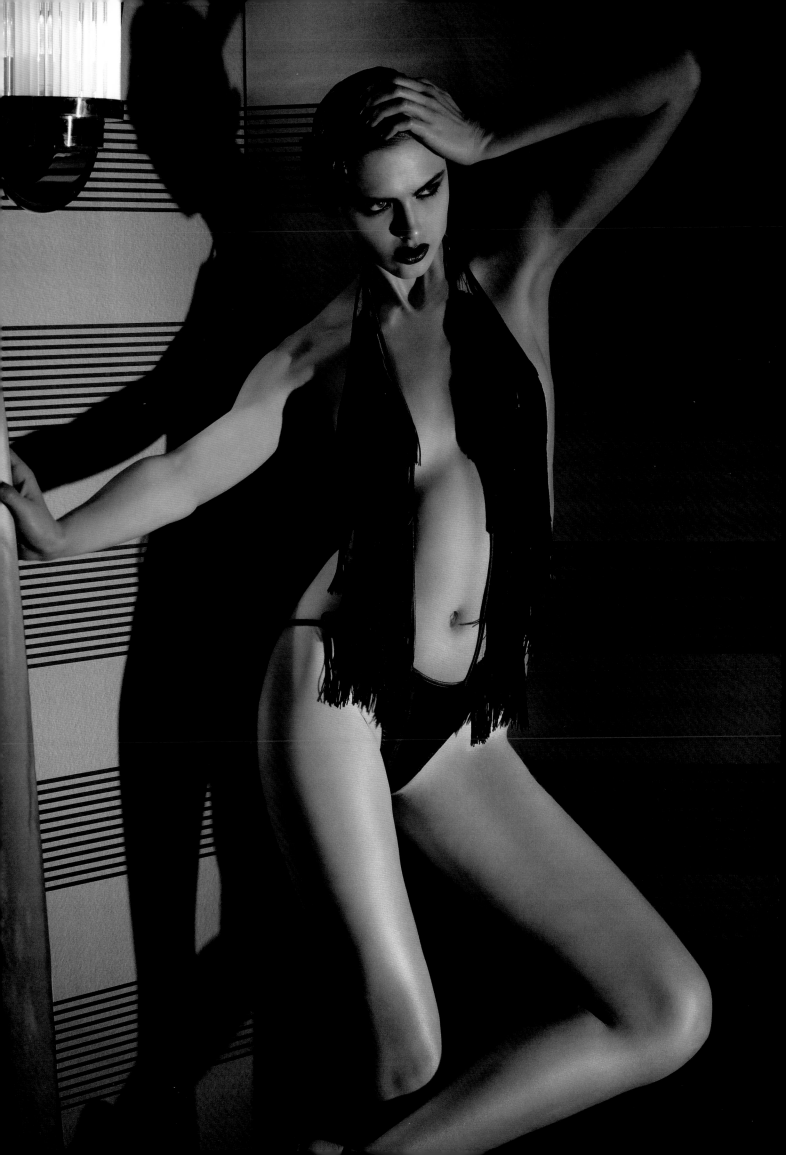

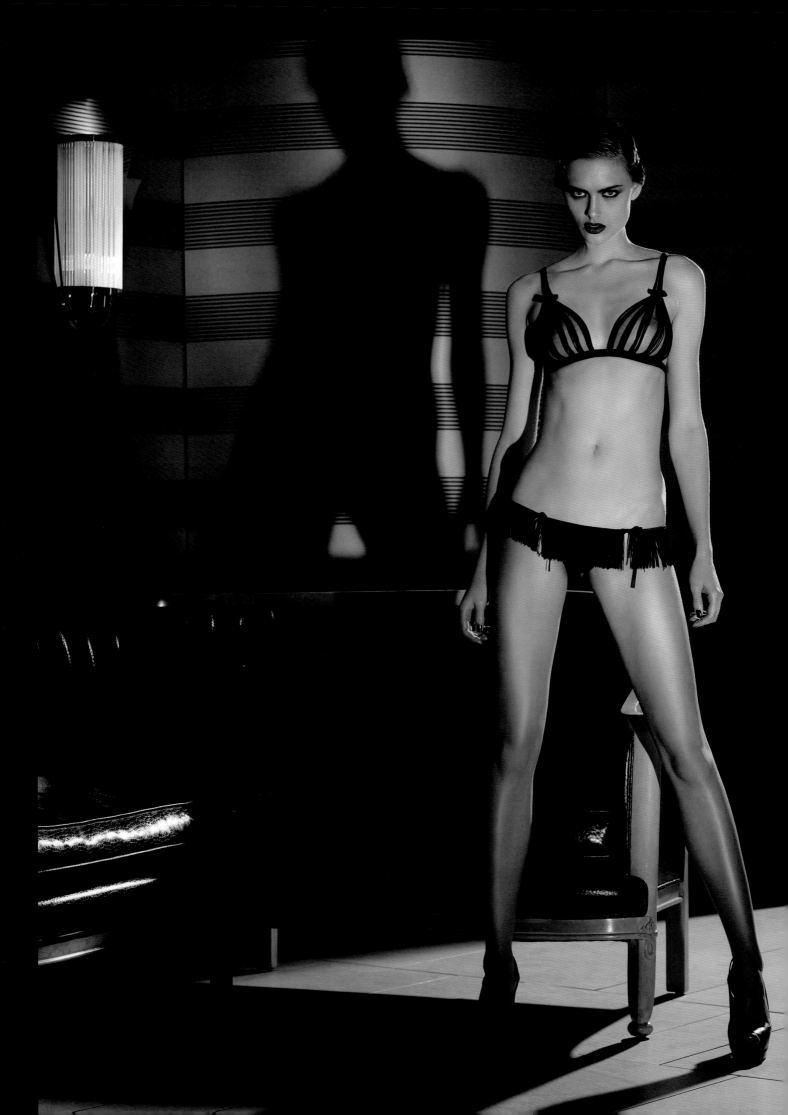

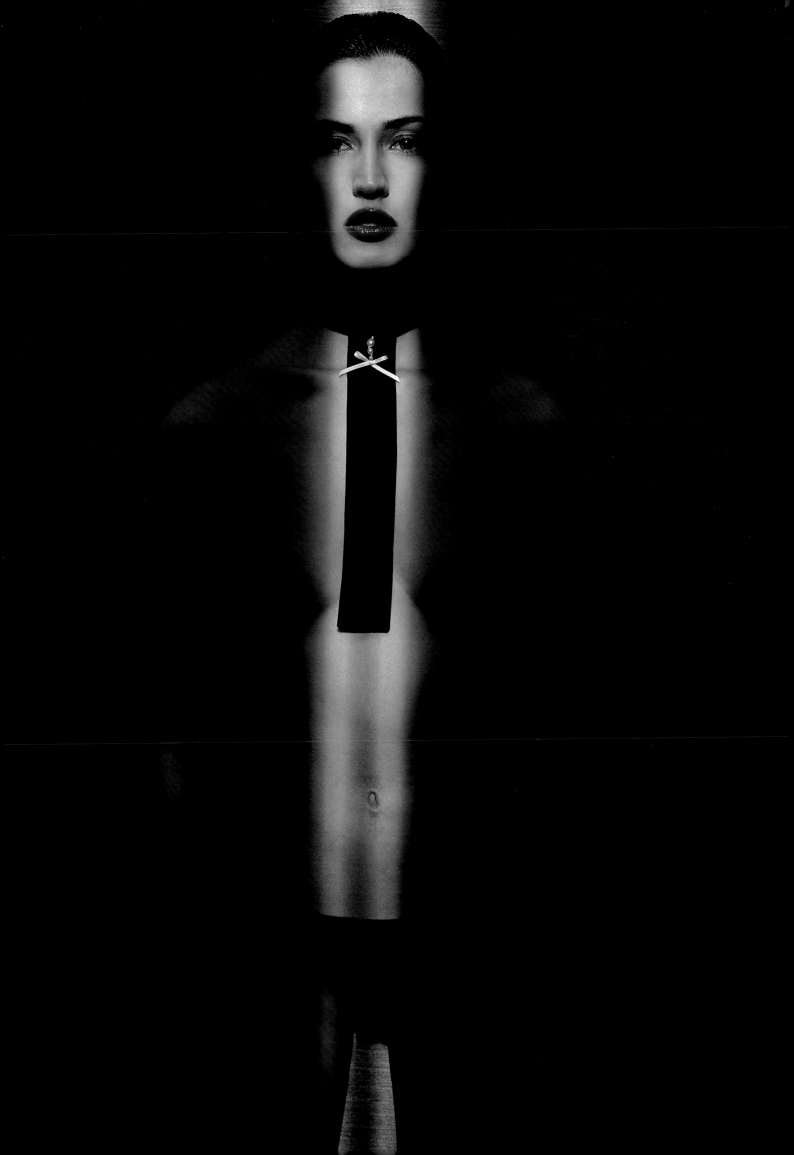

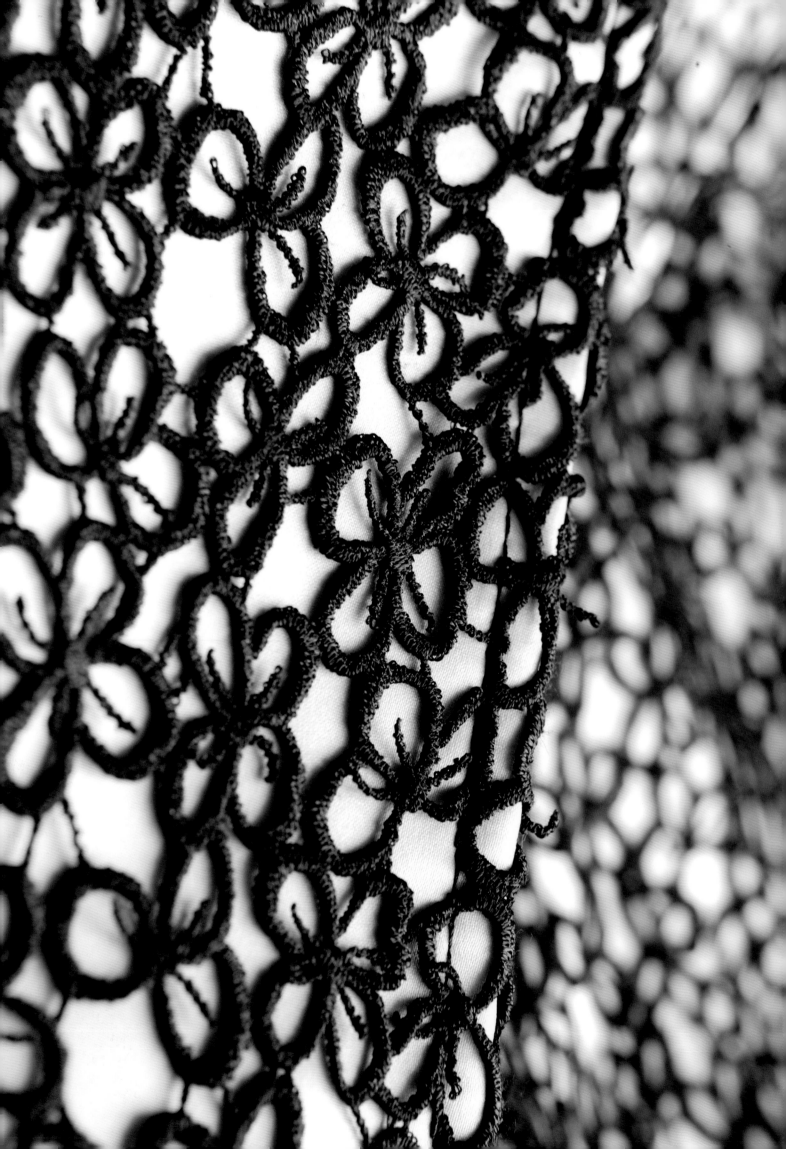

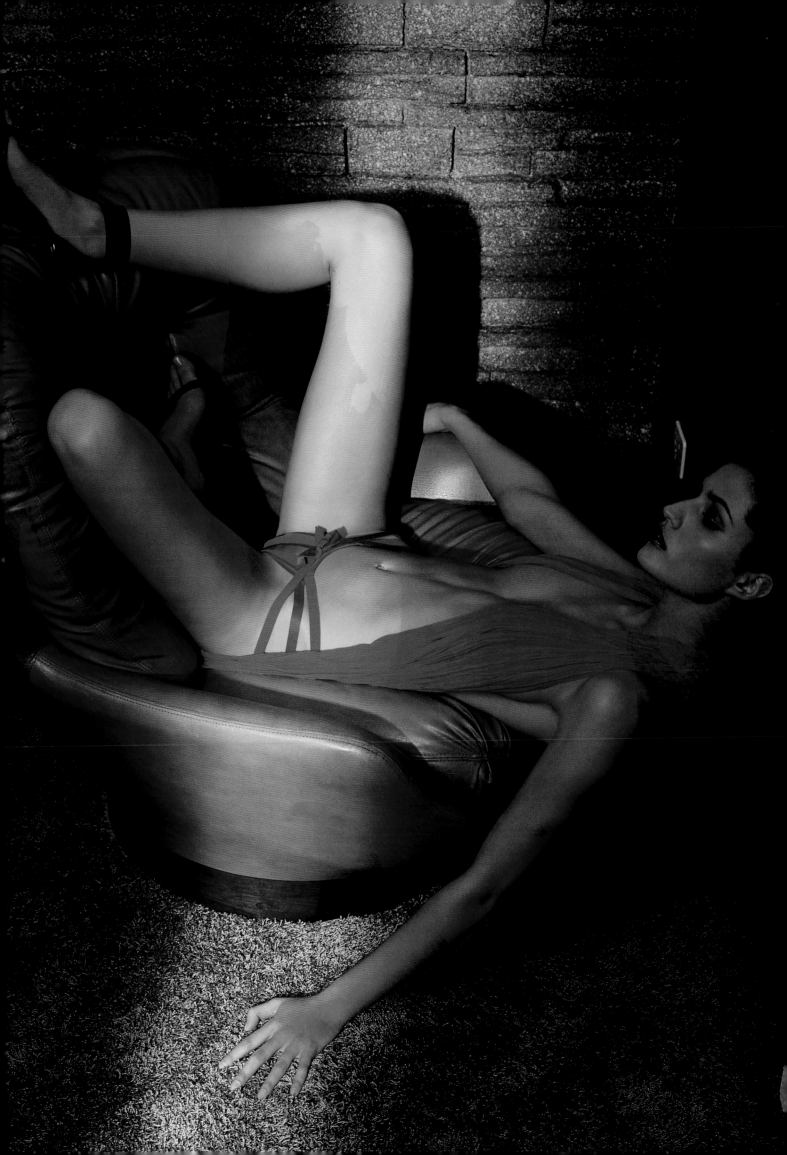

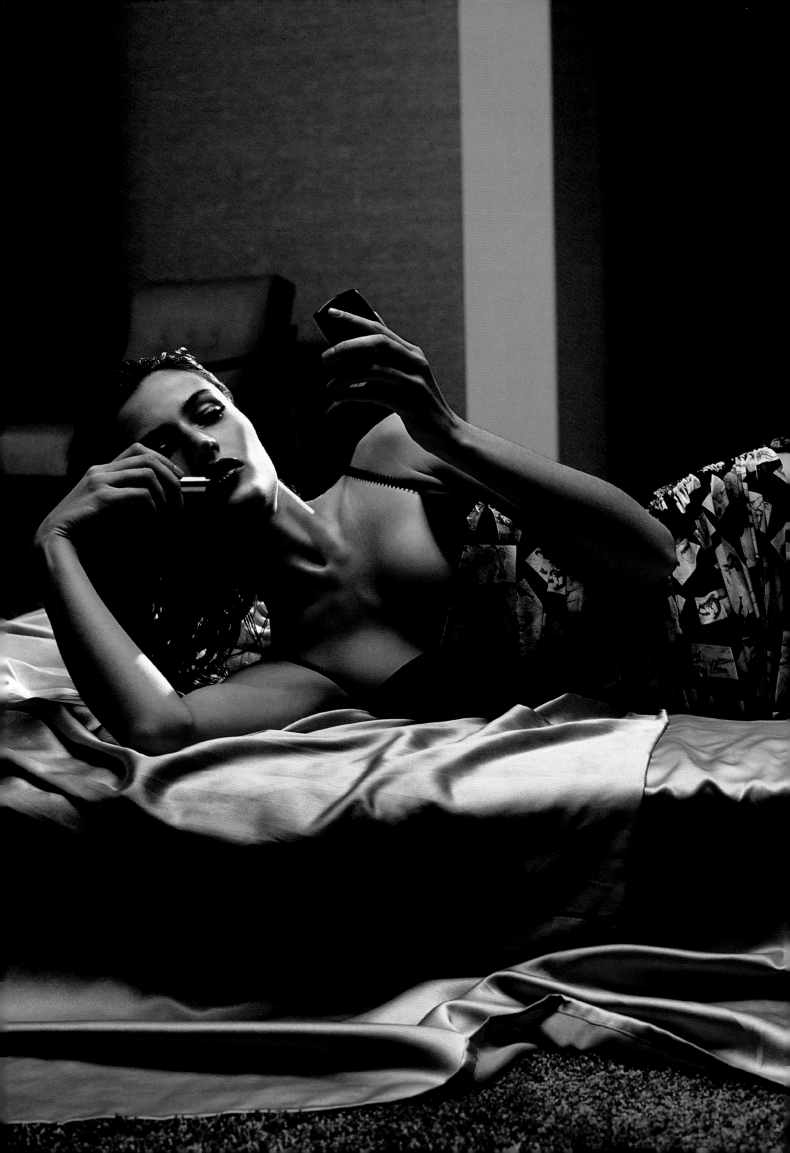

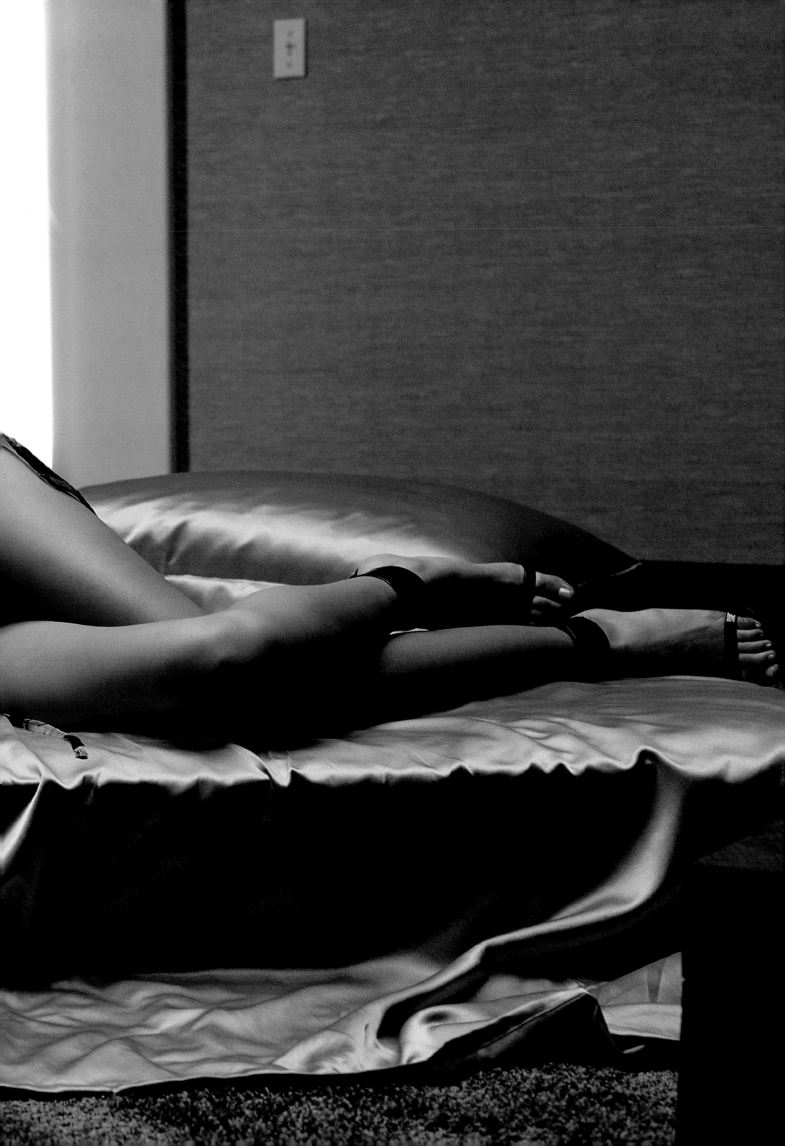

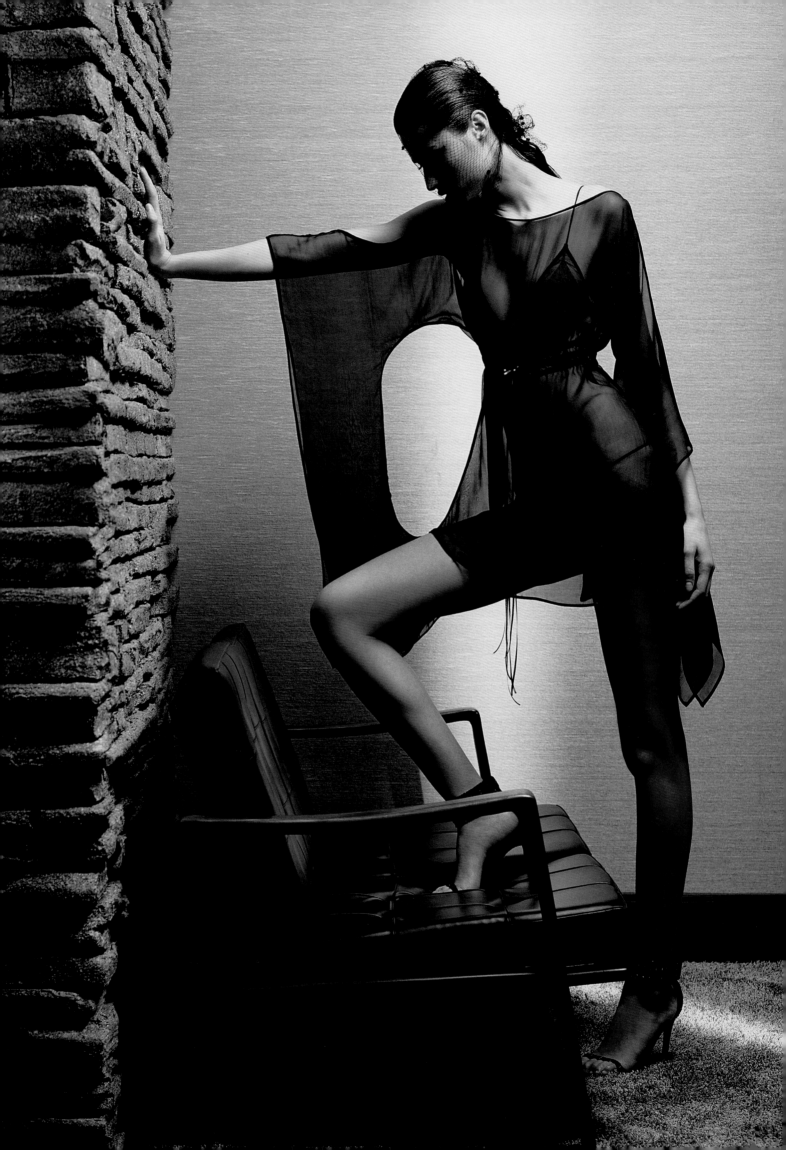

EPICENTER OF THE SENSES
AND EMOTIONAL SHORT-
CIRCUIT. ANY ATTEMPT AT
A DEFINITION FALLS SHORT.
AN AWE-INSPIRING ELECTRIC
SHOCK SPRINGS FROM
A DETAIL, A GESTURE,
OR A GAZE. THE PRESENCE
THAT LINGERS IN THE AIR,
THE ANCIENTS WOULD HAVE
CALLED *DIVINE*.

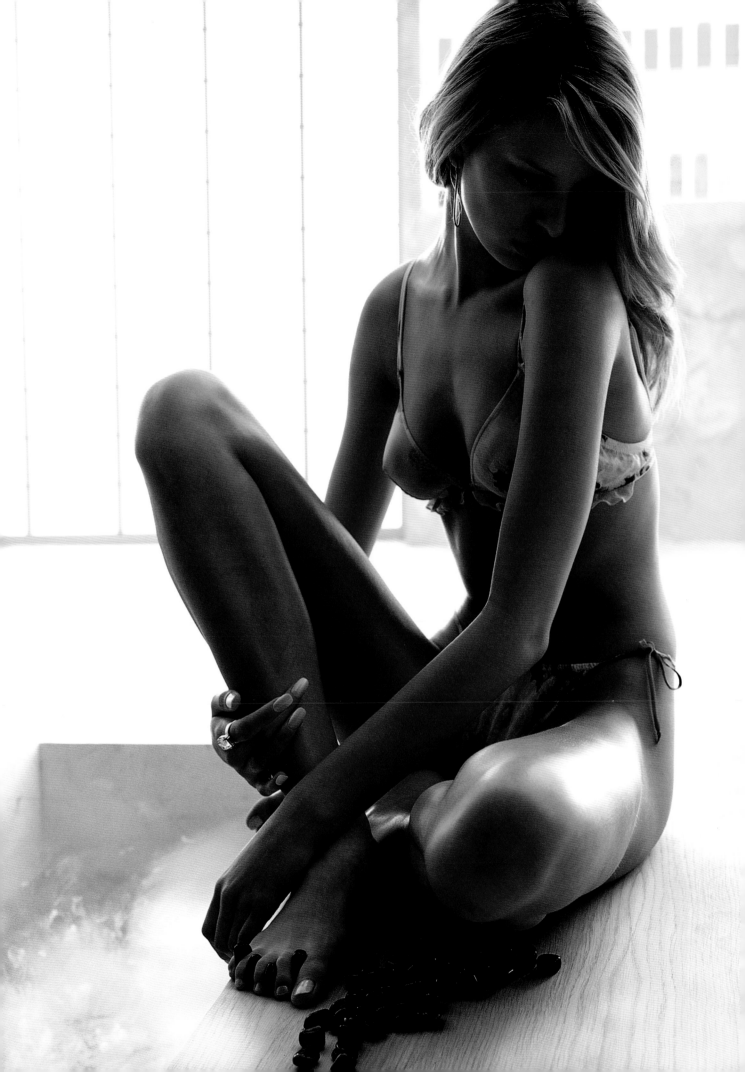

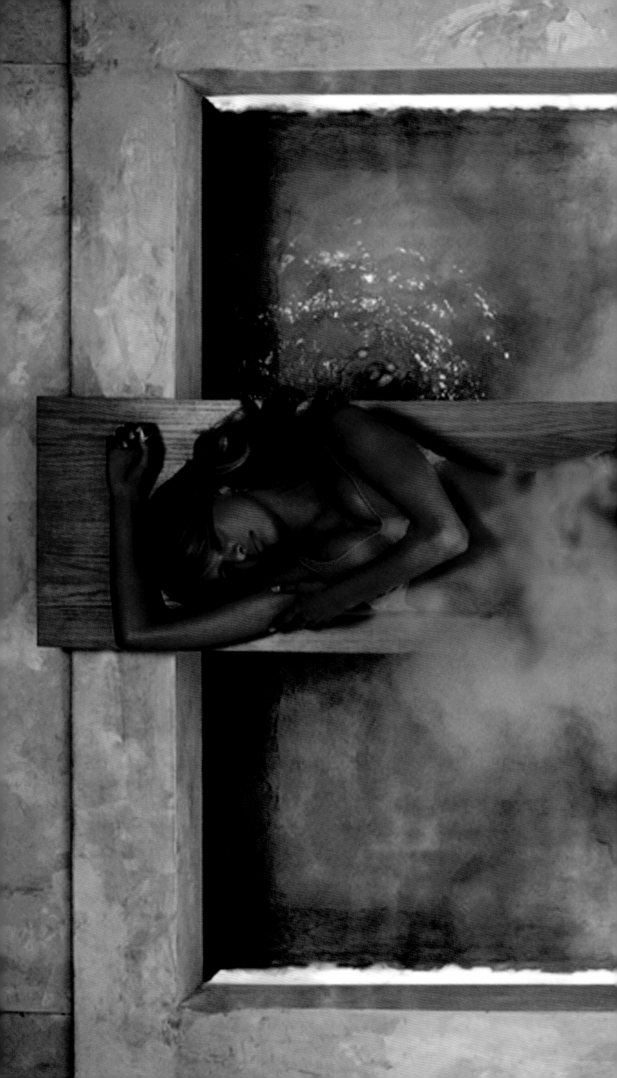

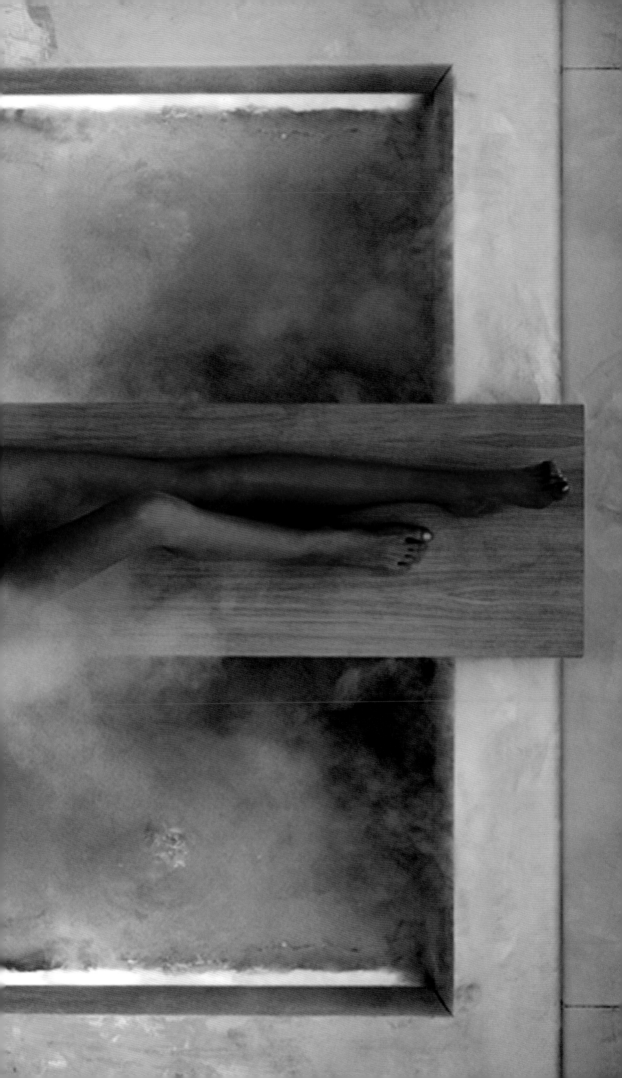

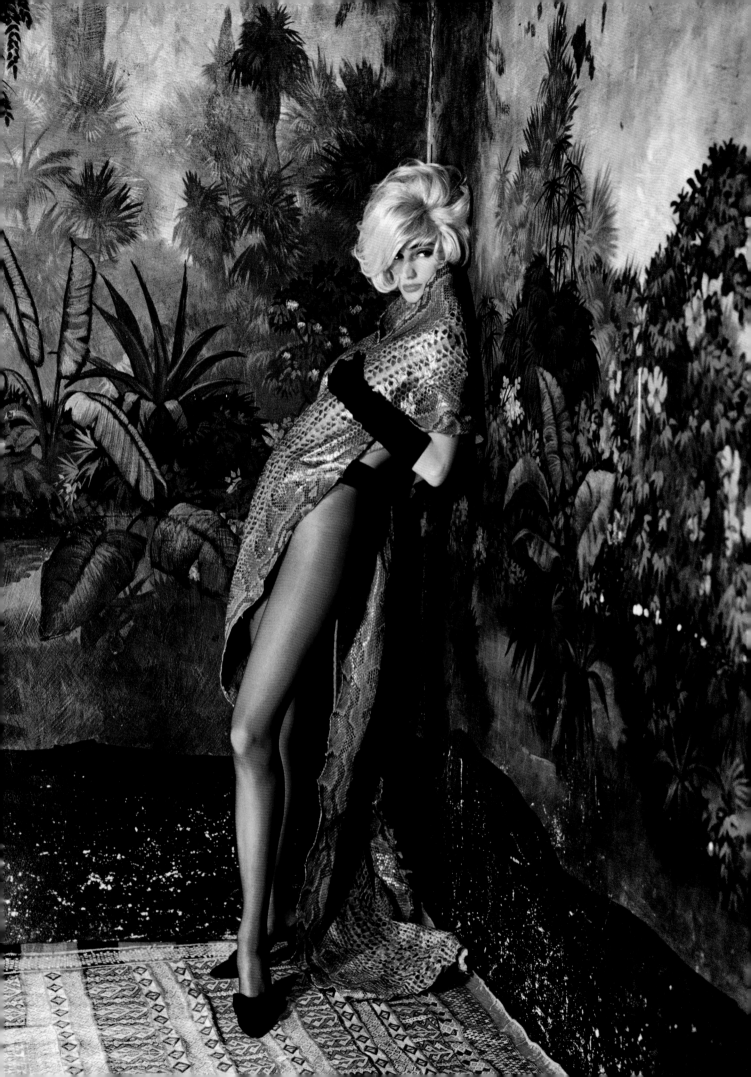

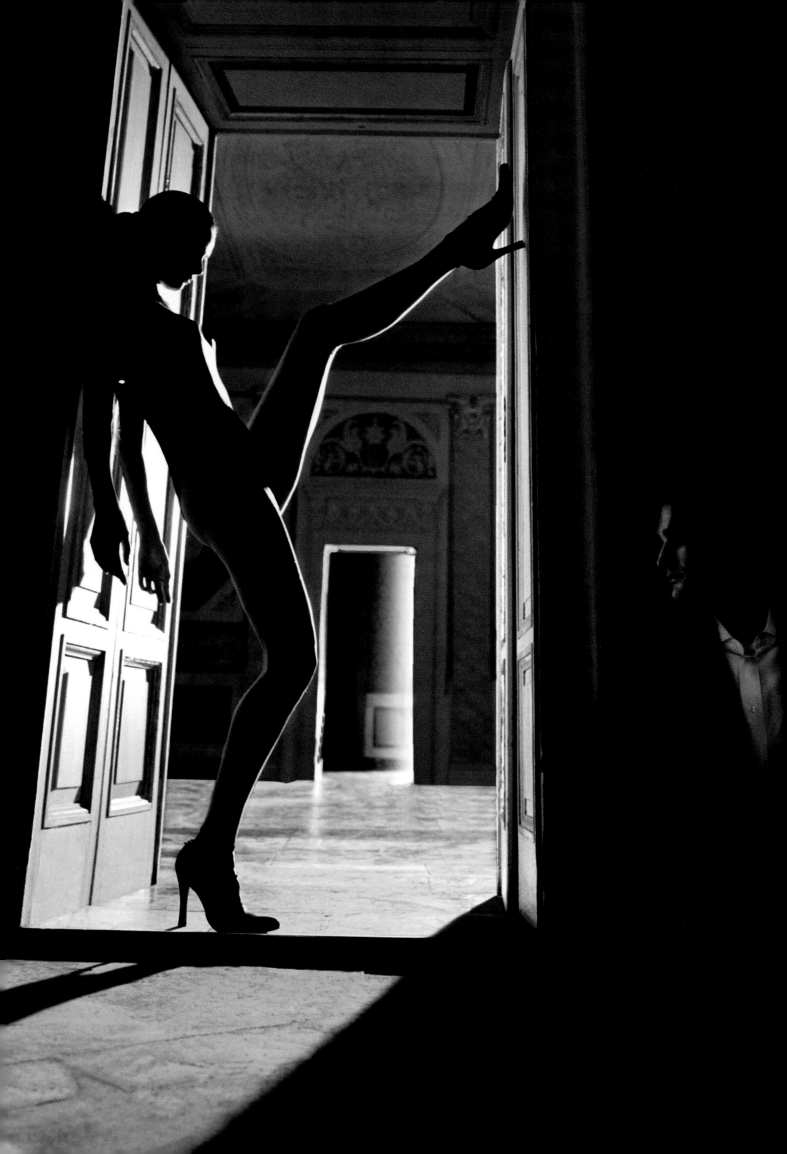

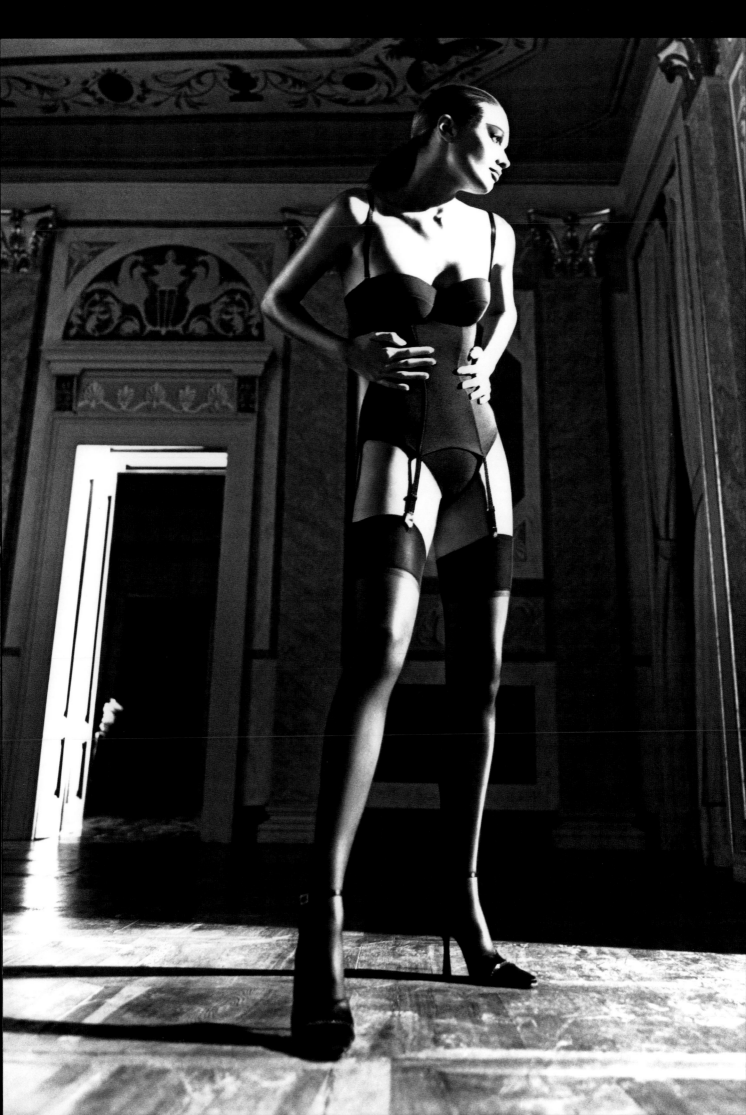

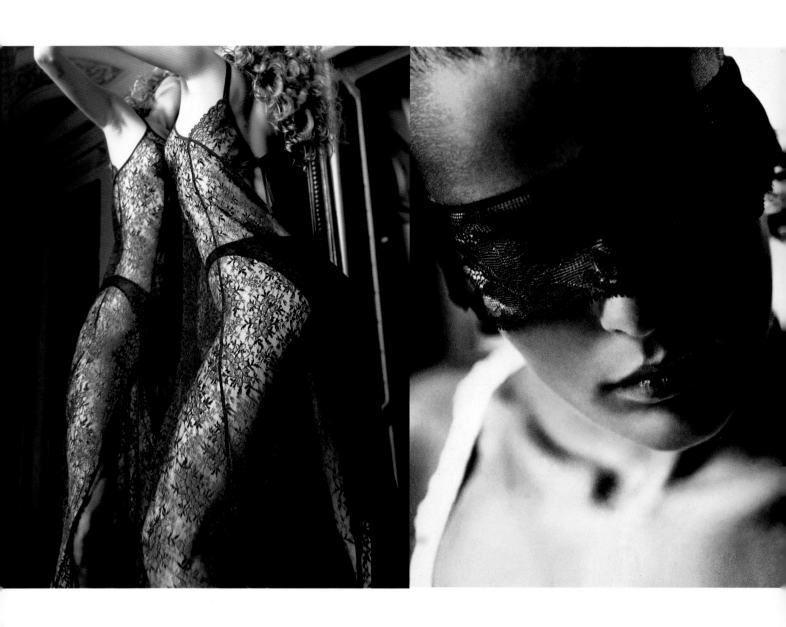

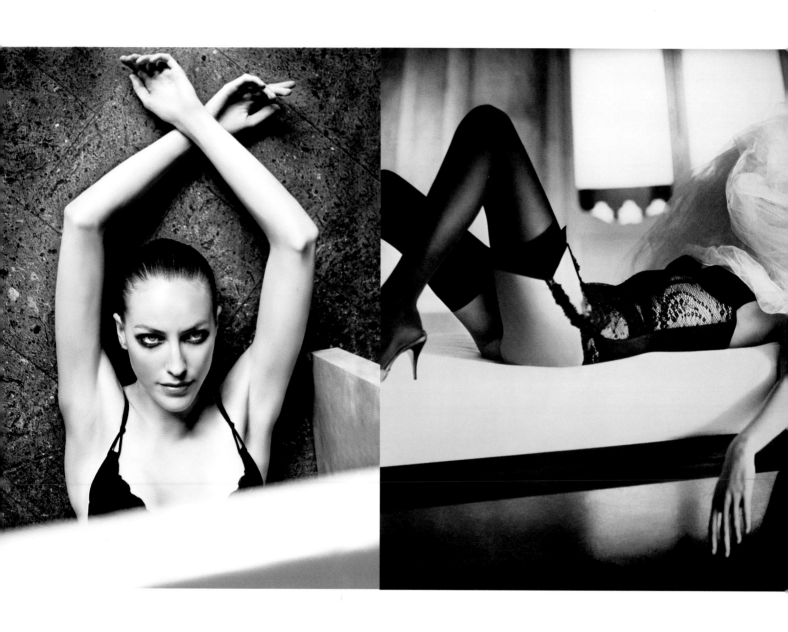

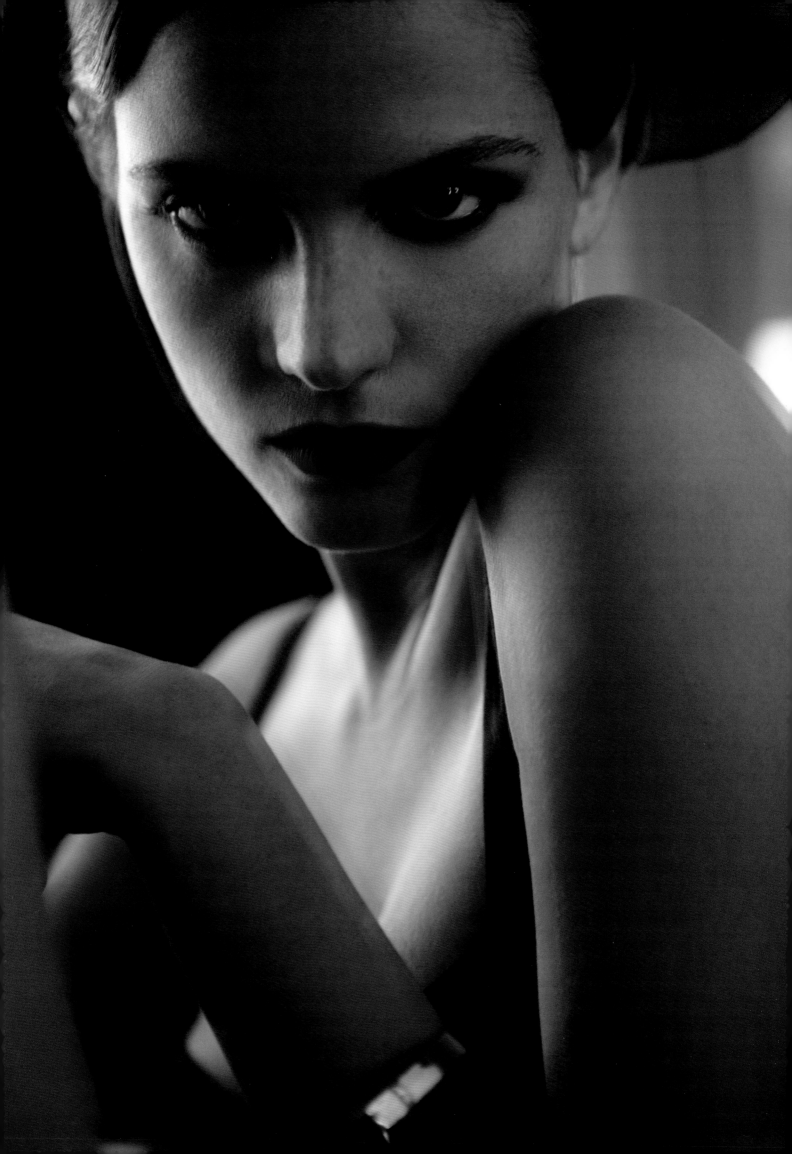

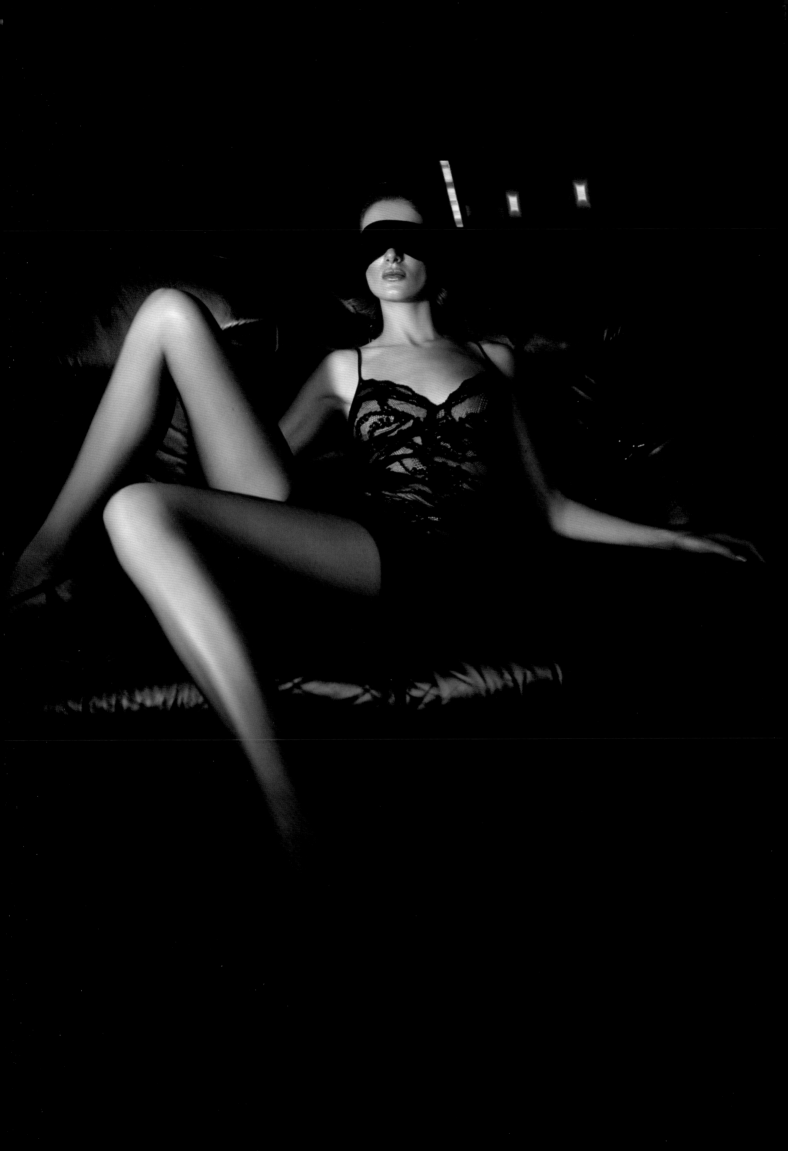

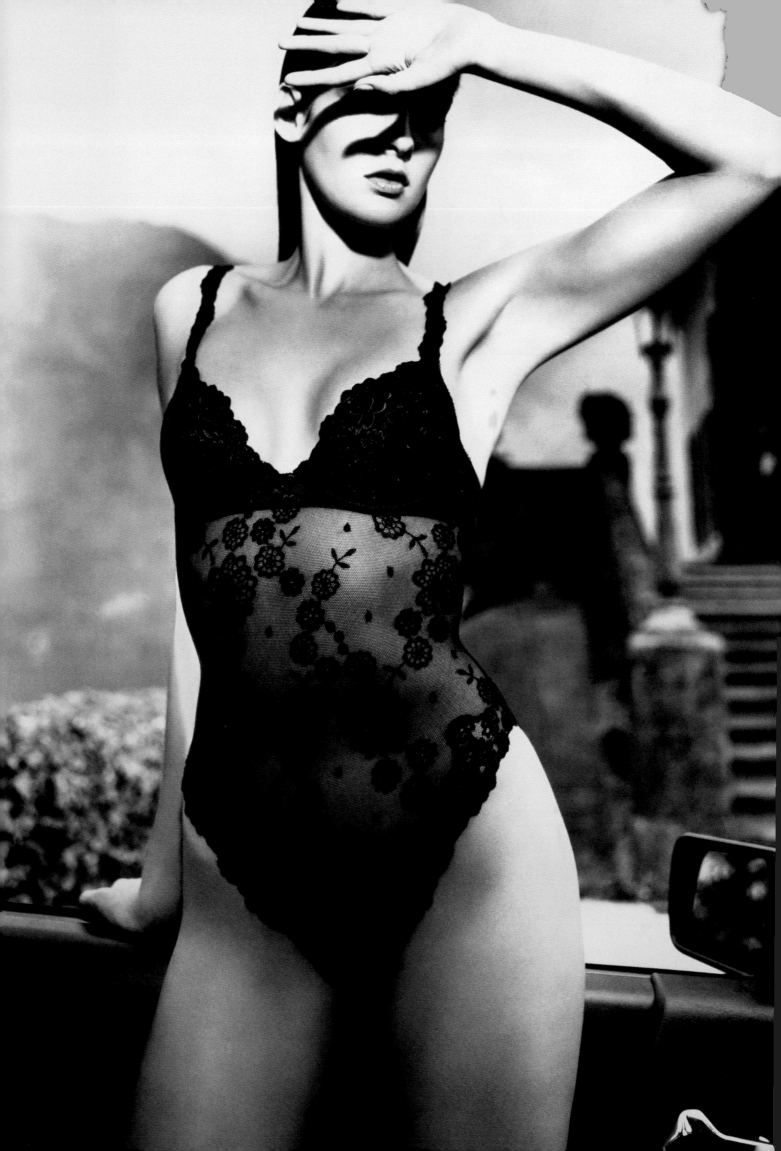

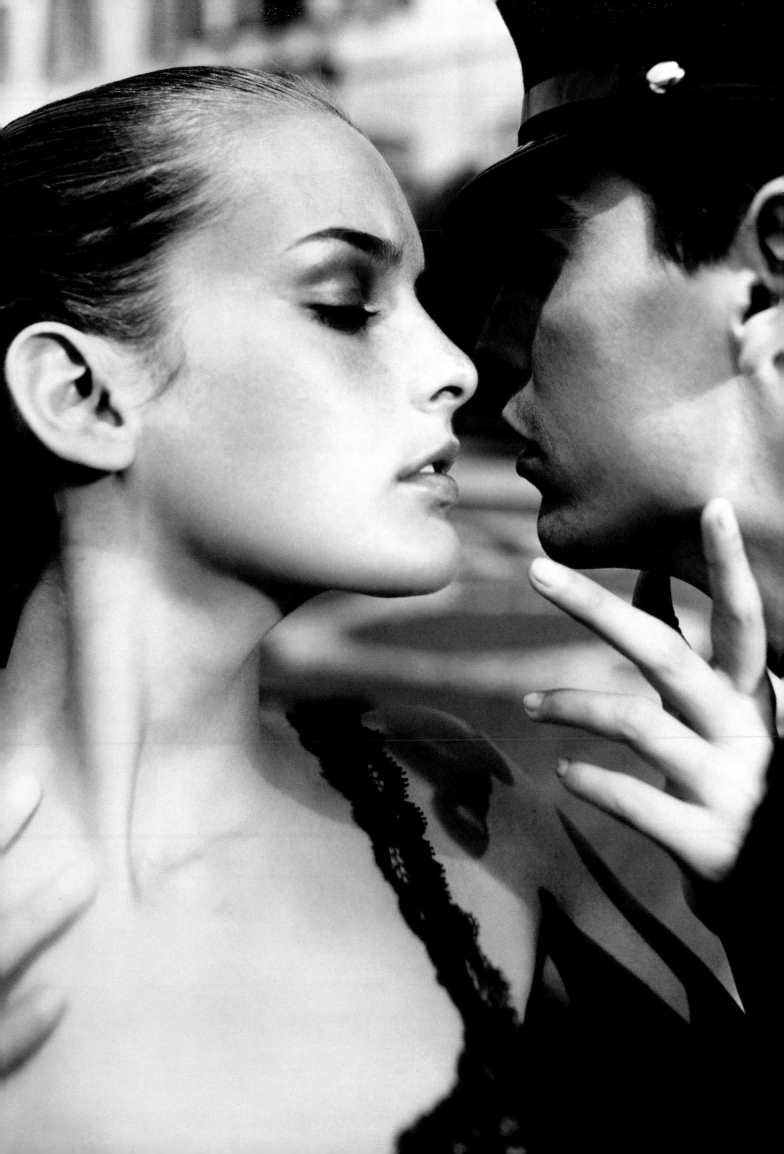

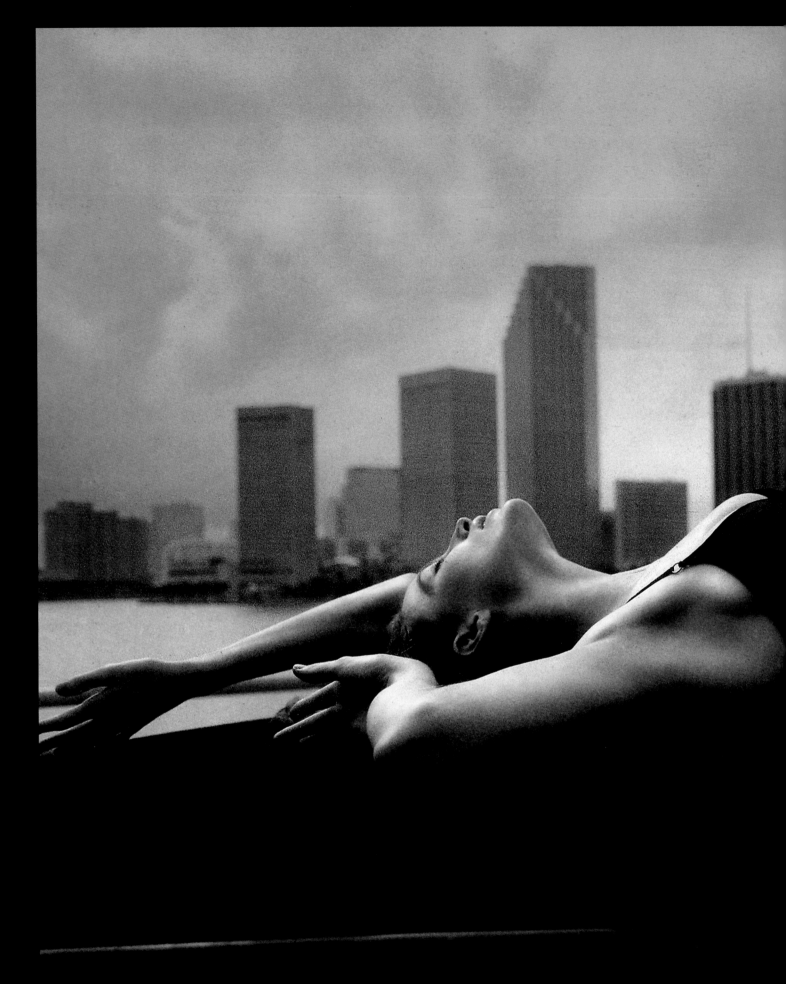

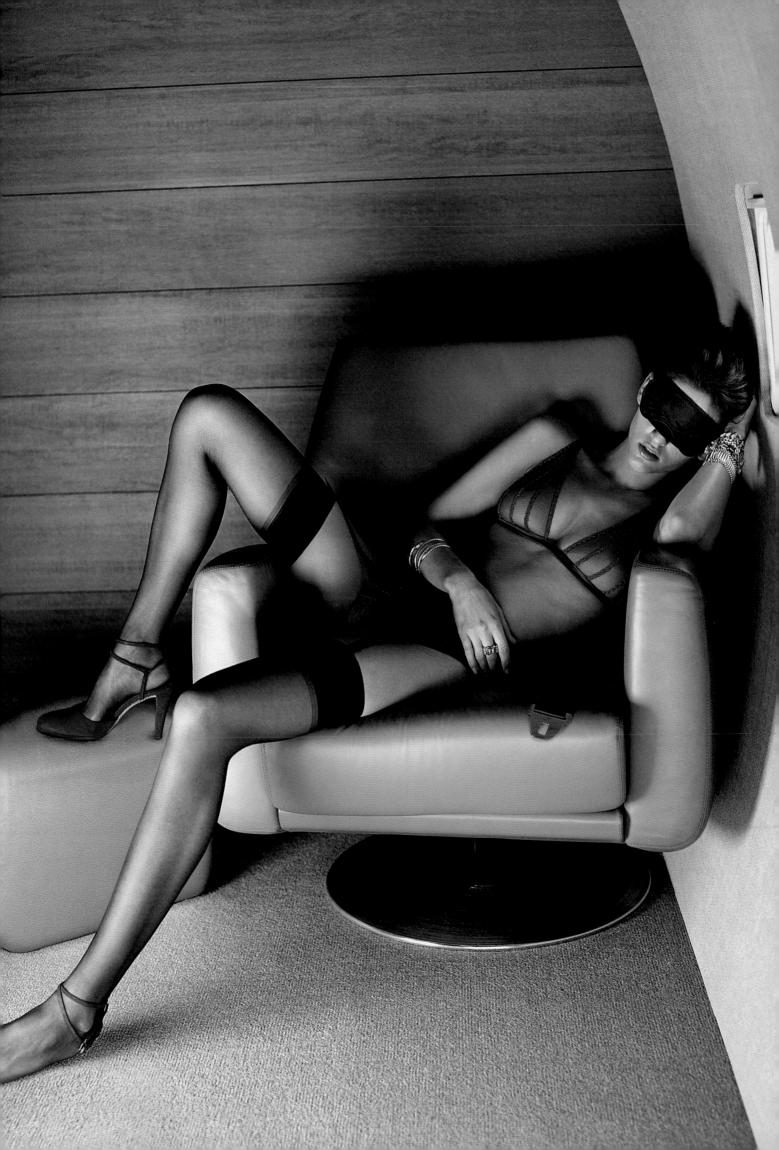

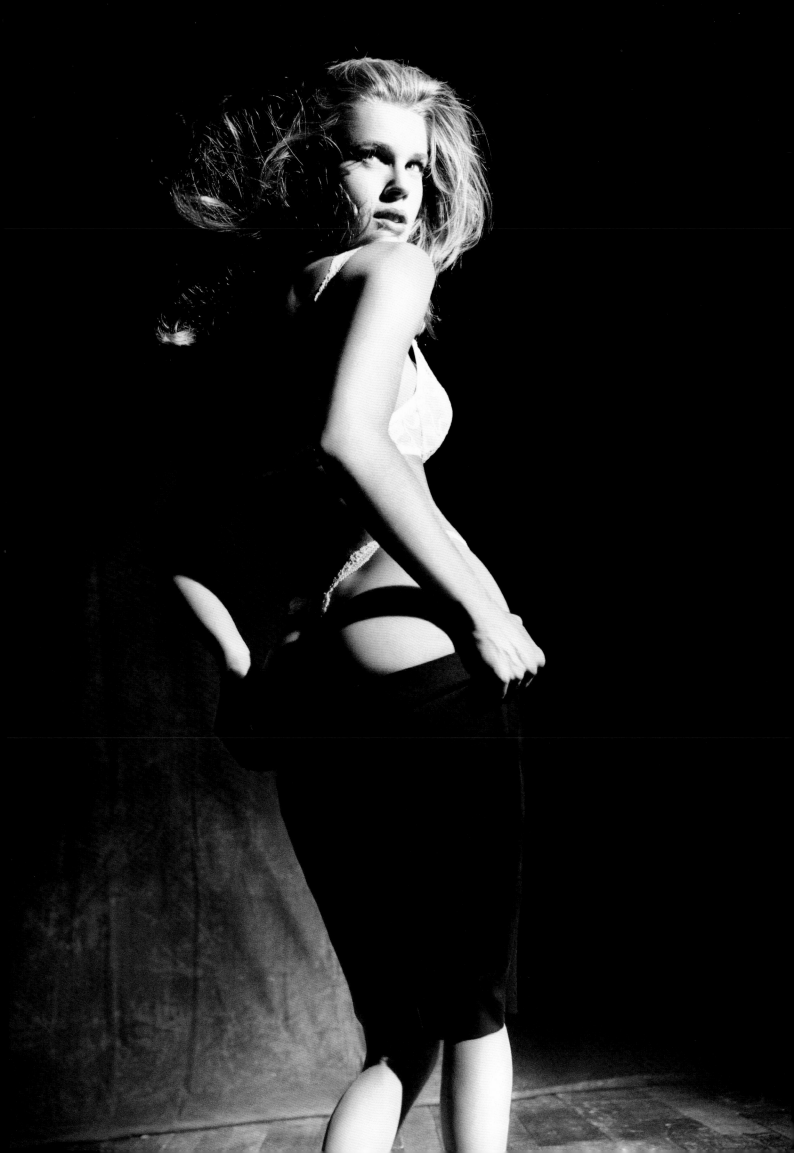

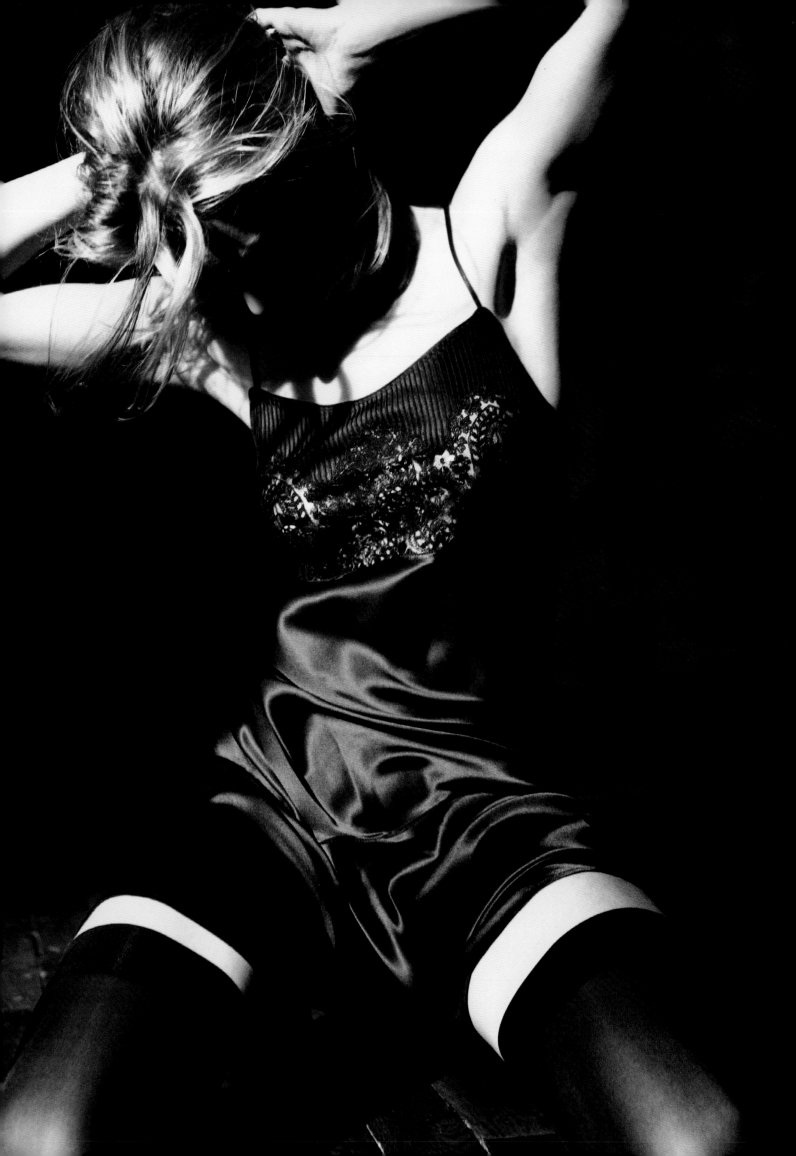

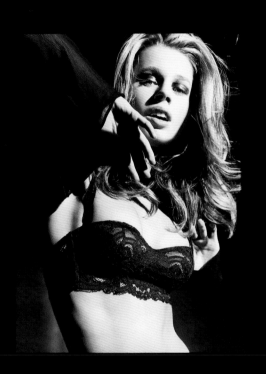

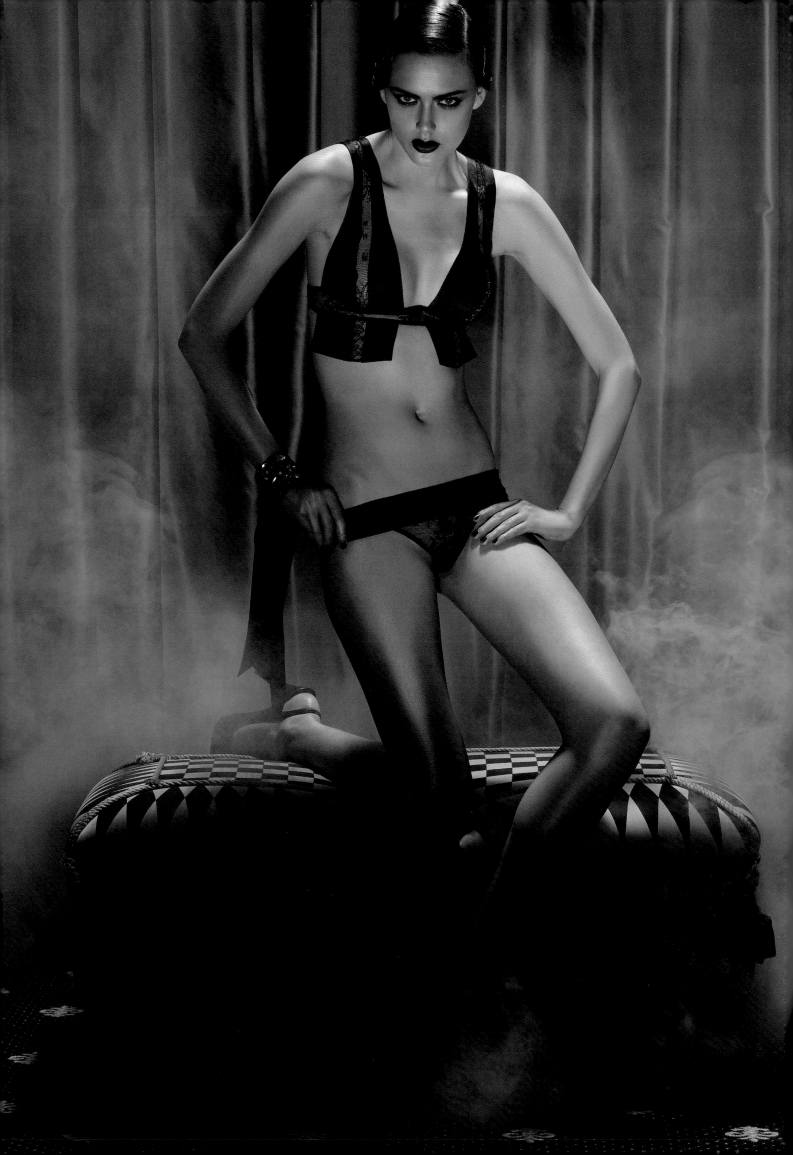

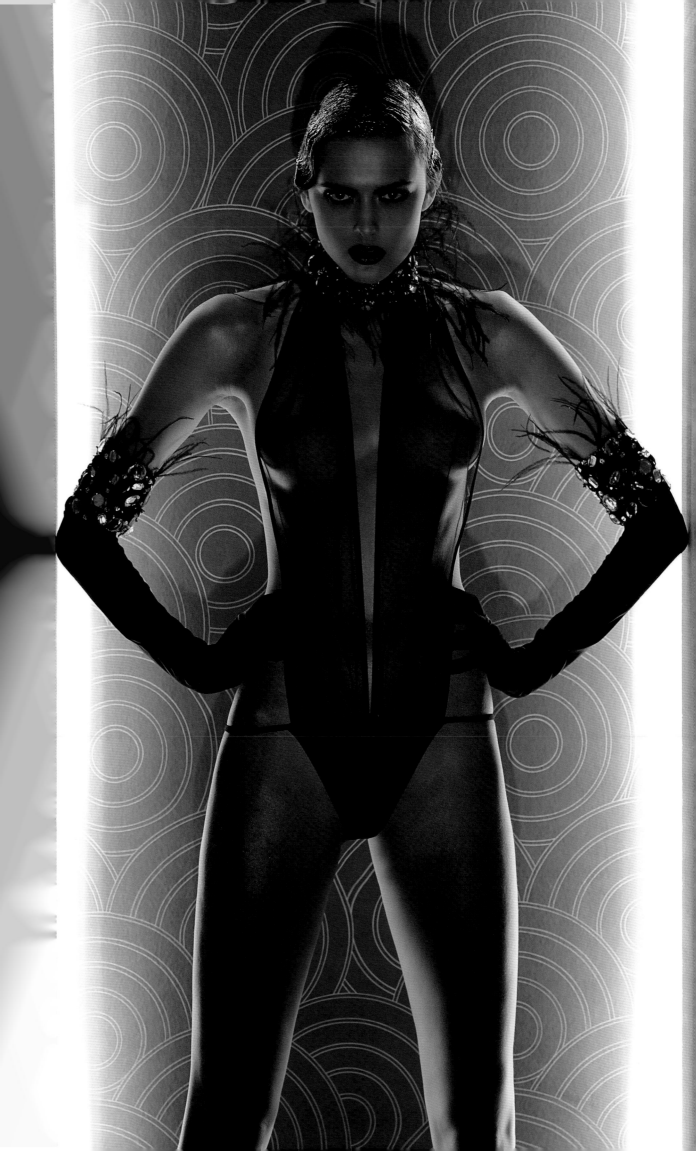

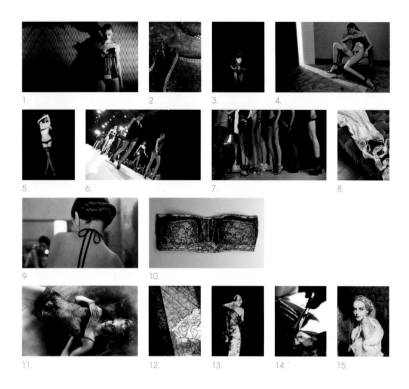

La Perla

1. S/S 2009 Collection
Photo: Nadir
Model: Zuzana Gregorova

2. La Perla Details
Photo: Midivertounmondo

3. S/S 2008 Collection
Photo: Nadir
Model: Edita Vilkeviciute

4. S/S 2004 Collection
Photo: Nadir
Model: Maja Latinovic

5. Legwear Collection
Photo: Nadir
Model: Polina Kasina

6. F/W 2011
Backstage
Moscow Fashion Week

7. F/W 2011
Backstage
Moscow Fashion Week

8. S/S 2008 Nightwear Collection
Photo: Sonia Marin

9. F/W 2011 Collection
Photo: Mary Rozzi
Model: Jeisa Chiminazzo

10. F/W 2008 Couture bra
Photo: Corrado Dalcò

11. F/W 2004 Collection
Photo: Michelangelo di Battista
Model: Rianne Ten Haken

12. La Perla Details
Photo: Midivertounmondo

13. Parfum Privé
Photo: Alistair Taylor Young

14. Lace cutting
Photo: Gianmarco Chieregato
Portrait of La Perla worker's hands

15. S/S 1993 Collection
Photo: Nadir
Model: Simonetta Gianfelici

Sixties

1. S/S 1968 Collection
Photo: Studio Martelli

2. F/W 1966 Collection
Photo: Studio Martelli

3. S/S 1969 Collection
Photo: Studio Martelli

4. S/S 1969 Collection
Photo: Studio Martelli

5. S/S 1965 Collection
Photo: Studio Martelli

6. S/S 1965 Collection
Photo: Studio Martelli

7. F/W 1966 Collection
Photo: Studio Martelli

Body

1. Leavers lace Bustier
Photo: Alistair Taylor Young

2. S/S 2008 Pap Collection
Photo: Gianluca Simoni
Backstage Fashion Show

3. Leavers lace
Photo: Gianmarco Chieregato
Portrait of La Perla worker's hands

4. F/W 2011 Collection
Photo: Mary Rozzi
Model: Jeisa Chiminazzo

5. S/S 2009 Collection
Photo: Nadir
Model: Zuzana Gregorova

6. F/W 2007 Panier
Photo: Corrado Dalcò

7. F/W 2011
ShapeCouture Collection
Photo: Nadir
Model: Carolina Piovano

8. F/W 2011
ShapeCouture Collection
Photo: Nadir
Model: Carolina Piovano

9. F/W 2011
ShapeCouture Collection
Photo: Nadir
Model: Carolina Piovano

10. F/W 2004 Collection
Photo: Nadir
Model: Maja Latinovic

11. S/S 2008 Collection
Photo: Nadir
Model: Edita Vilkeviciute

12. F/W 2007 Cage Bustier
Photo: Corrado Dalcò

13. S/S 2008 Pap Collection
Photo: Gianluca Simoni
Backstage Fashion Show

14. F/W 2003 Collection
Photo: Nadir
Model: Maja Latinovic

15. S/S 2008 Collection
Photo: Nadir
Model: Edita Vilkeviciute

16. S/S 2004 Collection
Photo: Nadir
Model: Maja Latinovic

17. S/S 2008 Collection
Photo: Nadir
Model: Edita Vilkeviciute

18. S/S 2008 Collection
Photo: Nadir
Model: Edita Vilkeviciute

Seventies

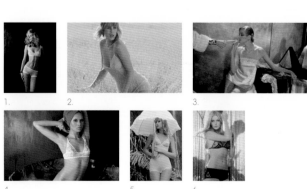

1. S/S 1970 Collection
Photo: Studio Martelli

2. S/S 1976 Collection
Photo: Marco Emili

3. S/S 1977 Collection
Photo: Marco Emili

4. F/W 1971 Collection
Photo: Marco Emili

5. S/S 1976 Collection
Photo: Marco Emili

6. S/S 1979 Collection
Photo: Marco Emili

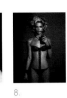

Black

1. F/W 1997 Collection
Photo: Marino Parisotto
Model: Andrea Orme

2. F/W 2003 Collection
Photo: Michelangelo di Battista
Model: Brigitte Swidrak

3. F/W 2003 Collection
Photo: Michelangelo di Battista
Model: Brigitte Swidrak

4. F/W 2003 Collection
Photo: Michelangelo di Battista
Model: Brigitte Swidrak

5. F/W 2003 Collection
Photo: Michelangelo di Battista
Model: Brigitte Swidrak

6. F/W 2003 Collection
Photo: Michelangelo di Battista
Model: Brigitte Swidrak

7. F/W 1996 Collection
Photo: Nadir
Model: Anna K.

8. F/W 2004 Collection
Photo: Michelangelo di Battista
Model: Rianne Ten Haken

9. F/W 2004 Collection
Photo: Michelangelo di Battista
Model: Rianne Ten Haken

Eighties

1. S/S 1982 Collection
Photo: Marco Emili

2. F/W 1981 Collection
Photo: Marco Emili

3. S/S 1984 Collection
Photo: Marco Emili

4. S/S 1982 Collection
Photo: Marco Emili

5. S/S 1985 Collection
Photo: Marco Emili

6. F/W 1983 Collection
Photo: Marco Emili

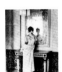

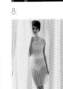

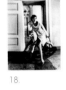

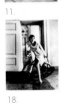

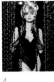

White

1. S/S 2010 Bridal Collection
Photo: Mary Rozzi
Model: Maria Piskac

2. F/W 1996 Collection
Photo: Marino Parisotto
Model: Teresa Maxova

3. S/S 2010 Bridal Collection
Photo: Mary Rozzi
Model: Maria Piskac

4. S/S 2007 Collection
Photo: Marco Onofri

5. S/S 1995 Collection
Photo: Marino Parisotto
Model: Teresa Maxova

6. S/S 2010 Bridal Collection
Photo: Mary Rozzi
Model: Maria Piskac

7. Sewing
Photo: Gianmarco Chieregato
Portrait of La Perla worker's hands

8. S/S 2006 Bridal Collection
Photo: Gianluca Simoni

9. S/S 2006 Bridal Collection
Photo: Gianluca Simoni

10. S/S 2006 Bridal Collection
Photo: Gianluca Simoni

11. S/S 2006 Bridal Collection
Photo: Gianluca Simoni

12. F/W 2006 Bridal Collection
Photo: Marco Onofri

13. F/W 1996 Collection
Photo: Marino Parisotto
Model: Teresa Maxova

14. S/S 1995 Collection
Photo: Marino Parisotto
Model: Teresa Maxova

15. S/S 2012 Collection
Photo: Mary Rozzi
Model: Jeisa Chiminazzo

16. S/S 2007 Collection
Photo: Marco Onofri

17. F/W 1996 Collection
Photo: Marino Parisotto
Model: Teresa Maxova

18. F/W 1996 Collection
Photo: Marino Parisotto
Model: Teresa Maxova

19. S/S 2007 Collection
Photo: Midivertounmondo

20. S/S 1995 Collection
Photo: Marino Parisotto
Model: Teresa Maxova

21. F/W 1996 Collection
Photo: Marino Parisotto
Model: Teresa Maxova

22. F/W 1997 Collection
Photo: Fabrizio Gianni
Model: Maria Cseh

23. S/S 1996 Collection
Photo: Marino Parisotto
Model: Teresa Maxova

24. S/S 1996 Collection
Photo: Marino Parisotto
Model: Teresa Maxova

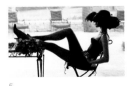

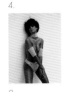

Nineties

1. F/W 1991 Collection
Photo: Nadir
Model: Carmen Carmen

2. S/S 1996 Collection
Photo: Nadir
Model: Magdalena

3. S/S 1996 Collection
Photo: Nadir
Model: Magdalena

4. F/W 1992 Collection
Photo: Nadir

5. S/S 1992 Collection
Photo: Nadir

6. F/W 1995 Collection
Photo: Nadir
Model: Johanna Rhodes

7. F/W 1993 Collection
Photo: Nadir

8. F/W 1993 Collection
Photo: Nadir

9. S/S 1992 Collection
Photo: Nadir
Model: Carmen Carmen

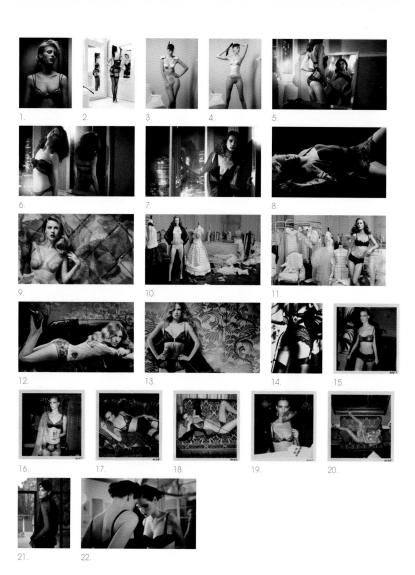

Precious

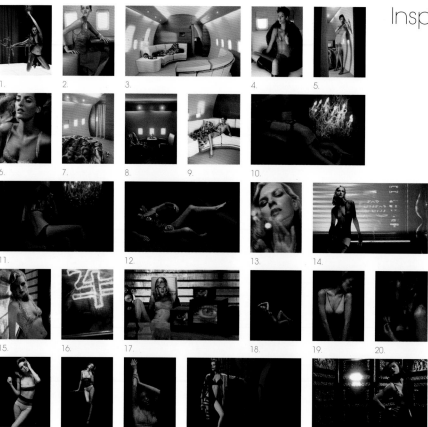

Inspiration

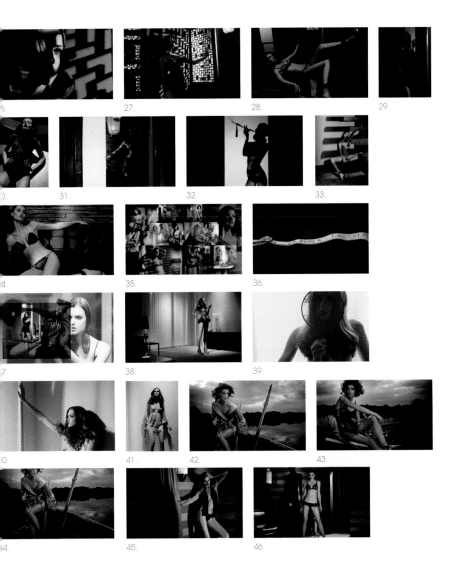

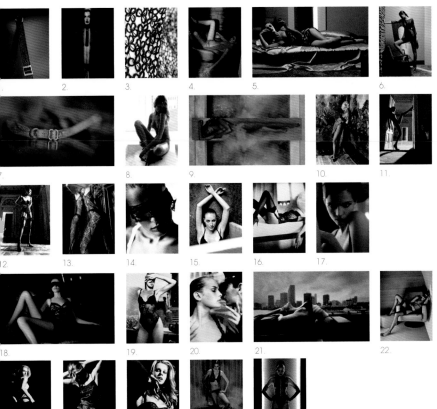

Eros

Printed in China